DRAWING YOUR BABY

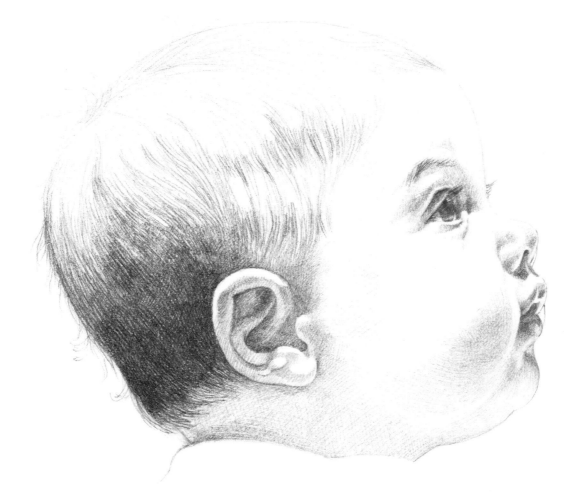

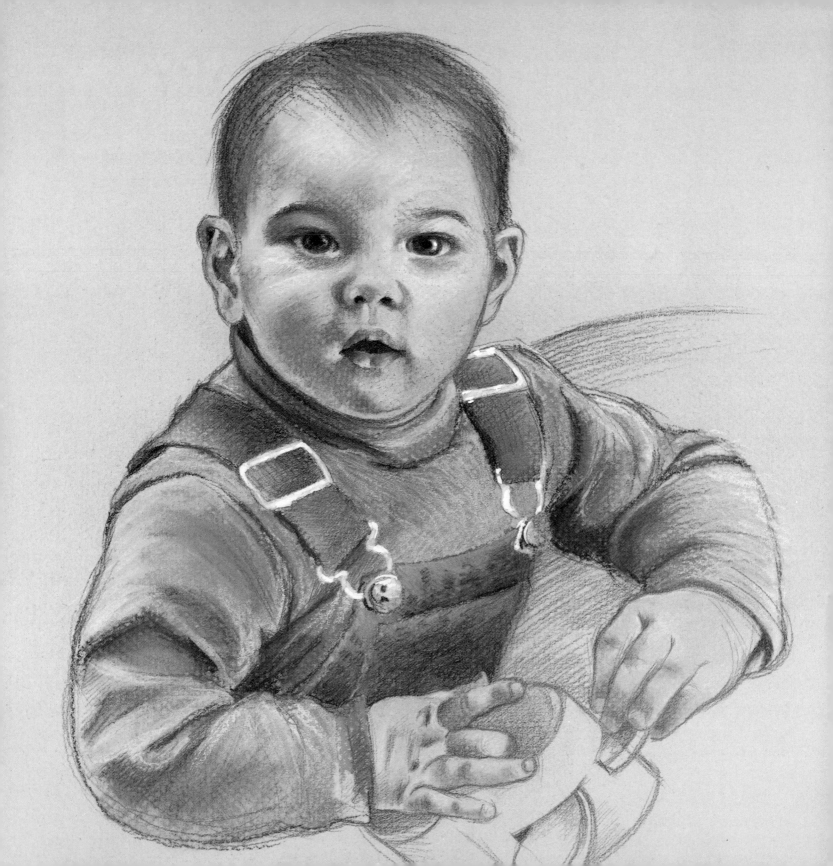

DRAWING YOUR BABY

JUDY CLIFFORD

WATSON-GUPTILL PUBLICATIONS/NEW YORK

Art on title page:
Nicky in Overalls. Pastel on Canson Mi-Teintes
paper, 9¼ × 8″ (23.5 × 20 cm). Artist's collection.

Edited by Janet Frick
Designed by Bob Fillie, Graphiti Graphics
Graphic production by Ellen Greene
Text set in 11/12 Horley Old Style

All the art in this book, unless otherwise noted,
is by Judy Clifford.

First published in 1990 in New York by Watson-Guptill Publications,
a division of Billboard Publications, Inc.,
1515 Broadway, New York, N.Y. 10036

Library of Congress Cataloging-in-Publication Data

Clifford, Judy.
 Drawing your baby.

 Includes bibliographical references.
 1. Portrait drawing—Technique. 2. Infants in art.
3. Infants—Portraits. I. Title.
NC773.C55 1990 743′.45 89-25033
ISBN 0-8230-1369-3

Manufactured in the U.S.A.

First printing, 1990

1 2 3 4 5 6 7 8 9 10/94 93 92 91 90

CONTENTS

Phil

Aug 6th, 1985: Today I found out that I am pregnant - after waiting so long... Phil and I are finally going to be parents. I feel like a different person, I am a mother-to-be... almost immediately I hunger to see you, who will you look like? Phil and I talked alot about having a baby even before we knew you were coming.

Your dad and I celebrated this wonderful occasion and both of us cried w/ joy!

Judy

You will be a symbol of our togetherness and symbols are, above all, visual things. I can't even feel you moving inside me yet I try to visualize you.

Now your childhood will be filled with all the paraphernalia of childhood... stuffed teddy bears, little clothes, knitted caps and books about...

Aug. 28th: Second pre-natal visit... and Dr. Givati (Carol) talks about nutrition - I hurry back to the studio as I am working on an illustration.

I wonder if I have somehow drawn you without knowing it... as they say... artists subconsciously draw themselves in the people they portray. I looked back through some of my old paintings and I found this one of a fair haired boy - will you look like this?

Venus et l'Amour
by Botticelli
ivory

Nov. 14th Today I listened to your tiny heart-beat which was loud and strong - I am filled with awe. "Seeing" you on the sonogram has helped me to grasp your reality...

Nov. 6th Amniocentesis today. I have to drink 3, 8 oz. glasses of water 2 hours before the sonogram. I held it. Very tricky!

Nov. 18th: I felt you kick for the first time!

Mother and Child by Henry Moore, 1938

March 21 - April 19

Dec. 8th
Because
I can't
know your face - the reality
I seek sometimes finds its
expression in the symbols
of "babyness" Safety pins!
what powerful
symbols these are...
they signify safety
and danger, they hold
things together and until the
advent of disposable diapers -
they were also called diaper pins.

Dec. 10th:

What do you look like? Your father and I hope that you
will be a combination of the best in each of us.
We look so different, he and I. His face is long and
narrow, he has dark wavy hair and light brown
eyes. Also a long, elegant nose and large almond-shaped
eyes. I have a basically oval-shaped face dominated
by round cheeks and topped w/ blondish hair. My
eyes are hazel and my mouth is small, but my
lips are full and I also have a mole above my
mouth. I will play the "Police Artist" game
and try to make a composite of your face
based on the faces of your father and mother.

December 13th Ten more
days till my birthday -
39 years old. I was
already 17 years old when my mom
was 39. Ours is the generation of
geriatric parenthood... certainly in
N.Y.C. - What would I like for my
birthday? A peek into that warm, dark,
liquid place inside me - a peek at you!

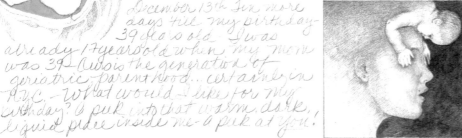

Dec. 20th: We finally got the results
from the Amniocentesis - a normal
baby boy! We are both relieved
and very excited - I picture
Nicky frolicking with his
chromosomes! Oh yes, we've
already named you - my
sweet, sweet baby boy -

Nicholas Landon Clifford

middle name middle name
Paternal Grand- Maternal
father grandfather

Here are two pages from my
pregnancy journal, in which I
jotted down thoughts and
images as I tried to capture my
feelings about my growing baby.

INTRODUCTION

Long before he was a separate physical reality, my baby lived inside my heart and mind as well as inside my body. He was the product of my imagination and my maternal scribblings. I was trying to understand him. Being an artist, I had an insistent need to see him before he emerged from my body, and no physical clues to his existence could satisfy me. His tiny, racing heartbeat, my swelling belly, and, finally, his most athletic kicks were not enough to assuage my visual craving.

Drawing my baby after he was born was even more compelling. Every phase of his infancy had its own fascination, and I wanted to record *everything*. Skills that I had learned in life drawing classes, skills that had taught me how to really see, gave me the ability to understand and record the miracle that he was. My hope in writing this book is to show other parents how to observe their children, not just as parents but as artists. Hopefully the basic knowledge and special tips contained in this book will help you record your child's image and capture it for the future.

(By the way, because my own child is a boy, I refer to the baby as "he" throughout this book, just to keep the grammar simple. But all the principles of observing and drawing that I describe—and nearly all the anatomy—will apply equally well whether your baby is named Nicholas or Nicole.)

Part of the reason most people do not draw is a belief in the divine nature of the artistic talent. Nonartists have a vision of artists on automatic pilot receiving guidance and inspiration from some "power beyond" common man or woman. This mythical artist's hand moves as if by magic to produce masterpieces, while those not so endowed are relegated to stick figures. Sometimes a belief in this magical ability is perpetuated by artists themselves, who enjoy their mystique and prefer others not to see them more mundanely as problem solvers with obstacles to overcome in order to produce a work of art. If this sounds familiar to you, it might help you to think of an artist as someone who works at solving drawing and painting problems.

The only "power beyond" an artistic education that operates to help artists create masterpieces is the power we all have when we draw something that is important to us: an emotional involvement. As a parent drawing your baby, you already have this distinct advantage.

Having a baby and learning to see as an artist are two significant milestones in anyone's life, and the first can help bring about the second. Your baby is just learning to see for the first time. He has no preconceived ideas as to how something should look, so he is forced to use all his powers of concentration to make sense of the physical world before him. This is also how artists view their surroundings: They are constantly aware of what they *really* see and do not take anything for granted. You can learn to see this way along with your child. It will be harder for you because you will have to discard many years' accumulation of stereotyped images of what things *should* look like, which dull perception. But remember, seeing with a fresh eye is a gift everyone is born with. You can rediscover it in yourself as you watch your baby develop it for the first time. Together you will explore the world's wondrous patterns and configurations.

Learning to draw is an exercise in learning to see in a very precise manner. Well-known artist, author, and teacher Frederick Franck wrote, "I have learned that what I have not drawn, I have never really seen, and that when I start drawing an ordinary thing, I realize how extraordinary it is, sheer miracle."[1] Imagine how much more extraordinary it will be to draw something that already seems to be a miracle: your baby! Seeing takes time, patience, and—especially—an intense interest in your subject. The reward, aside from the drawing itself, is a more profound visual experience and a stronger memory of a special moment in time.

As your baby grows and becomes a toddler, your heightened visual awareness will enable you to watch and record the changes. Besides just looking at your child, you will constantly find other clues to the physical changes taking place: Old clothes are too tight; when you take hold of his arm or leg it will feel more muscular than the baby limbs that you massaged earlier; and imprints of feet in the sand or plaster casts of hands offer another opportunity for comparison. All these methods can be more meaningful than just recording statistics with a measuring tape. But to me, drawing is the most satisfying way of all to keep track of my son's development. It records the objective facts of his size and appearance, but also makes me observe him very closely, and captures the subjective mood of a moment as nothing else can.

UNDERSTANDING HOW YOU SEE

Perhaps you have never really thought about how you see. Many people just take for granted that when they open their eyes in the morning, they see the world around them—without ever realizing how complicated this process is. What you see is influenced by the physiology of your eyes and brain, by the physics of light, and by many subjective factors that determine how you interpret the signals that your eyes receive. To capture visual images on paper, an artist must understand the components of seeing and use them as tools.

The purpose of this section is to make you aware of how the physical world influences the way you see. This foundation of knowledge will increase your confidence in your ability to see what is really there and to depict it on paper. Once you have achieved that, the most important goal is to become completely absorbed in the subject you are drawing—your baby. If the information in any section of this book makes you less eager to experience this feeling—for example, if learning the names of muscles makes drawing seem like a chore—just skip over that information for the present. After you have made some sketches and have begun to experience the joy of really seeing your child, you may want to return to passages previously skipped. Use this book as a reference source, not as a compulsory textbook.

The use of texture/detail gradient will help create the illusion of depth by giving nearer objects more texture and greater detail than more distant objects. Object size can also be a clue to depth because similar objects appear smaller as they move away from the viewer. The artist can effectively place one object behind another by hiding part of one behind the other.

HOW YOUR VISUAL SYSTEM WORKS

Your eyes are horizontally separated. Although they work in tandem to give you a single perception of solid objects, they each receive different views of those objects. As illustrated in the accompanying figure, the brain is able to judge depth from certain physical signals: the angle of convergence between the two eyes, and the disparity between the two images they perceive.

How can the artist compensate for the fact that everything on the surface of a drawing (the picture plane) is flat? He can manipulate the visual signals that reinforce the physical signals described above. Some visual signals of depth are object size, shadows, texture/detail gradient, and hiding far objects behind nearer objects.

Object size is a clue to depth because similar-sized objects appear smaller as they move away from the viewer. Shadows help to create something surprisingly close to binocular depth. The light source revealed by the shadow replaces the "missing eye" by giving the viewer a second view of the object represented, the view from the angle of the light source. Drawing nearer objects with more texture and greater detail than objects that are seen farther away will also help to give the illusion of depth. Finally, the artist can effectively place one object behind another by hiding part of it behind the nearer object.

There are also some things that you do subconsciously when looking at objects that affect the way you see and draw them. For example, when judging the size of an object, your visual system automatically takes distance into account, not just the absolute size of the object's image on your retina. Two men, one standing near you and one a block away, create images of very different sizes on your retina—and yet you instinctively know that they are about the same height anyway. This is called size constancy.

In drawing you must use this principle backward. Although you know that two objects are the same size, in order to give the illusion of depth you must draw the distant object smaller. It is much harder to overcome this visual prejudice than it sounds.

Another subconscious tendency is to draw objects or parts of objects with more interest or detail larger than they actually are. For example, beginning artists often draw a human face much larger than it actually is in relation to the rest of the body, or they draw the facial features onto a head that has very little skull behind it. In learning to draw you must become aware of such subconscious visual prejudices and deliberately work against them. You must also overcome the impulse to rely on the stereotyped symbols (perfect circles or footballs for eyes, an even upward C-curve for a smile) as a shortcut for drawing what you *really* see.

(**a**) This is how a block looks when it is viewed straight on, first by the left eye alone, then by both eyes together, and finally by the right eye alone. The nearer the object, the greater the disparity between the two views. This is one clue to depth. (**b**) When an object is viewed from up close, the angle of convergence is great as the eyes pivot inward sharply to view it clearly. (**c**) As the object is moved farther away, the angle becomes smaller as the eyes pivot outward slightly in order to keep the block in focus. This change in the angle of conversion provides another signal that the brain reads as depth.

A BABY AS A SHAPE

Your baby is a visual object existing in three-dimensional space like any other object. His arms, legs, head, and body can be seen as separate shapes, and they present certain problems of form and mass. The two-dimensional surface of your drawing paper must be handled through the use of artistic techniques and perspective to create the illusion of a three-dimensional form. As mentioned earlier, shadows and texture can help establish a sense of roundness and depth. This takes practice! It is sometimes helpful to think of a complicated shape as a composite of simpler ones, and to practice making simple shapes look three-dimensional before attempting to draw your child. Still lifes are excellent for practice drawings, especially since (unlike your baby) they will hold still indefinitely! Experiment with your materials for ways to convey roundness, flatness, density, various textures, and so on. Later in this book you will find specific ideas on how to achieve these effects.

This charcoal drawing, in which my son's torso is isolated from the rest of his body, accentuates the ripe, rounded form of his abdomen similar to that of a pear.

Quick preliminary sketches can be useful in analyzing the simple shapes that make up a more complex subject.

SOCIAL AND HISTORICAL VALUES

The drawings you will create with the help of this book will be a special record of your child. Most likely, they will not conform to a perfect likeness of your baby, but present an image of your child *as seen through your eyes*. What you see, or think you see, is filtered through several levels of personal interpretation. Because these levels of interpretation will inevitably come out in your drawings, it is important to understand them.

Whether you are aware of it or not, your drawings will reflect the social values of your time. As essayist Michel de Crèvecoeur wrote in 1782, "The easiest way of becoming acquainted with the rules of conduct and the prevailing manner of any people is to examine what sort of education they give their children, how they treat them at home, and what they are taught."[2] Added to this list might certainly be ". . . and how their children are artistically portrayed."

Let's first see some examples of how children are being portrayed by artists who live now, and then take a quick backward glimpse at children in earlier centuries of Western art.

CONTEMPORARY ARTISTS AND THEIR CHILDREN

Some social analysts say that ours is a youth-oriented culture in which anything projecting youthfulness is coveted. Certainly the advertising and cosmetics industries glorify the advantages of staying eternally young—and sell an astonishing variety of products that promise to help the consumer maintain that illusion! In stark contrast to earlier centuries when children were dressed like tiny adults, may modern fashions make adults look as childlike as possible. And beauty magazines uphold models in their late teens as the standard of loveliness for women of all ages.

Children have become important to popular culture for many reasons. The emergence of Freudian psychology at the beginning of this century placed new emphasis on the importance of childhood in forming lifelong personality; parents have become increasingly aware of their children's psychological needs. Thanks to the technology of photography and videotape, parents can record every phase of childhood exhaustively. Children are also a popular subject in contemporary art. Styles of portraying them now vary widely, from nonrepresentational images of dots and cubes to startling realism.

When an artist draws his own child, the relationship between the artist and subject becomes entwined with the relationship between parent and child, and a whole different dimension of emotional connections emerges. Because an artist is by nature extremely observant, he cannot help but see the physical resemblances between himself and his own child. He will draw these similarities

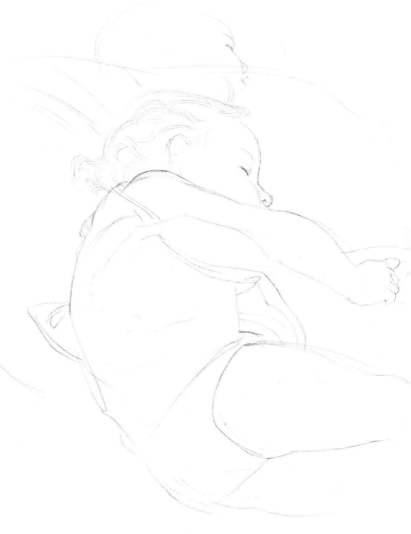

James McMullan, *Leigh Asleep*. Pencil on watercolor paper, 8 × 10½" (20 × 27 cm). Artist's collection. Used by permission.

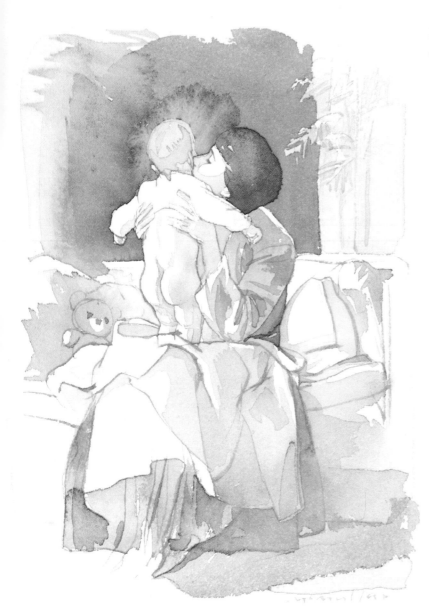

Above: James McMullan,
Kate and Leigh. Watercolor
on Whatman board, 5 × 7"
(13 × 18 cm). Artist's collection.
Used by permission.

Opposite page: Larry Rivers,
*The Continuing Interest in
Abstract Art: From Photos
of Gwynne and Emma*.
Mixed Media, 78⅛ × 80¾"
(198 × 205 cm). Artist's
collection. Used by permission.

either as positives or as negatives, depending on his own self-image. And because children today are seen as people with the autonomy and physiological complexity of adults, the artist/parent will also convey his own attitude toward his child's personality.

Talking with the creators of contemporary art provides a glimpse into the process of drawing children as it is experienced by people who spend their lives working at expressing themselves through art. For James McMullan, one of America's foremost illustrators, a sketch of his child not only serves as a memento of her image at a certain age, but also constitutes part of the continual process of the artist working at seeing and recording faithfully what he has seen. "When I have drawn my daughter Leigh, I have struggled with how subtle the forms of the face in a child are. I always seem to make the cheeks too muscular and lose the delicacy of the forms—or, over-reacting in the other direction, I make the cheeks so rounded that they no longer suggest the particular shape of her face. The way that the chin melts almost imperceptibly into the cheeks is very difficult to capture."[3]

As you can see from his sketch on page 13 and his finished watercolor illustration shown here, McMullan is one artist who has been able to retain the immediacy and emotional content of his drawings even as he creates a finished painting that radiates a luminous warmth.

Larry Rivers, a major figure in contemporary American art, not only paints and draws with authority and exuberance, but has always been willing to admit publicly to emotions motivating his work that other artists share only privately. The openness—along with his predisposition toward personal nostalgia—makes him a rich source for examing the psychological and technical problems that arise when an artist draws his offspring.

In his painting *The Continuing Interest in Abstract Art: From Photos of Gwynne and Emma Rivers*, Rivers covered most of the large canvas with representations of earlier photographs and draw-ings of his two girls. He worried about other people's reaction and imagined them saying, "Oh, that's just Larry drawing his daugh-ters." He could have illustrated himself in the painting working on a shoulder or a feature of his daughter's face, but he chose instead to "capture the moment when my brush was on Gwynne's vagina to do away with the notion of sentimentality."[4]

As emotionally charged as this painting is, Rivers speaks of drawing his children as he would of painting any other subject. "The child becomes a problem in composition just like any other element I might choose to use."[5] But perhaps the artist is not the final authority on the emotional content of his art; the viewer also has an emotional response to the artwork—and, through it, to the subject. The connection between parent and child is sometimes so subtle that the artist himself is not fully aware of it.

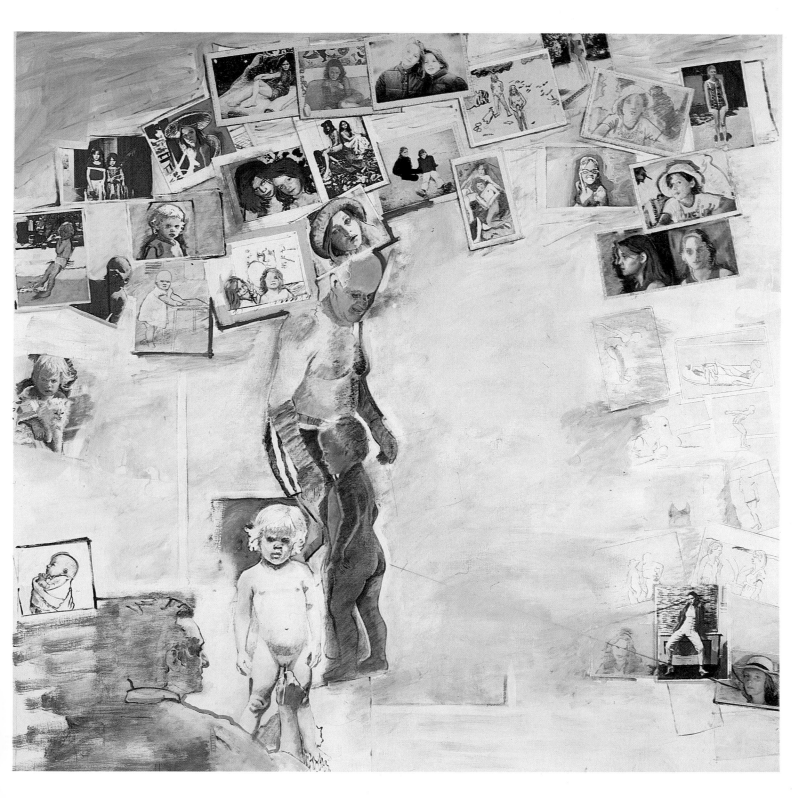

CHILDREN IN ART HISTORY

The bodies and faces of children may have looked about the same throughout the last several hundred years, but their image as found in art has gone through quite an evolution. The first truly childlike figures in Western art appeared in the late fourteenth century in the form of young angels with the round, pretty features of children barely out of infancy. These cherubs or *putti* were derived from the mythological god of erotic love, the Greek Eros and the Roman Cupid. These idealized figures had little relationship to the harsh realities of the time, when infant mortality rates accounted for a lack of attachment between parents and their often briefly-lived children. People understandably did not dwell on the image of childhood. It was considered "a period of transition which passed quickly and which was just as quickly forgotten."[6]

The model for little children in the early centuries of Western art was baby Jesus. Through the years his portrayal changed from that of an adult on a reduced scale to a more realistically proportioned child. As his image continued to evolve, it also became more secular. Eventually artists went beyond painting the childhood of Jesus to portraying the childhood of wealthy and then ordinary people.

Late in the fifteenth century the children of wealthy parents began to appear in family portraits. Even deceased children were included, in recognition of the belief that the souls of baptized children were immortal. The seventeenth century was a high point in the emergence of the childhood portrait, as evidenced by the works of Rubens, Hals, and Van Dyck. These works, along with traces of children's jargon found in the literature of the time, indicate that (at least in Dutch and Flemish cultures) the child's importance in life as well as in art was increasing.

Portraits of early American children show them as mini-adults, their sober demeanor reflecting the fact that life was hard. Half of all youngsters in seventeenth-century New England died before the age of ten. The children who did survive were continually reminded that they had been born in sin and were doomed to hell if they did not mind their elders. The normal playfulness of children was viewed as depraved and consequently an unlikely subject for artistic portrayal.

In eighteenth-century European art, children looked more like children and were shown as members of an affectionate family. The prevailing wisdom concerning childhood was less focused on religion, and the home became the most important influence because a child was now considered a blank tablet to be written on by observation and reasoning. More idealism and sentimentality crept in and led to the image of children as innately pure beings who could be corrupted only by society.

The nineteenth century introduced a more relaxed, natural image of children. They were shown with their toys and in more informal poses. In some interpretations, this degenerated into emphasizing the child's dependence on his parents and portraying him as "his parent's proudest possession."

Children's portraits clearly reveal much about the surrounding culture. They also are greatly influenced by the values and style of the individual artist.

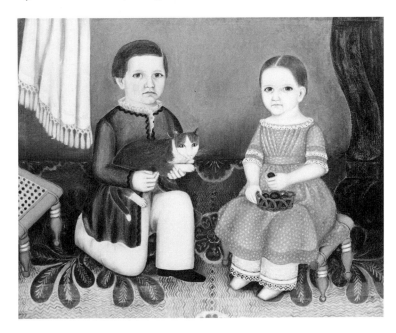

Susan Waters, *Francis and Sarah Johnson*. Oil on cotton fabric, 33½ × 41" (85 × 104 cm). Courtesy of Arnot Art Museum, Elmira, N.Y. Gift of Mrs. Joseph W. Buck, 1957.

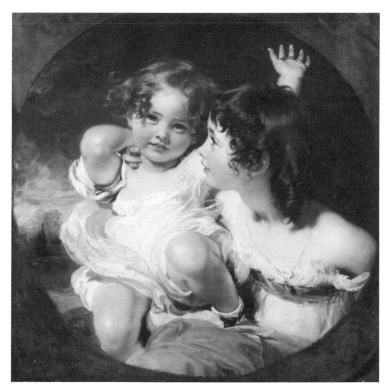

Sir Thomas Lawrence, *The Calmady Children (Emily, 1818–1906, and Laura Anne, 1820–1894)*. Oil on canvas, 30⅞ × 30⅛″ (78 × 77 cm). Courtesy of The Metropolitan Museum of Art, New York. Bequest of Collis P. Huntington, 1900.

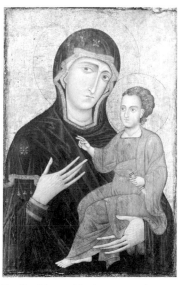

Berlinghiero, *Madonna and Child*. Tempera on wood, gold ground, 30 × 19½″ (76 × 50 cm). Gift of Irma N. Straus, 1960.

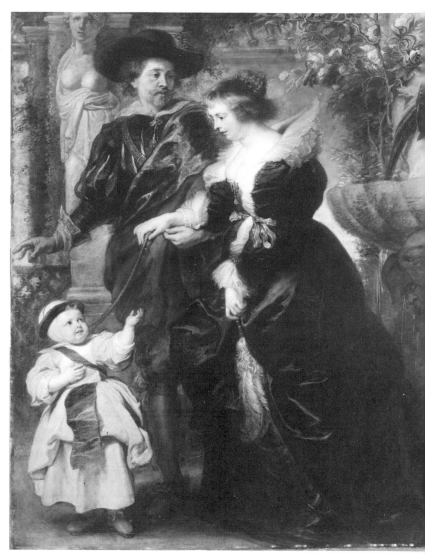

Peter Paul Rubens, *Rubens, His Wife Helena Fourment, and Their Son Peter Paul*. Oil on wood, 80⅜ × 62⅝″ (204 × 159 cm). Courtesy of The Metropolitan Museum of Art, New York. Gift of Mr. and Mrs. Charles Wrightsman, 1984.

PERSONAL VALUES AND EXPERIENCE

If you could set aside all cultural influences, you would see your baby simply as a human animal: a very small and vulnerable being with very basic motivations who eats, sleeps, laughs, and cries. But it is difficult to see this "pure" state for very long because as you spend time interacting with your baby, you become subliminally influenced by other, more complex levels of interpretation.

As you watch your baby, you automatically order what you see through the use of a visual vocabulary, terms you use to make sense of the visual world. These terms are based largely on your own personal experience: your own childhood and adulthood with the accompanying cultural and social memories. Thus, the contorted face of a lustily crying infant can be seen and recorded in different ways, depending on the point of view of the observer.

A crying baby may project an assertive personality. Since this is acceptable behavior to some people, they will see the image as a positive one and perhaps emphasize the visual clues of strength or aggressiveness. On the other hand, the same crying baby may be seen by others as a spoiled, whining child, which is less socially acceptable. In that case, the observer may choose to downplay the visual clues perceived as "fussiness."

Just as crying can be seen and portrayed in a positive or negative way, other behavior can be seen and recorded differently by different observers depending on their visual vocabulary. A languid, quiet child could be seen as an angelic infant—the perfect baby— by one person. To someone else the same child might seem unenergetic or possibly sick. The first person would choose to portray the quiet aspect of the child, while the second would wait for a more animated visual image.

The images of your child that you choose to draw not only provide insight into what your baby is like, but also mirror your own values. As a parent, you will choose to make pictures of those aspects of your child that you consider positive or acceptable.

Occasionally anxiety or even animosity may be seen in a child's portrait as the parent's subconscious feelings emerge.

Reflected in Picasso's lithograph *Paloma and Doll* are the artist's feelings not only for the compositional problems of his drawing, but also for the subject, his daughter. Paloma's face shows signs of a fragmentation of the features, as well as lines running in African-like designs over her skin. These elements relate stylistically to other works of art Picasso was doing at the time. But perhaps he was also hinting at the dual personality that he found present even in his young daughter.

Picasso's ambivalent relationship with Paloma during her early childhood became a full-blown rejection as she matured and developed a mind of her own. In his article "Picasso: The Man" written for *New York* magazine, Pete Hamill stated, "After Paloma Picasso was fourteen, she and her brother were never allowed through the gates of their father's houses; childhood was over. 'He was not such a grown-up himself,' she said. 'When the kids were kids, then he could handle the situation very well. Whereas when you were growing up, and the child was becoming a person in its own right, then you couldn't have the same relationship.'"[7]

The work of Mary Cassatt offers quite a contrast to that of Picasso in the emotions reflected through her handling of a similar subject. In the painting *Baby's First Caress*, Cassatt created a moment of intimacy through the use of rounded forms, rosy flesh tones, and the gentle way the mother cups her child's foot in her left hand while she kisses his palm. The unity of mother and child is reinforced by the symmetry of the pose, especially in the position of the two figures' right arms. The mother's right arm, which is out of sight, is behind and parallel to her baby's and supports his body. The look on the child's face and the confident way he grips his mother's chin project a positive attitude concerning the individuality of the child.

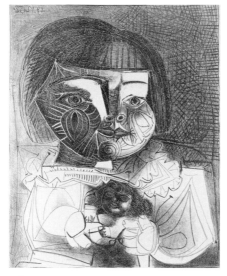

Pablo Picasso, *Paloma and Doll (Black Background)*. Lithograph printed in black, 27¾ × 21¾" (70 × 55 cm). Courtesy of The Museum of Modern Art, New York. Bequest of Curt Valentin.

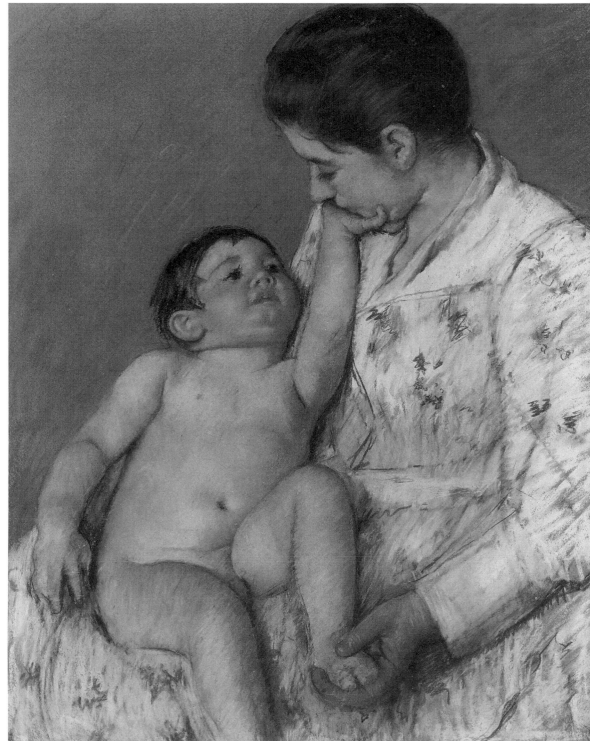

Mary Cassatt, *Baby's First Caress*. Pastel on paper, 30 × 24" (76 × 61 cm). Courtesy of New Britain Museum of American Art, New Britain, Conn. Harriet Russell Stanley Fund.

EMOTIONAL TIES

Your baby will present himself in many ways, both direct and intangible. On an emotional level there will be magical information flowing between you and your baby. This element, which goes beyond technique and any intellectualizing of the process of seeing and drawing, is inspiration. Since true art relies more on inspiration than on technical expertise, there is a very good possibility of something special being created by a parent who is emotionally motivated to record his child in a drawing.

The terms you use to describe the physical reality of your baby constitute your visual vocabulary (such as how long, short, round, or smooth he is). The terms for the personal, cultural, and inspirational interpretation of his image let you edit your visual vocabulary to say certain things, depending upon your feelings. When skilled, you will be able to *consciously* pick and choose which physical details you want to record and which ones you wish to distort, downplay, or ignore.

By understanding and manipulating the visual image, you will be able to control the viewer's reaction to your drawing and recreate not only an image of your child, but an understanding of the emotions you felt at the time. Remember, someday in the future you also will be a viewer of your own drawings. Hopefully they will bring back memories of how you felt at the time you drew them.

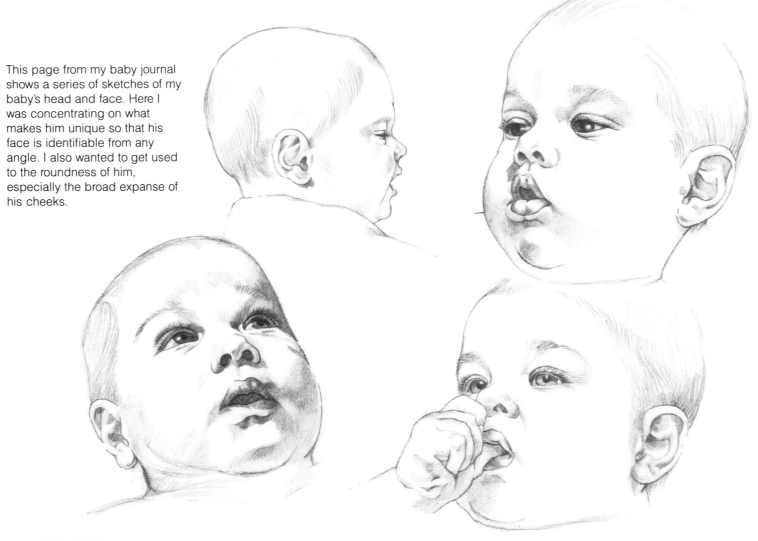

This page from my baby journal shows a series of sketches of my baby's head and face. Here I was concentrating on what makes him unique so that his face is identifiable from any angle. I also wanted to get used to the roundness of him, especially the broad expanse of his cheeks.

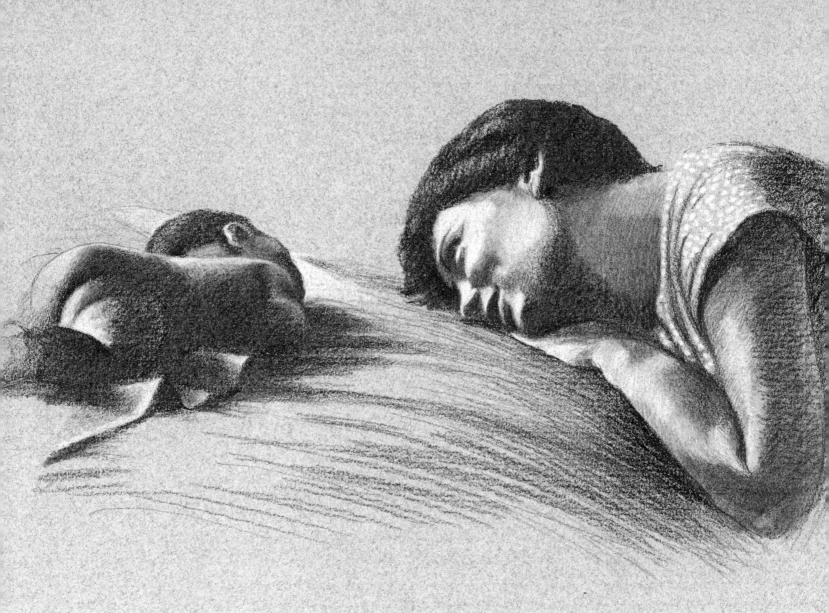

Observing your child as an artist
can add an extra dimension to
the already joyful activity of
looking at your baby.

UNDERSTANDING WHAT YOU SEE

There are basically two philosophies about drawing: one is an analytical, intellectual approach that analyzes form, function, perspective, and light—as well as human anatomy—in an effort to help the emerging artist understand why he sees something a certain way. The other approach is nonanalytical and assumes that true perception can take place only when verbal knowledge of something is not allowed to overwhelm the visual reality. Some people emphasize one approach over another, but a blending of both approaches is probably best, especially once an artist knows when the visual perception must take precedence over the intellectual idea.

Taking an analytical approach to the various parts of your baby's anatomy, I have included a brief geometric analogy in each description (such as seeing the upper and lower arms as cylinders). Many great artists have founded their work on this approach. Cézanne is said to have advised young painters to treat nature according to the cylinder, the cone, and the sphere, all seen in perspective. I also believe that an understanding of how bones and muscles look and work below the surface of the skin is important, because many factors can distort or confuse a visual image. You will need to know the body as a whole in order to choose an appropriate gesture or pose that is representative of your child. Of course, it is possible to become so overburdened with knowledge that it discourages the act of seeing and drawing. As I suggested earlier, read the text for what you can absorb the first time, and then refer back to specific sections as you fine-tune your drawing skills. Information that applies to more than one part of the body is repeated so that the sections read independently and can be referred to one at a time.

The anatomy section contains special massage exercises for you to do with your baby. These will feel soothing to him and will simultaneously help you explore the structure of his body with your hands, not just your eyes. The direct tactile information collected by your fingertips will bring all the diagrams of muscles and bones to life, so that the anatomical information will make more sense to you.

What you see when you look at your baby depends not just on his anatomy, but on his gestures and facial expressions. Capturing a characteristic gesture can make the difference between an ordinary drawing and one that you will treasure because it expresses your child's personality. What you see also depends on perspective, light and shadow, and color. All these are key tools you will need in order to convey what you see in a two-dimensional drawing. Later sections of this chapter will introduce you to each of these facets of learning to see like an artist.

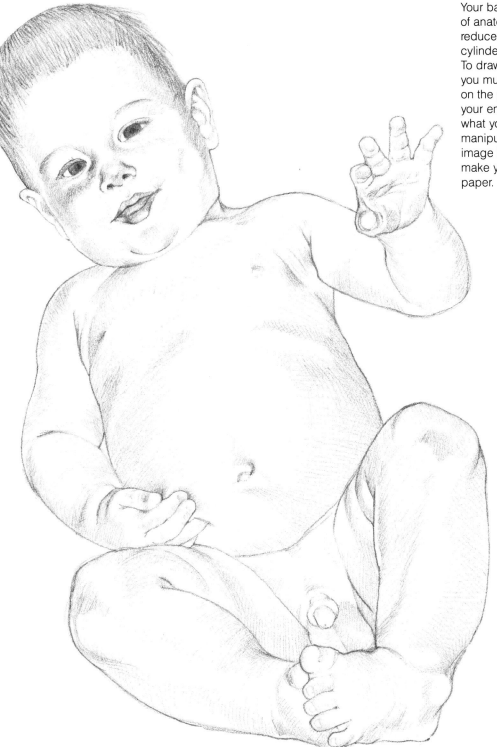

Your baby's body is composed of anatomical parts that can be reduced to the basic shapes of cylinders, cones, and spheres. To draw anything well, however, you must not concentrate solely on the physical reality, but allow your emotions to flow through what you are observing. You can manipulate and even distort the image if necessary, in order to make your sketch "live" on the paper.

BABIES' ANATOMY

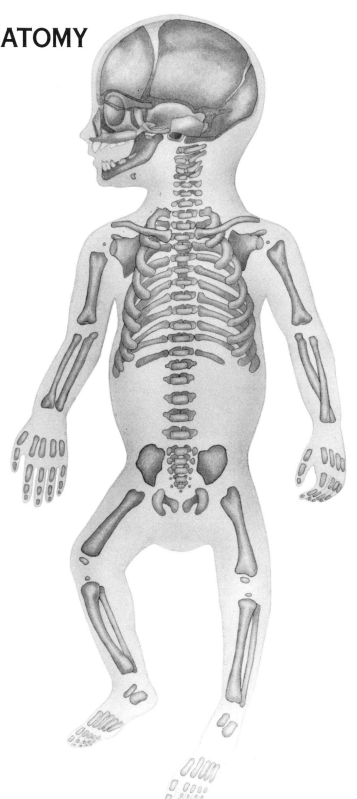

What do you notice first about your baby's body? Perhaps you are surprised by the disproportionally short, weak legs, or the relatively large, protruding belly. Since many babies are virtually hairless, you are aware of the soft spots on the head (fontanels) where you can see his pulse beating. The most obvious physical difference between an infant and an adult is the relative proportion between head and body length. Approximately one fourth of the total length of your baby is the head, whereas an adult's head is proportionally one seventh of his total length. By comparing an adult skeleton and an infant skeleton scaled upward so that the head sizes match (allowances being made for the teeth in the adult head), you can clearly see how much more length there is to the adult body.

Other, equally dramatic differences lie hidden beneath your baby's skin. The skeletal system of an infant at birth is composed of about 350 segments of cartilage and bone. The cartilage is pliable enough to pass through the birth canal. It grows quickly and many of the segments fuse together as they harden. This process continues through adolescence, eventually becoming the adult skeleton of 206 to 209 bones. Certain organs are disproportionally large at birth: particularly the thymus and liver, located in an already overcrowded little chest and abdomen.

This chapter will analyze what your baby looks like in terms of dimension and form, thus expanding your visual vocabulary. You will find parts of the body discussed individually: each one's appearance in simplified geometrical form; its function and relationship to the body as a whole; a discussion of the underlying muscles and bones; and some massage techniques, where appropriate, to help you interpret the anatomical information.

It is important to note that none of the diagrams of muscular systems show the overlying layer of fat that is present in an infant. The muscles in the diagrams appear to be just under the skin, which of course they are not. The diagrams are included to help you understand the functions of the various muscles and to help you identify them as they become more pronounced. Of course you should also draw the fat as you see it.

The massage techniques will be helpful before you actually sketch your baby. When he is a newborn, your baby will enjoy the massage and you will be learning about his body. Later, when he is older and you have more time, you can invent your own massage techniques to help augment the visual information you have gained through sketching.

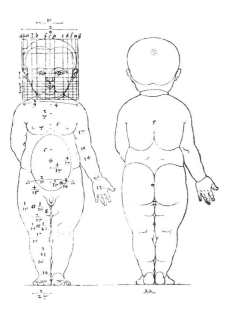

Above: Albrect Dürer, *The Proportions of an Infant*, woodcut illustration from *De Symmetria Partium Humanorum Corporum* (Nuremberg, 1534; first edition, 1528), 12 × 7¾″ (30 × 20 cm). Courtesy of The Metropolitan Museum of Art, New York. Gift of Mortimer L. Schiff, 1918. Even though Albrecht Dürer measured hundreds of men, women, and children to calculate ideal proportions, his lack of interest in the function and underlying structure of human anatomy make this diagram of infant proportions seem stylized and somewhat unnatural.

Left: The skeletal system of an infant at birth is composed of about 350 segments of cartilage and bone. Note also the buds for the baby teeth.

Right: These skeletons, one of an adult and one of an infant, show clearly how much larger the adult's body is in proportion to the head, even though the baby's skeleton has been drawn on a larger scale so that the heads are the same size. (The teeth in the adult skull make it appear larger.)

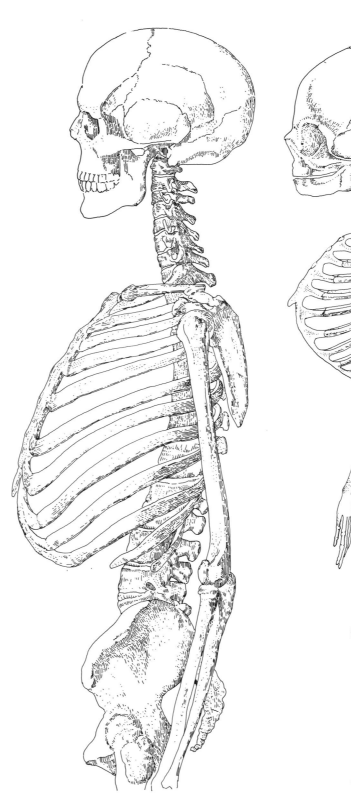

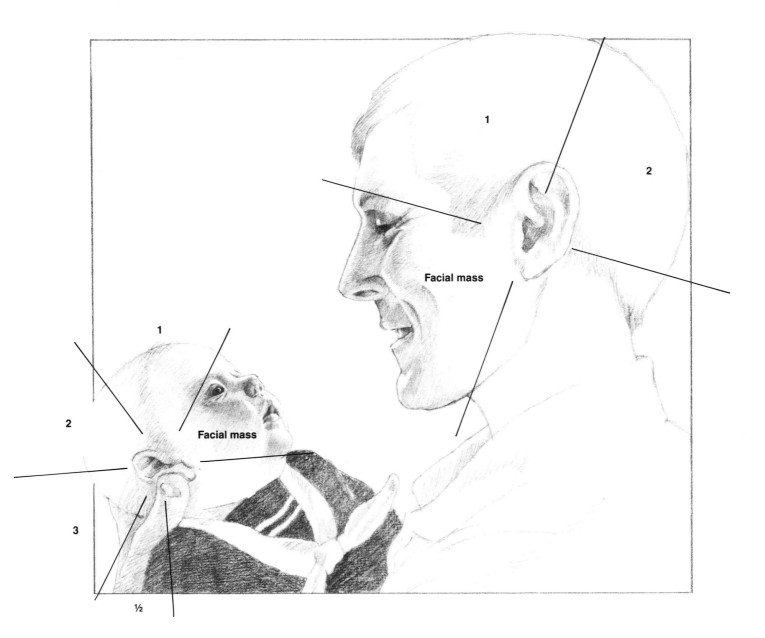

Facial mass (adult)

1

2

1

2

3

Facial mass (infant)

½

Above: The facial mass is much smaller in proportion to the cranial mass in an infant's head than in an adult's. If you conceptualize the facial mass as a "pie slice" of the total skull seen in profile, an infant's cranial mass is 3½ times larger than the facial mass. (An adult's cranial mass is only twice as large.)

Right: The basic shapes employed in drawing the head are the egg-shaped cranial mass and the half cylinder of the facial mass. Here you can see the relative proportions of the two.

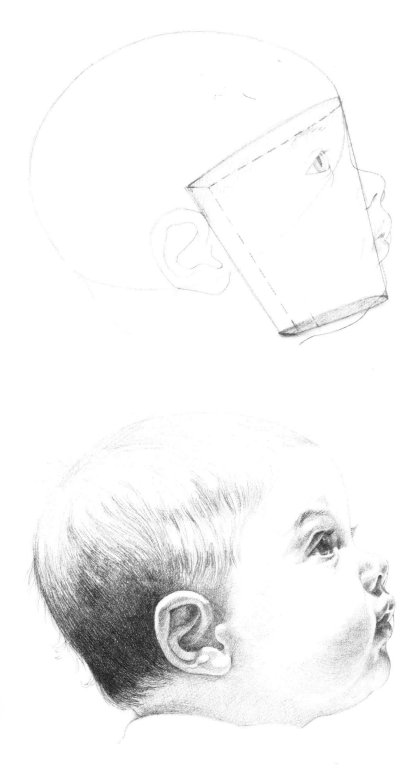

THE HEAD AND NECK

An infant's head is very different from an adult's, and even from that of a slightly older child. All human heads consist of two visual masses: the *facial mass*, which includes the eyes, nose, and mouth; and the *cranial mass*, which extends from the eyebrows to the back of the neck. The ratio of the facial mass to the cranial mass is 1 to 3½ at birth and gradually increases as the baby ages. At around fourteen years old the proportion reaches 1 to 2, which continues through adult life.

The cranial mass is egg-shaped and the facial mass is a half cylinder. Although the cranial mass is much larger than the facial mass, the facial mass is often mistakenly drawn larger than it actually is because it is so animated. The artist must be aware of this tendency and never forget the true relative proportions of the two masses.

The cranial mass curves upward from above the eye socket. The back of the head slopes outward on a slightly oblique line toward the back and curves down toward the protuberances at the base of the head, which are much more pronounced in a baby than in an adult. From these bulges, the trapezius muscles stretch out and down toward the shoulder blades. The view of an infant's upper body from behind is very distinctive: large head; short, feeble neck; and high, narrow shoulders. From the front, the neck is not visible under the chin.

The profile of the facial mass is a continuous S-curve formed by the forehead and nose. At the end of the nose, the line curves inward and then scoops out again along the upper lip, which thrusts out over the lower lip. Below the lower lip the chin curves higher than most people realize. This curve is similar in profile to the curve at the tip of the nose and the curve of the upper lip. The jawline under the chin is rather flat, without the distinctive upward angle of an adult. It is important to stress the overall roundness of the infant's face (forehead, cheeks, chin, neck).

The facial features have more impact on the viewer than any other part of the body. To correctly place the features in the head frontally, for a front view, begin by drawing a slightly rectangular ovoid. Divide it vertically in equal halves from crown to chin, and again midway with a horizontal line. Where the two lines cross is the midpoint of the head; the horizontal line delineates the center of the eyes. Below this horizontal line, draw in the line for the center of the mouth. In a baby's face this line should be just over halfway between the center of the eyes and the bottom of the ovoid. Finally, the tip of the nose is a little less than halfway between the center lines for the eyes and the mouth. Once you have these lines cast, you can add in the browline, the base of the nose, and the top and bottom of the mouth by observing how they fill up the divided areas. Of course, these are only approximations because all faces are different, but you will be able to make the adjustments that help

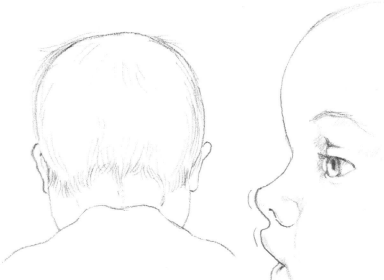

to create your own child's face once you have this framework. It is interesting to note that the lines cast to place the features correctly in an adult show the center of the eyes still at the midpoint of the face, but the nose and lips are considerably lower. Also remember that the vertical placement of features described above works only when the face is seen straight on. The proportions change when the face is viewed from above or below.

Once the features are placed in a correct vertical relationship, it is also important to see other relationships among the features so that they reflect your baby's individuality. The middle of the browridge is also the top of the nose; this area is depressed in an adult. But the infant's nose is a continuation of the forehead without any evidence of the bony prominence underneath. The nose is also broader and flatter than an adult's: its tip is closer to the face, and its base seems wide in proportion to the mouth and the chin.

The zygomatic arch is the bony connection between the cheekbone and the temporal bone in front of the ear (just below the temple). Its gently curving arch lines up with the middle of the ear and the tip of the nose. It is the widest point of the face, but in most babies it is hidden under the fat of the cheeks. And since a baby's face is relatively wider than an adult's face from ear to ear, the zygomatic arch tends to appear somewhat flat.

The base of the nose is 1½ times as wide as an eye. The eyes of an infant seem set wider apart because of the relative flatness of the area between them with no depression along the browline. The outer corners of the eyes form an isosceles triangle with the tip of the nose. Start the inside corner of the eye on a line directly above the side of the nose, but remember that the actual corner of an infant's eye is often hidden under a fold of skin. The lower eyelid is about halfway between the eyebrow and the tip of the nose. In a profile view, note that the lower lid lies on a backward slope of about 45 degrees from the outthrust upper lid.

Too many beginning artists draw mouths as pink lips on a flat surface. Actually the mouth begins to extend forward from just under the nose and reaches all the way to the chin. This whole area extends forward in a rounded double curve, so that the overall shape of the mouth is like a barrel lying on its side. (See illustration on page 35.) The sides of this mouth barrel (not always in line with the corners of the lips) line up with the centers of the eye sockets above. The bottom edge of the lower lip comes about halfway between the bottom of the nose and the bottom of the chin.

The chin is a small, box-like shape under the mouth which appears wider than the mouth barrel when the lips are relaxed. The chin recedes noticeably beneath the mouth when seen in profile.

The ears generally line up with the top of the eye socket and the top of the mouth. They appear to be quite large and are tilted slightly back, but the lobes swing slightly forward from their

Above: The distinctive view on an infant from behind includes the large head; the short, feeble neck; and high narrow shoulders. The continuous S-curve of the facial mass is formed by the forehead and the nose. The curve at the tip of the nose is echoed in profile by the curve of the upper lip and chin.

Right: To place the features correctly in a front view of a baby's head: (1) Draw a slightly rectangular ovoid. (2) Divide it vertically into equal halves from crown to chin. (3) Divide it again midway with a horizontal line; this is the midpoint of the head and delineates the center of the eyes. (4) Below this horizontal line, draw in the line for the center of the mouth about halfway between the center of the eyes and the bottom of the ovoid. (5) Finally, place the tip of the nose slightly higher than halfway between the center lines for the eyes and the mouth.

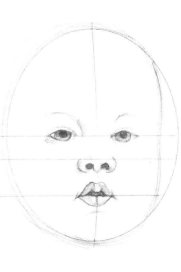

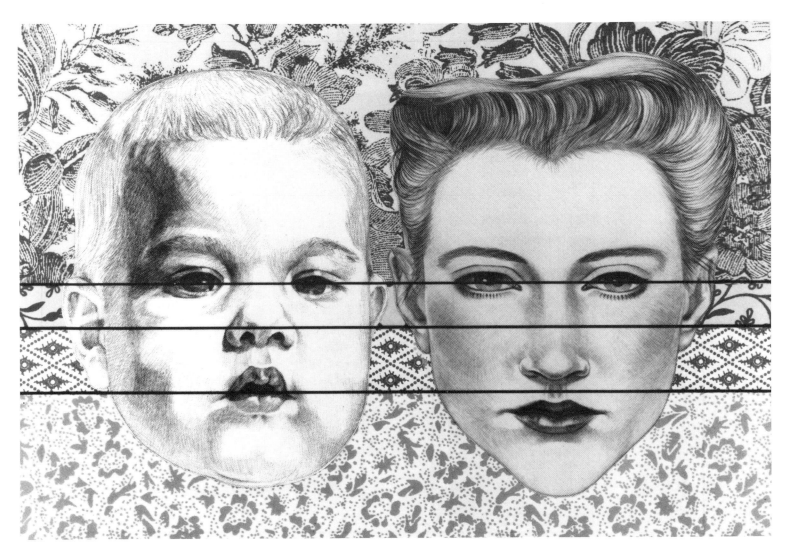

attachment to the side of the head. Again, there are individual differences, so *look* at your baby carefully!

EXERCISES The first two exercises can be done while your child is sleeping.

1. Gently run your fingers over your baby's head and face, feeling for the planes of the cranial and facial masses.

2. Trace his profile with your finger, perhaps as you watch in a mirror, so that you see and feel the curves.

3. Give your baby a gentle neck and shoulder rub and feel how small and weak the neck is. Also, notice the protuberances that bulge out over the neck in the back of the head.

If you compare the placement of the facial features in an infant and an adult, you will see that the center of the eyes remain at the midpoint of the face, but the adult's nose and lips have shifted downward considerably.

THE EYE

An infant's eyes are the focal point of his face, just as they are with an adult. The most important thing to remember when drawing the eyes is to place them in the face correctly. As artist and author Richard Hatton wrote in *Figure Drawing*, "A good eye out of place is worse than a bad eye in its proper position."[8] Many people draw the eyes too high, or too small. Remember that they are fully halfway down the face, and two-thirds as wide as the base of the nose.

The visible part of a baby's eye is about one inch across. The almost spherical eyeball lies within the deep cavity of the orbit and is surrounded by bony structures. In the front it is covered by the upper and lower lids. The upper lid is larger and more mobile than the lower lid, which curves around a lower arc of the eye. This is especially evident by its set-back position on the eye when seen in profile. The edges of both lids are thick at the widest part of the curve and thinner at the edges. In a baby, the inside corner of the eye is sometimes covered by a fold of skin that stretches from the inside of the nose to the bottom of the eye. This inner corner of the eye can be seen in a three-quarters view of the face and, along with the membrane at the outer corner of the eye, sharply defines the oval shape of the eye.

The opening between the two eyelids is not a symmetrical almond shape, and *definitely* not a circular shape. The upper lid arches high on the inside corner of the eye while the low point of the lower lid curves toward the outside corner. These points, when joined with a line, form the axis of the eye. The iris of the eye appears to be suspended from under the upper lid—that is, part of its circumference is always cut off on top except when the baby is staring widely or very frightened. The lower lid often cuts off a portion of the iris below. Be sure to study each eye and draw the contours correctly, because they often differ even from each other.

The pupil in a child's eye is more dilated than an adult's. It is important to study the shape of both the pupil and the iris as you view the eye from different angles. When viewed from above or below, they are horizontal ellipses; in partial side views, they are vertical ellipses; and in side views, the pupils are almost flat within the vertical ellipse of the iris. It is also important to note that the pupils are recessed within the eye and thus from some angles do not appear to be in the middle of the iris. They should not look pasted to the outside of the cornea.

When working with directional lighting (strong light coming from a particular place), remember that the cornea, or lens over the iris, is a bulging mass that sticks out beyond the spherical curve of the rest of the eyeball. It catches more light than the rest of the eye, and raises the lid a bit. The highlight on the cornea makes the eye look lively and animates the whole face.

The disproportionally large eyes of an infant and the fact that they seem set wide apart create what is sometimes called the *babyface signal*, which functions as a powerful stimulus for releasing a flood of protective feelings. This is why pet animals, dolls, toys, and cartoon characters such as Tweety Bird and Bambi are so appealing.

Left: Both eyelids curve around the eye, but the lower lid is set farther back. This is most evident when the eye is seen in profile. In this illustration, the farthest point of the upper lid is marked by a solid line, while the farthest point of the lower lid is marked by a dotted line.

Right: When seen from the front, the upper lid of the eye arches highest at the inside corner, while the lower lid curves farthest downward at the outside corner. When these two points are joined (see dotted line) they establish the axis of the eye and accentuate its asymmetrical almond shape.

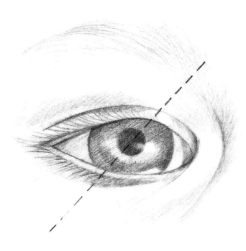

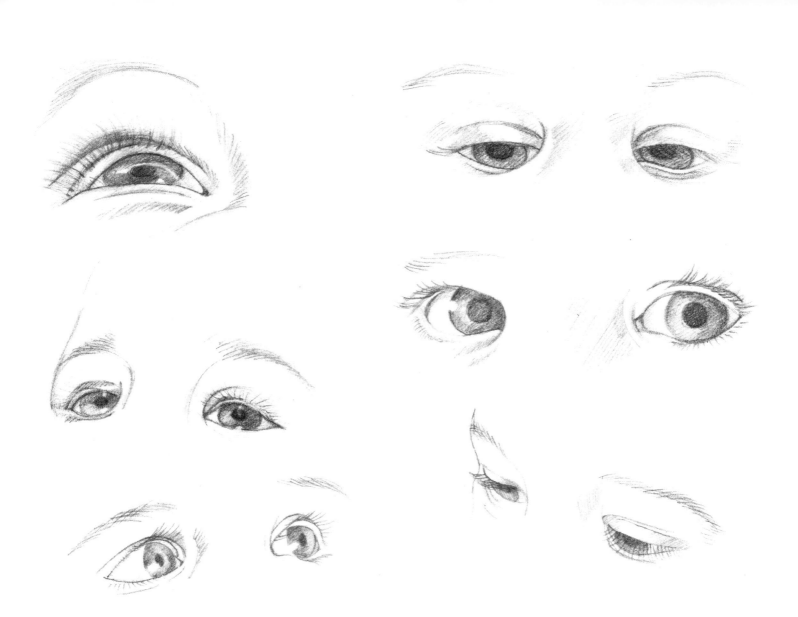

The eyes are shown here from various angles. Note that they are *never* a perfect circle. Also, when certain parts of the eye are visible—such as the inside rim of the upper lid (see drawings in upper and lower left corners)—this is a clue to the angle being depicted; in both these cases the eye is drawn from below.

THE NOSE The nose begins under the brows between the eyes and is a wide and softly curved surface the width of about 1½ eyes from the inside corner of one eye to the other. The tip is sloped upward and located a little less than halfway between the center line of the eyes and the mouth. The nostril cavities at the base of the nose form a triangular shape with the tip of the nose, which has a flattened top. The base of the triangle is gently curved as it rests on the top of the mouth barrel. When seen in profile, the tip of the nose curves into the face above the mouth at an angle similar to those of the upper lip and chin, as shown on page 28.

One third of the way down the bridge of the nose is a ridge that delineates the edge of the bony upper part of the nose. The tip of the nose actually consists of two symmetrical bulbs, but in a baby it appears as one central bulb. Both the central cartilage and the nostrils curl up into the nose. The curving arch of the nostril is echoed in many other natural forms, such as seashells.

The tip of the nose is located a little less than halfway between the center line of the eyes and the center line of the mouth. The nose is approximately 1½ eyes wide, both at the top between the inner corners of the eyes and at the base. The tip of the nose forms an isosceles triangle with the outer corners of the eyes.

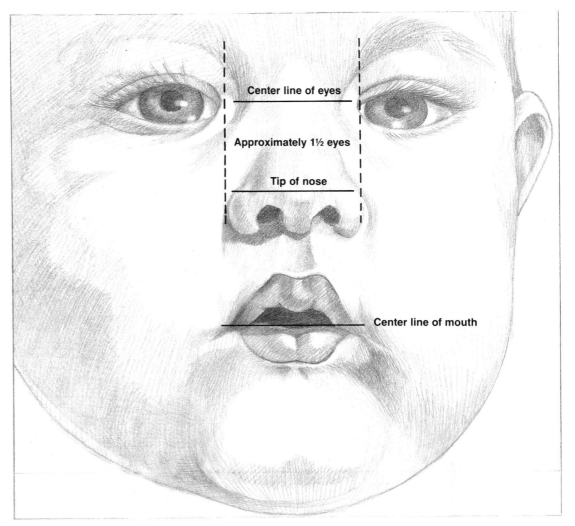

Center line of eyes

Approximately 1½ eyes

Tip of nose

Center line of mouth

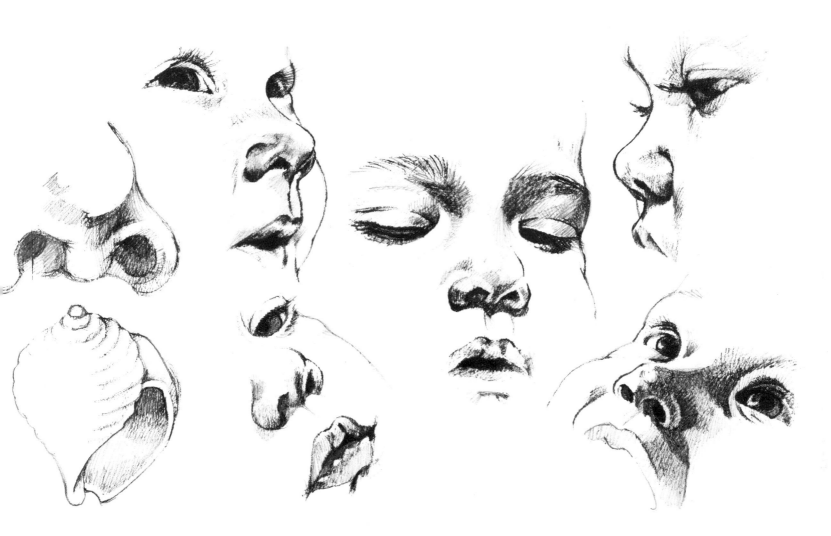

When placing the nose in relation to the other facial features, you may find it helpful to concentrate on the shadows it casts. The graceful arch of the nostrils is echoed in other natural forms, such as a seashell.

THE MOUTH AND CHIN The bottom of the lower lip is about halfway between the bottom of the nose and the bottom of the chin. The corners of the mouth align vertically with the centers of the eyes in an adult. In an infant, however, the mouth is smaller, and when the lips are relaxed their corners line up with the inner corners of the eyes. To aid in placing the mouth in the face, squint your eyes and locate the shadowed areas between the lips and under the lower lip.

The lips extend quite far forward, and so do the fleshy folds of the cheeks that cover the corners of the mouth. These folds form an indentation at an angle crossing the center line of the mouth. The upper lip forms an M, while the lower lip can be simplified into an elongated U. The central mass of the upper lip at the middle of the M extends out and downward and it is cradled in a slight channel in the lower lip, a Y-shaped depression between the two mounds of the lower lip. The central depression at the top of the upper lip extends upward to the base of the nose, where it narrows somewhat. The two pillars on either side of this depression can be quite pronounced in an adult, but in the infant and child they are only slightly higher than the depression.

The lower lip terminates abruptly, with the mounds rounding off at the sides. The upper lip tapers off less abruptly. The corners are not level with the center line of the lips, but below it and at either side of the lower lip. The lower lip is recessed under the upper lip; this is inconspicuous from the front but very obvious in a profile view. The chin extends farthest forward not in the center, but high up under the mouth.

The mouth is a very mobile feature, especially the lower lip, and it changes dramatically with different expressions. Generally, the infant's mouth is slightly open at its most relaxed. When a baby is cooing and babbling, the corners are pulled slightly to the side and back. In a smile, the upper lip is pulled farther back and up.

When an infant's mouth is relaxed, its outer corners align with the inner corners of the eyes. The oblique lines formed by the cheeks overlapping the mouth hide the extreme corners of a baby's lips. When viewed at eye level from the front, the upper lip forms an M and the lower lip forms either an elongated U or W.

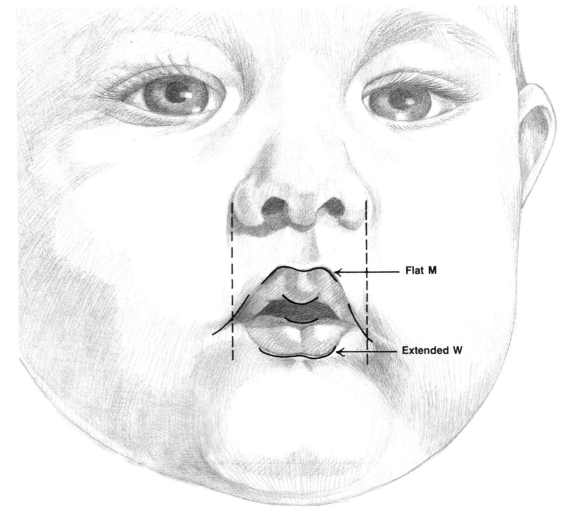

Flat M

Extended W

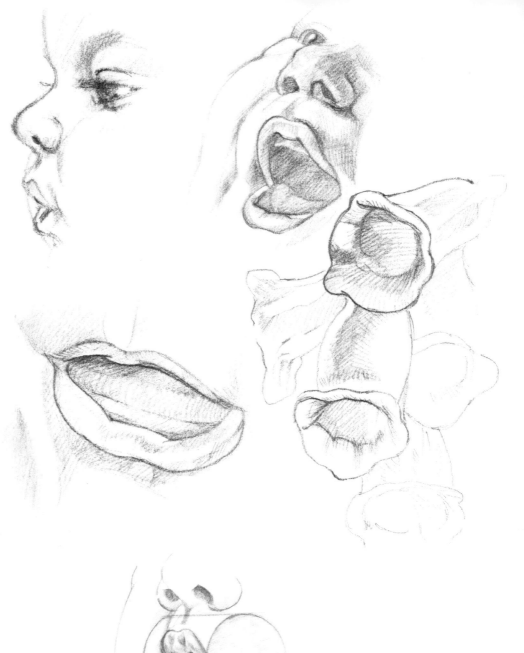

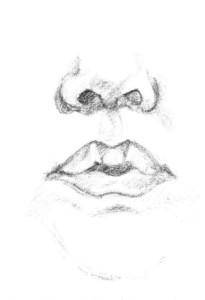

Above: The mobility of the mouth is evident in this series of sketches. An especially tricky angle to draw is a three-quarters view of an open mouth, but through direct observation you will be successful. It also helps to find analogies in nature, such as the flowers of a foxglove.

Left: The mouth is barrel-shaped and takes up two thirds of the distance between the tip of the nose and the bottom of the chin.

THE EAR The ears lie within two lines drawn across the top of the eyelids and the top of the mouth when viewed at eye level, either in profile or full-face. As noted before, the relationship changes radically when the face is viewed from above or below. The ears are quite large in a baby and proportionally they are twice as long as they are wide at their widest point.

The ear can be simplified into a C shape wider at the top and narrower at the base. Seen from the side, the ear tips slightly back from the line of the profile. Seen from the back, the ear stands away from the head on a slant that reveals the rounded back wall of the antihelix. Viewed from the front, the antihelix can stick out further than the helix and therefore hide part of it. Also, from the front, the forward twist of the helix becomes very apparent.

The actual shape of the ear varies greatly, allowing the artist latitude in his interpretation, but the distinct change of curve from the helix to the lobule is generally present.

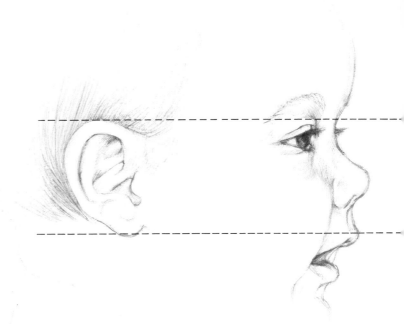

The ears lie within two lines, one drawn across the top of the eye sockets and the other drawn across the top of the mouth. This remains true whether the head is viewed straight on or in profile.

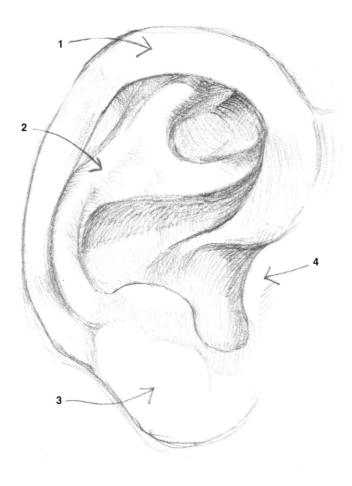

There are four major forms over and around the central depression of the ear. The helix (**1**) is the wide outer rim. The antihelix (**2**) is the smaller inside rim, which divides at the top into two arms forming a bent Y. The lobule (**3**) is the lower, fleshy lobe, and the tragus (**4**) is the vertical projection over the opening to the ear canal. The tragus has a small notch underneath it.

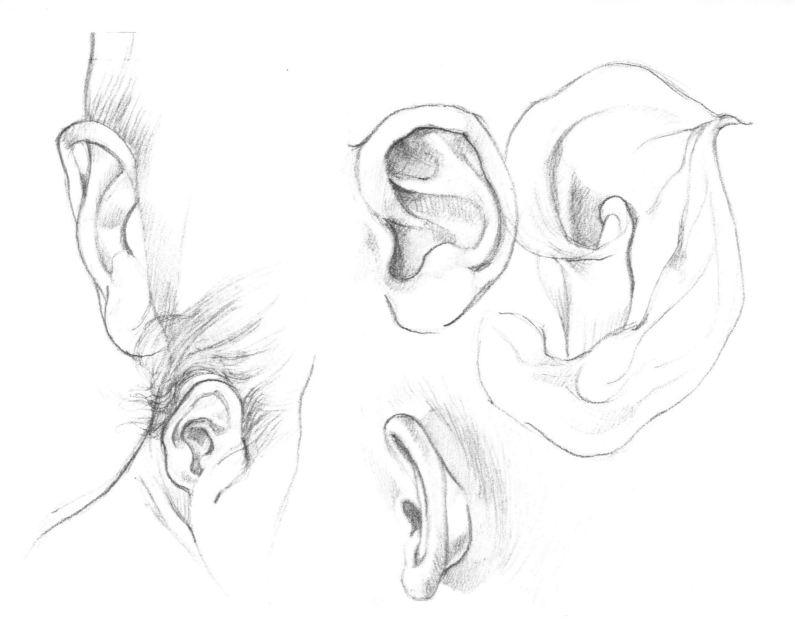

These sketches help to show the complex patterns of curves and spirals within and around the ear. I find them reminiscent of a sculptured calla lily.

THE CHEST AND ABDOMEN

Seen as a simplified form, the chest, abdomen, and back resemble a wedged box. It is broader across the shoulders and compressed somewhat toward the elbows, with the stomach ballooning out frontally and sideways (especially after eating). In an infant, the upper chest (the area between the shoulders) is about one third of the overall area from the pit of the neck to the bottom of the abdomen. This upper chest area is also considerably flatter in front and on the sides than the round abdomen.

Notice that a considerable bulk of the pectoral muscle passes over to the arm and shoulder and it makes a crease at the armpit. This crease deepens the closer the arm is to the body but practically disappears if the arms are extended out and backward from the body.

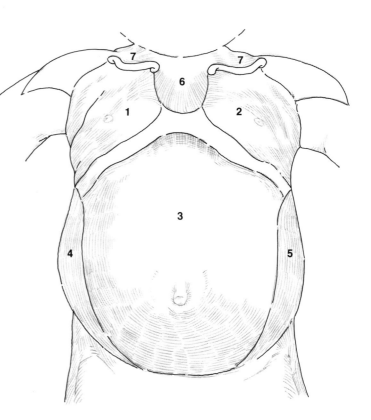

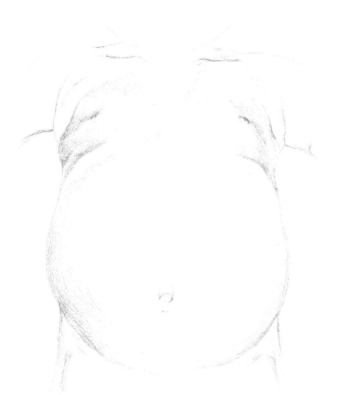

Seen in profile as a simplified form, the chest and abdomen form a wedged box. From the front, the roundness of the abdomen is quite conspicuous.

Above: The chest contains five important muscle masses: the two pectoral muscles (**1** and **2**), divided centrally by the sternum; the rectus abdominus (**3**), or abdominal muscle; and the external obliques (**4** and **5**), or side support muscles, which connect the ribs and pelvis. The end of the sternum (**6**), or breastbone, leaves a sharp, irregularly curved depression in the chest. The two clavicles (**7**), or collarbones, have a distinctive elongated S shape. It is important to note the bulging of the seventh rib and the obvious line of the thoracic arch, which is the graceful curve of the ribs as they fall away from the breastbone on either side of the body.

In these sketches of the chest, note particularly the crease at the armpit, where the pectoral muscle passes over to the arm and shoulder.

EXERCISES These should be done without a shirt on your baby.

1. Warm your hands by rubbing them together vigorously, and then place one hand on your baby's stomach. Let it rest there and mix with the warmth of his skin. Stroke rhythmically from the base of his ribcage to the pelvis with alternating hands. Feel the indentation at the end of the breastbone and the curve of the abdomen as it moves into the pelvis. It is important to stroke from the heart outward and only with the weight of a relaxed hand. First stroke to release tension, then explore.

2. Sit your baby up, if possible. Holding onto his arms, rotate them gently, one at a time, from the shoulders. Bring them forward, up, down, and back and observe what happens to the pectoral muscles, especially where they cross over the armpit.

3. Lay him on his back and gently bend and stretch his body at the waist to see how the abdomen compresses and elongates. Do this when the baby's stomach is empty.

THE BACK The back, with the chest, forms a wedged box and is composed of five large muscle groups. It is not important to remember the names of these individual muscle groupings, but do note how muscular the back is under the layer of baby fat, and how the movement of other parts of the body changes the contour of the back. Also, an infant's back bulges slightly outwardly until the baby stands on his own. Along with the distinctively narrow look of the shoulders and the relative bulk of the trapezius muscles as they ascend the neck, these characteristics serve to define your baby's back.

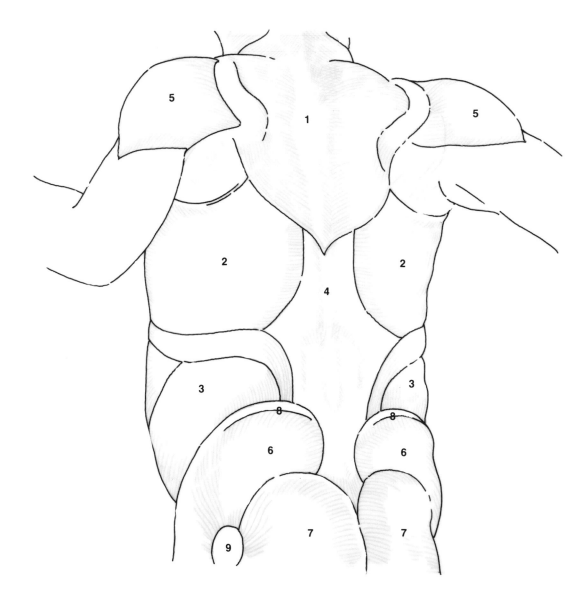

The back contains five major muscle groups. (Also included in the diagram are the muscles of the buttocks.) The two trapezius muscles (**1**) are located high on the back, on either side of the spine, and connect the skull and shoulder blades. Both latissimus dorsi (**2**) attach under the arms and end at the back of the pelvis. The two external obliques (**3**) come from either side of the abdomen, where they connect the lower ribs with the pelvis in back. The sacrospinalis columns (**4**) run down either side of the spine from the center of the back to a point between the gluteus medius muscles. The shoulder muscles include the deltoids (**5**), which cross to the arms from the back. The gluteus medius (**6**) are two muscles under the iliac crests (**8**), which—together with the gluteus maximus—form the buttock masses. The gluteus maximus (**7**) are the lower muscles of the buttock masses, the tops of which parallel the great trochanter protrusions (**9**) of the leg bones.

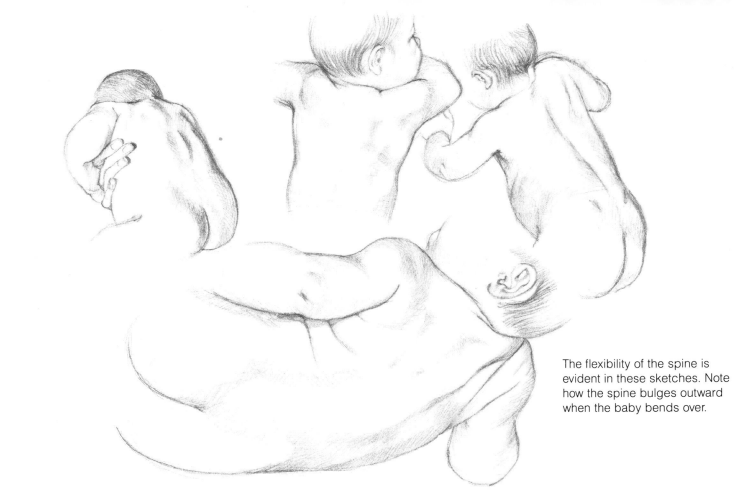

The flexibility of the spine is evident in these sketches. Note how the spine bulges outward when the baby bends over.

EXERCISES Before you explore and rub your baby's back, warm your hands by rubbing them together, and then remove the baby's shirt.

1. Lay your baby on his stomach on a blanket, or, if he is very tiny, across your legs face downward. First loosen his muscles by sliding your hands side to side across his back, starting at the neck and working down to the buttocks. Notice the central depression of the spinal cord, the pointed ends of the shoulder blades, and the flat triangular area with dimples between the buttocks (the sacrospinalis).

2. Gently trace the M shape at the edge of the trapezius muscles and the shoulder blades. With the baby sitting (if possible), raise and lower his arms and note what happens to the shoulder blades: As the arms go up, the high point of each shoulder blade swings down and the pointed ends are very visible under the arms.

THE PELVIS The pelvis is box-shaped with the two iliac crests and the two trochanters at each corner (see illustration on page 40). Basically, think of it as the area below the iliac crests and above the bottom of the buttocks in back, and the area below the abdomen and above the thighs in the front. The iliac crests are located at the base of the abdomen, and the two trochanters are at the top of the thigh bones. In a baby, the trochanters will not be visible because the bones are immature and the area is covered with fat. You can feel the tops of the thigh bones just below the surface when you gently press your fingers into the side of a baby's body above the bulge of the thighs.

Visualize two parallel lines, one running across your baby's back and over the tops of the iliac crests, and another running under his buttocks. This is the pelvic area, which opposes and balances the ribcage and shoulder line above. When a child is lying or standing straight, the pelvic area and shoulders are parallel. This relationship changes, however, when either the shoulders or the pelvis tilts. As the pelvis tilts in one direction, the spine curves and the shoulders tilt at a counterbalancing angle, enabling the child to keep his balance. (Note that the shoulders and pelvic area each remain defined by sets of parallel lines, even though the shoulders are no longer parallel to the pelvis.) Observe your child in different positions, especially once he becomes an active toddler, and study the relationship between the pelvis and shoulders. These opposing lines of the body help to animate your sketch.

The pelvis area is an important indicator of the pose you are trying to draw. Start by observing the relationship between the hips

and the ribcage with the mass of the abdomen connecting the two. Any pose that appears straight or rigid from head to toe will look unnatural, so it is important to see how these areas curve away from or toward each other. Sometimes a position is so subtle that you need to exaggerate it. Experienced artists can interpret these exaggerations into their drawings, but when you are just starting, it helps to actually manipulate the pose itself. For example, if your baby is lying down in a rigid pose, pull one side of his hips a little closer to his shoulders and create a more curved line to his body.

EXERCISES Warm your hands by rubbing them together. Then remove your baby's shirt but leave on his diaper, so that its top defines his waistline.

1. Place your baby on his back or stomach and gently tilt the pelvis to the left (left hip high), then to the right. Study the slant of his shoulders and hips. The waistline will serve as an indication of the hips' position.

2. If your baby is crawling, position yourself above him and watch how the angles between the shoulders and hips move in opposition as he crawls across the floor.

3. Feel with your hands and identify the separate curves of the shoulder blades, the latissimus dorsi, external obliques, and iliac crests. Now remove his diaper, and continue down the buttocks and locate the trochanters. Explore the way the back, hips, and legs flow into one another.

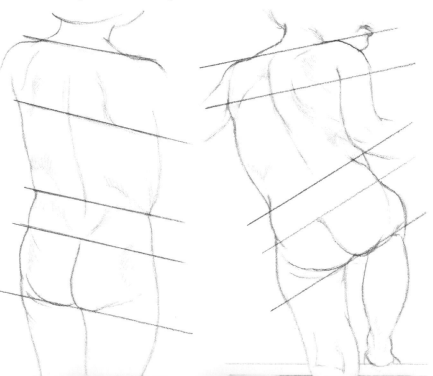

The pelvic area and the shoulders counterbalance each other when either one is tipped out of straight alignment, whether the child is standing or lying.

THE ARM The upper arm resembles an elongated cylinder surmounted by a rounded mass called the shoulder. The elbow is a tear-shaped surface at the back of the joint in the arm and is somewhat obscured by the surrounding layers of fat in an infant. The lower arm is a rounder, tapered cylinder which ends in the flattened form of the wrist. The flat part of the wrist is always facing the same direction as the flat part of the palm. Therefore, as the wrist rotates, so does the hand.

In an adult male the elbow lines up with the navel, and the wrist ends in line with the top of the thigh. The entire length of the arm is 2¾ head lengths (from shoulder to wrist). In an adult female the arm is slightly shorter in relation to the rest of the body, and the relative length of an infant's arm is dramatically shorter. The elbow falls midway between the nipples and the point where the thoracic curve meets the side of the body. The wrist lies at the navel, and the length of the entire arm of an infant is about 1½ head lengths. (Remember, the baby's head is also proportionately larger.)

Another important difference in the look of both the arms and the legs of a baby is the relative size of the joints (that is, the elbow, wrist, knee, and ankle) to the rest of the limb. There is only a very slight tapering toward the ankle or wrist, and the elbow and knee are much larger proportionally in a baby than in an adult.

The shoulder muscle (deltoid) attaches to the chest under a portion of the clavicle (breastbone), halfway from the outside of the shoulder to the center of the neck. It is important to remember that the arms attach to the body not at the shoulders, but high into the pit of the neck. This is why they have such tremendous range of movement.

The upper arm contains three major muscle masses: the biceps (**1**) in the front of the arm, which bend the lower arm; the triceps (**2**) in the back of the arm ending on either side of the elbow, which straighten the lower arm; and the deltoids (**3**), or shoulder muscles, on the top and sides of the arm. These raise the arm to the front, side, and back.

The lower arm (forearm) also contains three major muscles: the flexor muscles (**4**) on the underside of the arm, which bend the palm and make a fist; the extensor muscles (**5**) on the outside of the arm, which straighten the palm and open the fingers; and the supinator muscles (**6**) running from above the elbow on the outside of the arm down to the inside of the wrist. These rotate the hand. The flexor muscles are separated from the extensor muscles by the ulna (**7**), a bony ridge running from the elbow to the outside head of the wrist.

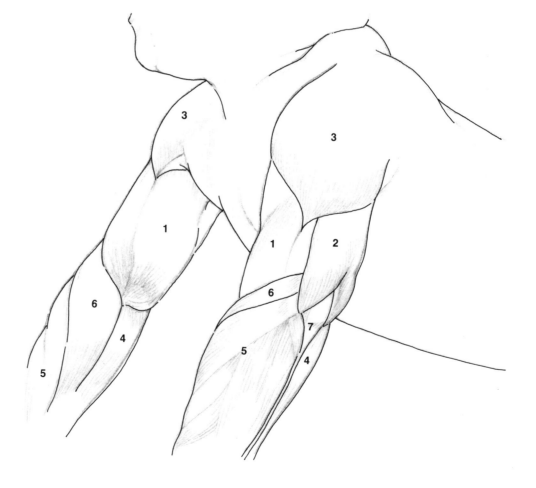

Left: The arm can be simplified into the basic shapes of a ball (the shoulder), cylinders (the upper and lower arm), a teardrop (the elbow), and a box (the wrist).

Below: These sketches show the arm both flexed and extended. Note the foreshortening in the bottom drawing, and the way the muscle and fat are pushed out above and below the elbow when the arm is flexed.

EXERCISES
Again, warm your hands and remove your baby's shirt.

1. Lay your baby on his side and make long strokes with your hand around his arms from the top of his shoulder to his wrist. Feel for and identify the muscle groups.

2. Massage the tops of his shoulders where the deltoids move into the neck, and observe how far into the neck the shoulders extend. Loosen up this area in preparation for the next exercise.

3. Lay your baby on his back or, if possible, have him sit up. Grasp his wrists and gently raise and lower his arms. Rotate them forward and, if he is sitting, backward. Notice that the arms move from the neck. This is most obvious when you raise his arms over his head.

4. With one hand, grasp the upper arm, and with the other hand, gently rotate the lower arm toward and away from his body. Notice the action of the wrist, palm, and supinator muscles.

5. Flex and extend the lower arm, and observe the hingelike movement of the elbow.

THE LEGS AND BUTTOCKS

The front of the upper leg looks like a cylinder that is slightly flatter on the inside. Unlike the leg of an adult or older child, an infant's upper leg does not taper at the knee. The front of the lower leg is a cylinder with a clublike appearance, bulged at the calf and tapering toward the ankle. The front area is flatter than the back with its mass of calf muscle. The area around the knee (front view) is oval-shaped with a punched-in or dappled look, especially when the leg is extended. This is caused by the abundance of fat. The back of an adult's knee is hollow, but in an infant this area is a rounded packet of fat tissue that is compressed between the calf muscles and the hamstrings when the knee is bent.

Don't allow the folds of fatty tissue that are so prominent in the upper leg to become more important than the overall shape dictated by the muscles underneath.

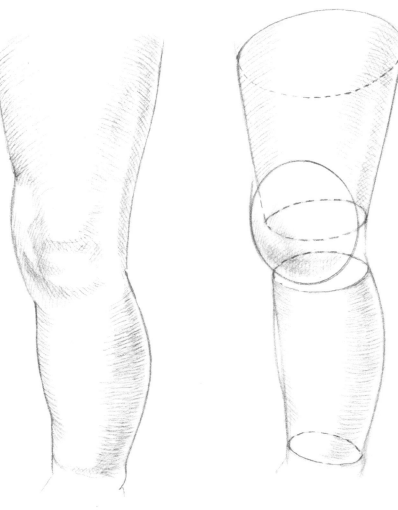

The upper and lower leg are both cylindrical in shape. The upper leg is flatter on the inside, and the lower leg is more clublike. Note that the ball of the knee is *not* directly centered below the upper leg, but protrudes on the inner side of the leg.

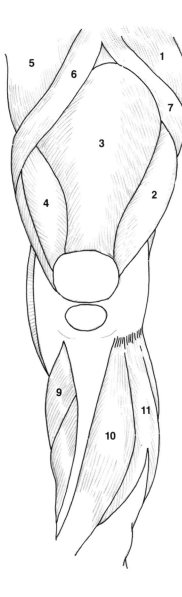

Left: This front view of the *left* leg shows the five major muscles masses of the front thigh. The gluteus medius (**1**) is located between the base of the abdomen and the top of the thigh. The vastus externus (**2**) is a side muscle ending above the knee. The rectus femoris (**3**) is a top and central muscle ending above the knee. The vastus internus (**4**) is an inside muscle that begins at the middle of the leg and ends above the knee. The groin muscles (**5**) are several muscles located high inside the leg that extend into the pelvis. Also, there are two long flat muscles that start together at the top of the thigh, and split. One, the sartorius (**6**), crosses the thigh to the inside of the knee. The other, the tensor fasciae femoris (**7**), runs outside the leg to below the trochanter. These muscles create the relatively flat area at the top of the legs below the abdomen.

There are four long muscles masses involved in the front of the lower leg. The soleus (**8**) lies under the Achilles tendon at the back of the lower calf, but stretches around so that it is also partially visible on both sides from the front. The gastocnemius (**9**) is the calf muscle that comes from behind the knee and bulges down to the middle of the inner lower leg. The tibialis anterior (**10**) is the central muscle that starts at the outside edge of the knee and runs the length of the lower leg, crossing over to the inside of the leg at the ankle. A separate group of muscles (**11**) above the tibialis on the outside of the leg attach behind the outer ankle bone.

Right: This back view of the *right* leg shows the five major muscles masses in the back of the thigh. The gluteus medius (**1**) and the gluteus maximus (**2**) together form the butterfly shape of the buttocks. The depressions at the trochanters (**9**) will become visible only as your child ages. The hamstring muscles (**3** and **4**) attach left and right to the back of the knee. Also, the sartorius and vastus internus together (**5**) are partially visible on the inner edge of the knee.

The back view of the lower leg consists of three large muscles and two smaller muscle masses. The calf muscles (**6**) extend from behind the knee to the middle of the lower leg, where they join at the Achilles tendon (**7**). This broad tendon reaches from the middle of the lower leg to the heel, and is the common tendon for the calf muscles. Part of the soleus (**8**) is visible along the outside of the calf before it goes behind the ankle and under the Achilles tendon.

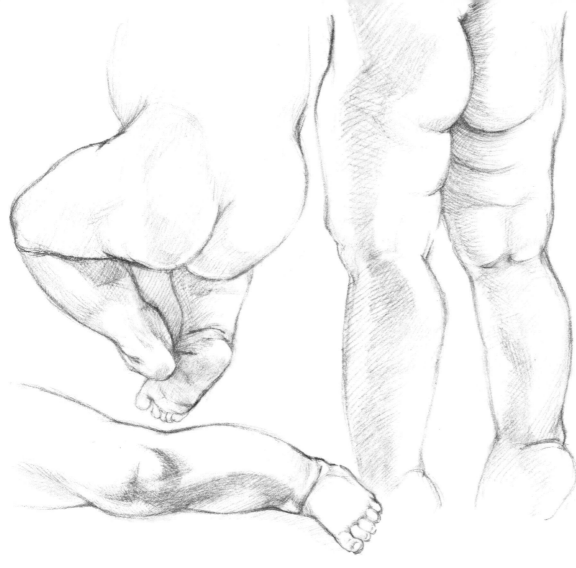

These sketches of a baby's legs and buttocks were done to explore how much the underlying muscles are obscured by the fat tissue in an infant. As you can see, the general shape of the leg is there, but the fat follows a different pattern from the muscles, especially in back of the thighs. Here the fat lies in broad bands around the leg. Note also the heavy overlap of flesh around the knee and ankle.

EXERCISES These exercises should be done with warm hands and diaper undone, but handy. You can use a little bit of nonperfumed oil to help your hands glide over your baby, but don't make them too slippery because you want to feel the muscles underneath. Also, it may be helpful to have this book open to this page so that you can refer to the diagram of muscle groups.

1. Give each leg a long stroke with both hands, all the way down from the top of the thigh to the ankles. Then place both hands around the diameter of one leg way up around the inner thigh, and move them slowly down the length of the leg, feeling for the major muscle groups discussed above. Repeat this exercise with the other leg.

2. With light strokes, slide one hand after the other down the side of the leg from the hip to the ankle. As you feel the outside contour of each leg, locate the external oblique, iliac crest, trochanter, gluteus medius, tensor fasciae femoris, vastus externus, outer calf muscles, and ankle bone.

3. Put one hand behind the knee to release it and, holding the ankle gently, bring the lower leg up and in toward the body. Then relax and extend the leg downward. Do each leg separately. When the baby is limber enough, you can hold each ankle and flex one leg and extend the other leg in succession (as in bicycling), watching how the knee changes as it is bent and straightened.

4. Holding the ankle in one hand, gently rotate the foot and observe how the ankle holds the foot like a wrench, restricting its movement. Learn what positions are possible for the foot in relation to the ankle. This will help you see whether or not you have drawn the foot at an awkward angle.

THE HAND Perhaps the hardest part of the body for most people to capture two-dimensionally and animate is the hand. It is helpful to see the overall poetry of the hand before trying to draw its various parts. As described by artist Burne Hogarth in his book *Dynamic Anatomy*, from the side there is a wavelike quality to the thumb and fingers because they are curved along their length; they are not straight or rigid. Viewed straight on, the palm is arched rather than flat, with its high point at the middle finger. It curves down and away to the thumb and little finger.[9]

The shape of the palm of the hand resembles a flat box with two curved edges, wider and thicker at the wrist. It is composed of three mounds: the ball of the thumb, the mass at the base of the little finger, and the mound across the base at the wrist. The back of the hand is flatter, and the knuckles create dimples in the center of the base of each finger when the fingers are extended. These dimples create a curvilinear pattern across the top of the hand. There are two muscles visible on the back of the hand: one between the thumb and forefinger, and the other at the outer edge above the little finger. But a baby's hands are so chubby that the overall impression is of a soft pad.

The fingers have soft undersides that squash out when they are gripping something. The tops of the fingers are flatter than the undersides, but still not as flat as an adult's because of the extra fat. They are marked by the knuckles, which protrude slightly when the finger is bent and form wrinkles when it is extended. The fingers are webbed below the knuckles on the underside of the hand, and they tend to curve into the middle finger, while the thumb arches away. Note the angle at which the thumb and index finger come together high up on the wrist (where the arm joins the palm). This relationship will help you see where to put the thumb in relation to the fingers when there is a question. The inside contour of the index finger lines up with the inside contour of the forearm, the little finger's outside contour lines up with the outside contour of the forearm.

To draw a fist, remember that the fingers close at a 90 degree angle. The last three fingers close into the hollow of the palm, while the index finger usually closes into the ball of the thumb. The thumb does not go beyond the little finger; it often covers only the index finger.

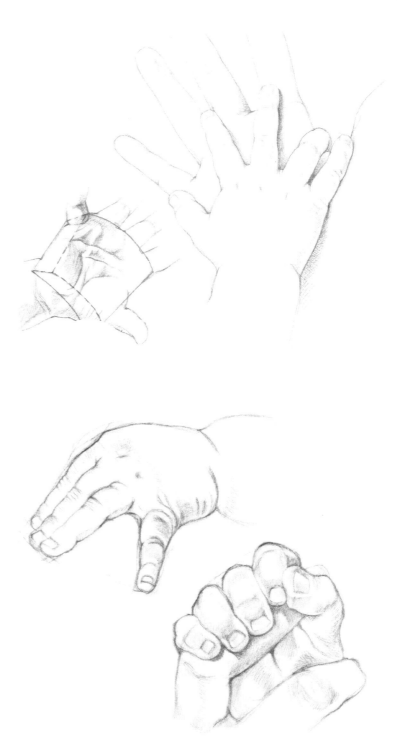

Opposite page, above: The shape of the hand resembles a flat box. The back of the hand is flat, but the palm contains three distinct mounds.

Opposite page, below: The fingers are webbed on the underside of the hand where they attach to the palm. Also, there is a wavelike quality to the curves along the tops of the fingers. Baby hands have a wonderfully powerful grip for their tiny size, which pushes the soft undersides of the fingers outward.

Looking at your child is more than just studying yourself in miniature, but there are moments when the contrast in size alone is awe-inspiring.

It is helpful to see the overall poetry of the hand before trying to draw its various parts. There is a unifying curve to the knuckles as they fan out in concentric circles from the palm.

"The sweetest flowers in all the world—a baby's hands."
—Algernon Charles Swinburne

EXERCISES Try these exercises and observations as early in your child's life as possible so that you can chart his remarkable progress in dexterity.

1. Begin with a few light strokes from the top of the arm to the wrist. Take the hand and make gentle circles with your fingertips on the top of the wrist. Then gently stroke the hand open if it is closed, but don't pry. Notice how the knuckles form ridges as the hand opens, and locate the mounds of the palm. If your baby's hand remains clenched, leave it closed and study the top of the hand and the pattern the closed fingers make.

2. Watch as your baby explores his own hand. You can observe his hand closely as he does the same thing.

Taylor on a Sunny Day. Oil pastel with turpentine wash, 7⅞ × 8⅝" (20 × 22 cm). Artist's collection. This illustration was done on a bright August day and captured the vivid, high-intensity colors that were created as light streamed in from the right onto the baby in her mother's arms. Because the baby's head is turned away, the hand serves as the focal point for the drawing.

THE FOOT The foot is a wedgelike shape with the top curving downward. From the side, it is made up of three major masses: the heel, the arch, and the front platform. The sole of the foot has four muscle masses, which are much more distinct in an adult than they are in an infant: the heel, the outer ridge of padded muscles from the heel to the little toe, the cushioned mass behind the big toe, and the cushioned mass behind the four little toes. In an infant, the bottom of the foot is almost a flat pad with a slight indentation at the arch.

The ankle and foot come together at a right angle over the heel and behind the area that will eventually become the arch. The small toes are cylindrical and tend to press downward, especially when there is weight on them. The big toe thrusts up at the tip and is generally more curved.

The foot is wedgelike in shape. The sole of an infant's foot is almost a flat pad; the indentation at the arch will gradually emerge as he begins to stand and walk.

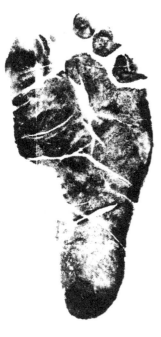

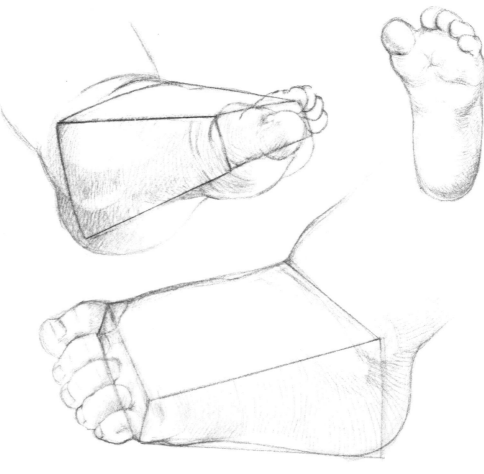

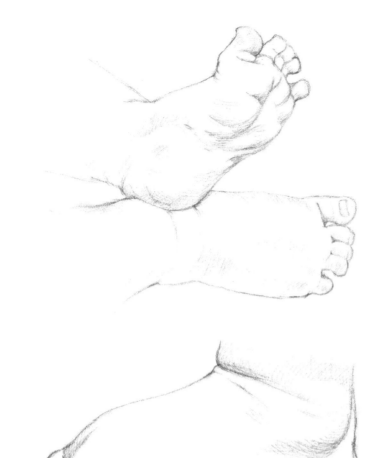

EXERCISES

Do these exercises before your baby has begun to stand, and then after he is walking. Note the changes in the shape and control of his feet and toes.

1. Lay your baby on his back and gently massage his feet. Make small rotations with your fingertips on top of his feet. Stroke the soles with your thumb from the heel to the toes with enough pressure so you won't tickle the feet. Feel the four muscle groups of the sole. Run your hands off the underside of the toe tips and watch how the big toe and the little toes work in gripping and letting go. Are they two separate units?

2. Gently rotate the foot back and forth and study how it moves in the ankle joint.

3. Put your baby's sole flat in your palm and notice the curve of the arch where it leaves your hand.

4. If your baby is older than five months and not too heavy, "stand" him on various surfaces: a flat table, the curve of your thighs, and so on. Note how his feet and toes grip in different situations.

The tiny toes of an infant seem to be continually in motion, often curling down toward the sole as if to grip something, or spreading outward so that their separate joints are more visible. Does your baby wiggle his toes as a sign of contentment?

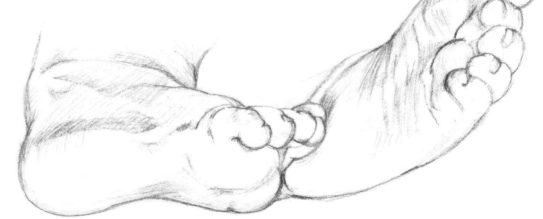

TODDLERS' ANATOMY

In the next few years your child will grow amazingly quickly, not only in terms of inches and pounds, but by developing internal bodily systems. As the rest of his skeleton grows more rapidly than his head, the change in proportion will make your baby less topheavy and more coordinated.

The soft spots on his head, which allowed for the passage through the birth canal and rapid growth of the brain, usually fuse together by 18 months. The protruding belly will become flatter as some proportionally oversized organs shrink and the abdominal muscles strengthen. The center line (linea alba) that divides the abdominal muscle becomes more pronounced. The slight outward bulge of the back will change, and the spine will take on the distinctive S-curve of the upright walker.

As your baby grows into a toddler, his muscles begin to gain definition. The entire group of back muscles can now be drawn in by identifying the M shape formed by the trapezius muscles and the shoulder blades. The inside of that M, the deep V shape, is the tapered line of the trapezius. The arms of the M are the edges of the shoulder blades. The neck is also more evident as a baby grows into a toddler, but the shoulders retain their narrow look.

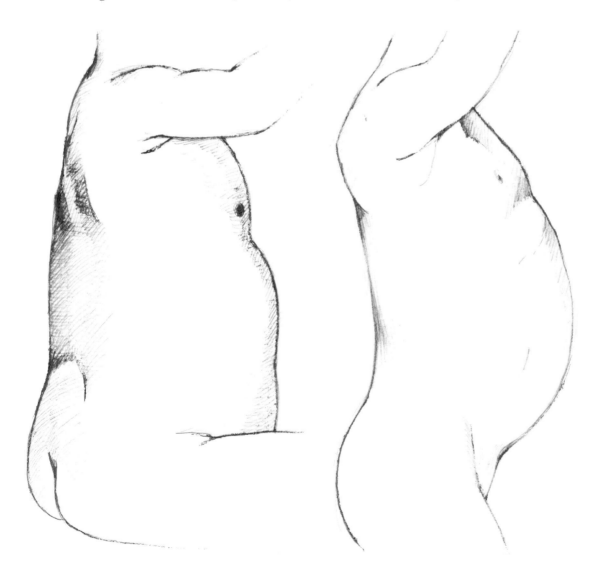

If you compare an infant's chest and back (left) with those of a toddler (right), you will note that the protruding belly becomes less pronounced as the abdominal muscles strengthen and the spine takes on the S-curve of an upright walker.

As your baby grows from six months to one year to two years, you will witness the gradual lengthening of his body and the emerging definition of his muscles as he learns to stand and walk and loses the baby fat of infancy.

As the arms elongate and become more slender, the muscles are more prominent (especially the biceps). Each elbow emerges as a triangular mass at the back of the arm, and there is a distinct tapering at the elbow and wrist. The proportion of hand length to arm length changes: In an infant, the arm is 2⅓ times as long as the hand, while a toddler's arm is 2½ times as long. This means that the hand does not look quite so disproportionately large.

The general shape of your child's hands changes, following the overall slimming of his body. The joints of the fingers become more pronounced as the bones of his hands grow and he loses much of his baby fat. Your child is now capable of a wide range of very precise movements with his hands and fingers. He uses his hands to pick up large and small objects and to balance himself. Accordingly, his hands will play a larger part in the poses and drawings that you create. He may even begin to mimic your sketching by trying to draw a picture of you!

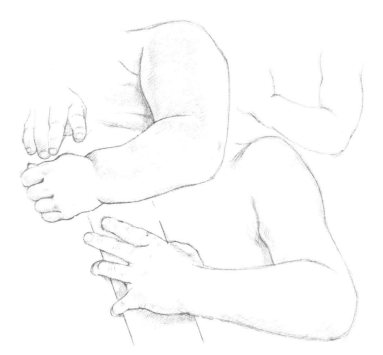

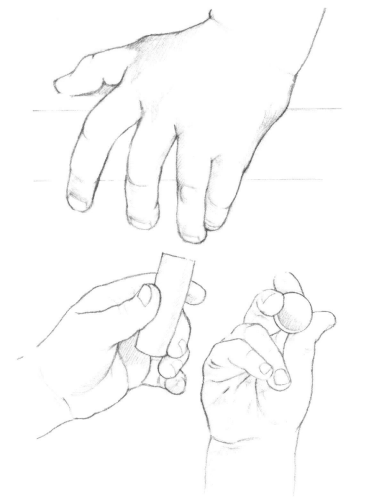

Left: The hands of a toddler are slimmer than an infant's and able to perform a wide range of very precise movements.

Above: Comparing an infant's arm (above left) with that of a toddler (below and above right), you will notice a dramatic change. The muscles have become more prominent. There is also an overall lengthening and slenderizing, especially at the elbow and wrist.

The legs also elongate and become more muscular. The front view of a toddler's leg, upper and lower, has an elongated B appearance. (The inner edge is straighter than the outer edge, and the knee and ankle narrow much more than a baby's.) When drawing your child standing, notice that the tibia (major bone of the lower leg) always curves into his body from the knee to the ankle. If this line is drawn too straight, the legs look like pipes. All the way down the leg, the relationship of the muscle masses is one of higher outside muscles relative to lower corresponding inner muscles (that is, the vastus externus versus the vastus internus, the outside calf muscles versus the inside calf muscles) except at the ankle, where the reverse is true. This relationship *never* changes.

As the bones grow, the knee of a toddler begins to take on a boxlike shape similar to that of the adult knee. The large prominences at the base of the femur and the head of the tibia form the upper and lower corners of the knee, respectively. The kneecap, still separate, sits on top of the knee box; this is the knoblike shape that protrudes from the front of the leg.

Right: The changes
that occur in the shape
of a child's legs as he
matures are as
dramatic as those that
alter the shape of his
arms. Seen in profile
the legs become
longer, more slender,
and narrower at the
knee and ankle joints.

Below left: The
difference in relative
size and shape of an
adult knee (lower left)
and that of an infant is
pronounced.

Below, right: This
sketch compares two
infant feet on the left
with the foot of a
toddler on the right.
The toddler has an arch
and better defined
toes, which help with
balance.

The fat little infant feet, which served only as something for your baby to put in his mouth as he was lying on his back, are now very hard-working parts of your toddler's anatomy. Accordingly, they have lost some of their baby roundness and have the beginnings of an arch. The toes are also more defined as their bones mature. They help your child balance and walk by gripping whatever he is standing on.

Now that your child is standing and walking, the ankle and its relationship to the leg and foot become more important. It is a large structure that works like a wrench to hold the arch of the foot securely. The inner ankle lies higher than the outer, creating the reversal of the relationship between the muscle bulges of the inner and outer leg discussed above. Like the relationship of the leg muscles, the relative position of the ankle bones *never* changes.

Since you will now be drawing your child in standing poses, it is important to pay close attention to the location of his center of gravity. This is to ensure that he will not look as if he is tipping over, but standing solidly on the ground. Generally, a vertical line from the chin should pass directly through the middle of the weight-bearing foot, or between the two feet if they are both supporting him equally. As his weight shifts, the line and chin will move accordingly.

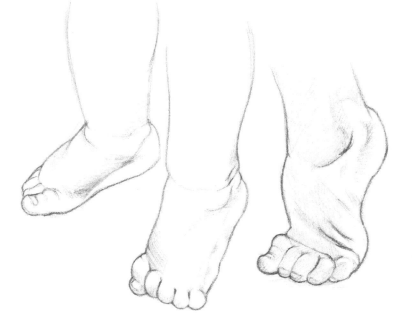

As an infant (left) grows into a toddler (right), the torso elongates, the back muscles emerge more clearly, and the spine becomes more defined.

Left: Here is a sketch showing my son using his strong, supple toddler's body in a way that no infant could: gripping with his hands and feet as he tries to climb up a wall using the strength of his arms and legs in unison.

Right: When seen from the front, the toddler's leg looks like an elongated letter B, with the contour of the leg straighter on the inside than on the outside. All the way down the leg, the relationship of the muscle masses is one of higher outside muscles and lower corresponding inside muscles—except at the ankle, where the reverse is true.

GESTURES

Is there a facial gesture more face-scrunching than the large, luxurious yawns that even newborn babies can manage? Their mouths open wide and practically take over their tiny faces, compressing their other features above and below. Facial gestures such as yawns are visual clues to your baby's personality, mood, and physical strengths or weaknesses. They can also be the central element in a sketch.

The three most important infantile gestures are crying, smiling, and laughing. Crying, which starts at birth, is followed about five weeks later by smiling, and then, at about four or five months, by laughing. Crying we share in some form with many other animals, such as whimpering puppies and kittens mewing to be fed, but smiling and laughing are uniquely human signals. In order to depict any of these actions, it is necessary to study and understand what is happening physically when your baby cries, smiles, or laughs.

Crying and laughing are very similar states, both physically and visually. The whole face is in a state of tension. Compare the facial gesture of a cry or a laugh with that signifying a sense of wonder. During crying there is considerable muscular tensing, a reddening of the skin, watering of the eyes, opening of the mouth, pulling back of the lips, and exaggerated breathing with intense expirations. These visual elements that accompany the high-pitched, rasping vocalizations are similar to those seen during intense laughing. The similarity is no accident. Despite the different subjective feelings that accompany the two actions, both serve to release emotional tension. In fact, one theory suggests that the laughing reaction evolved out of the crying one, as a secondary signal.

In *Manwatching*, Desmond Morris suggests that a baby begins to laugh at about the same time that he becomes aware of his mother. As soon as he identifies her as the person who will take care of him, a child begins to experience the kind of conflicting emotions that trigger laughter. If his mother does something to startle him, the child gets a double message. The activity itself is frightening, but the person who is controlling the activity is also his protector. Therefore the situation is both threatening and reassuring, and his response is part crying and part contented gurgle. The baby's facial expression when laughing is similar to his crying expression, but less intense; the sound of his laughter is as rhythmic as crying, but not as shrill.[10]

Like most parents, you are probably entranced by your baby's smiles, and eager to draw them. Exactly what happens to your baby's face when he smiles? Smile yourself and feel what happens to your own facial muscles. The same thing is happening to your baby's face. The corners of the mouth are brought back and

upwards, this in turn forces the cheeks upward. The cheeks are compressed slightly between the corner of the mouth below and the lower lid of the eye above. The eyes become more crescent-shaped and sparkle. (This effect can be portrayed by adding points of reflected light in the pupils.) Dimples in the cheeks often appear or become more pronounced.

Body gestures or attitudes can also be a clue to the mood you are trying to convey with your drawing. In a pose signifying sleep, you want to stress the weight and inaction of the baby's body. This can be done with props: A blanket or some fabric underneath the child can accentuate, with drapery folds, the heaviness of a sleeping child. Another effective way to signify inaction is to position the baby's head and limbs in a way that shows the curving line of his body in repose, a time when the body bends in on itself in the fetal position. Along with emphasizing the weight and limpness of the pose, use soft lighting, and draw with a soft medium. Be careful to avoid too much dramatic contrast because this tends to energize the work.

Alternatively, the kinetic side of an infant is brought out by drawing arms and legs akimbo or straight out at a sharp angle from the body to portray a burst of energy. The use of blurred images and directional lines, like streamers coming off the body, can invigorate a sketch. Emphasize the boldness and angularity of your child's movements through the use of bold, confident linework done with media that lay down strong lines.

When drawing your child as a toddler, you will witness a wider range of expressions and gestures, many of which will be very subtle. Emotional content becomes more important in portraying the older child as you seek to convey his distinct personality. It is a challenge to capture just what makes one expression convey a sense of wonder while another shows evidence of concentration, or even the more sophisticated emotions of determination and thoughtfulness.

As your child becomes older, he will not only be more active physically, but he will often shift quickly from one emotion to another without warning. One minute he will be quiet and introspective, and the next he will shout out to assert himself. This is the time to use props to distract and occupy your child as well as to provide other elements of interest in your sketch. Drawing older children in groups is often preferable because they will remain engaged in activities longer and afford you more time to draw. The use of photographs is almost a necessity at this age, to supplement the information you are able to put down very fast during a sketching period.

Facial gestures such as yawns can be
the central element in a sketch.

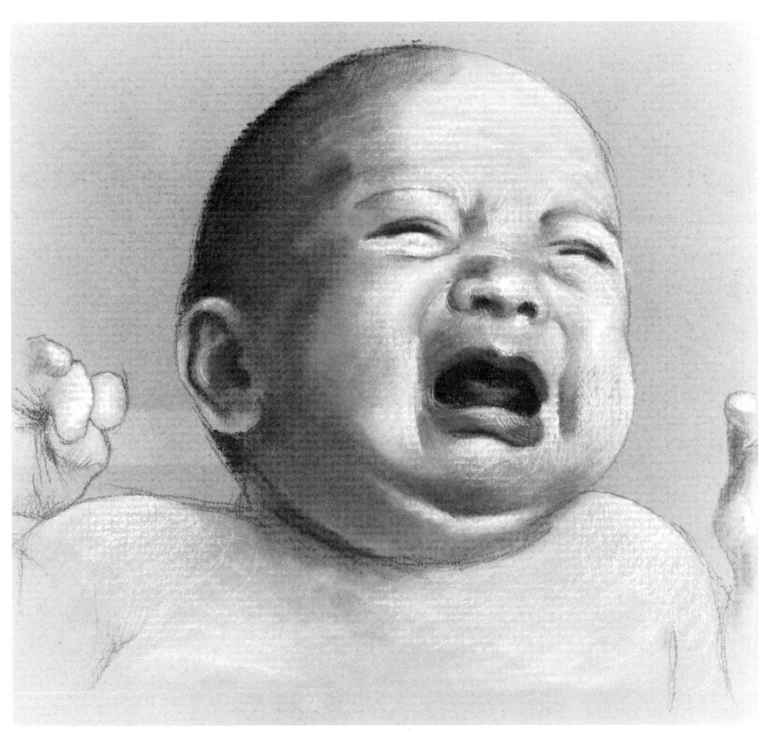

When your baby cries, his whole face is in a state of tension.

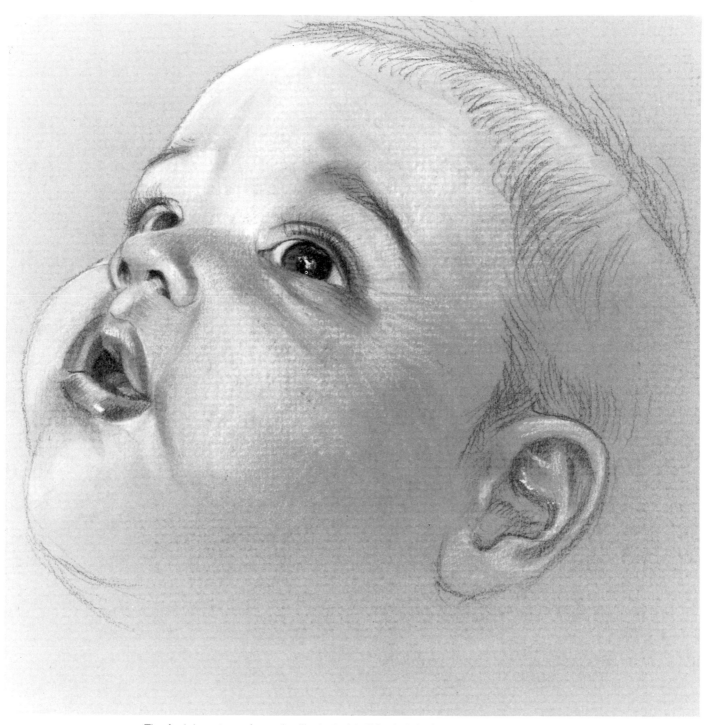

The facial gesture of wonder illustrated in this sketch shows a
relaxed face. The eyes are open wide, the eyebrows are arched, and
the mouth is only slightly pursed.

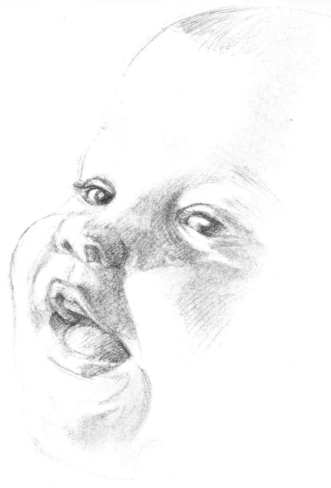

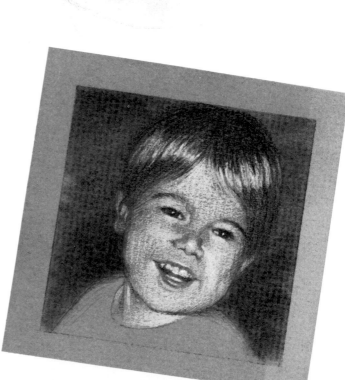

Seen from any angle, nothing is
more joyous than a child's smile.

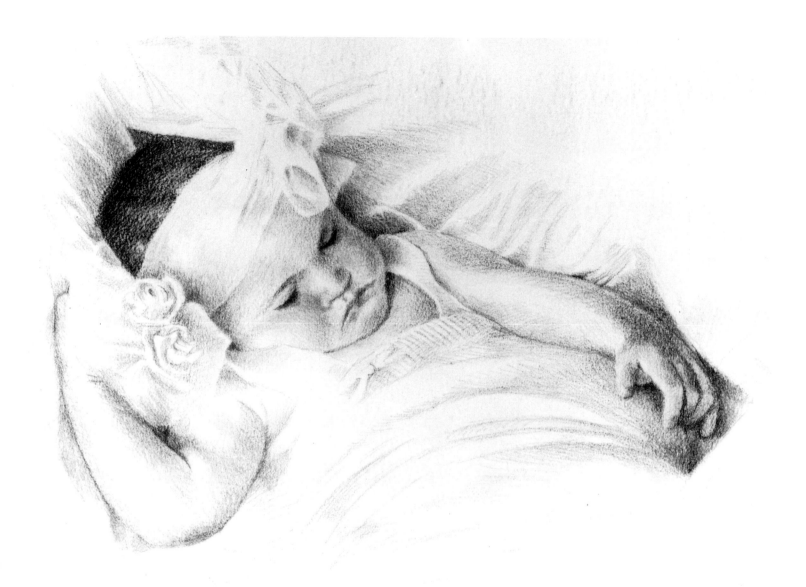

When drawing a pose signifying
sleep, you want to stress the
weight and inaction of the baby's
body.

Right: As your child matures he will display new, more subtle emotions such as thoughtfulness and introspection. In this instance my son was very involved drawing with chalk, so I was able to take some Polaroid photos of him as well as do a fast sketch to capture his mood. Later I did this drawing over the sketch and referred to the Polaroid photos to fill in details such as lighting.

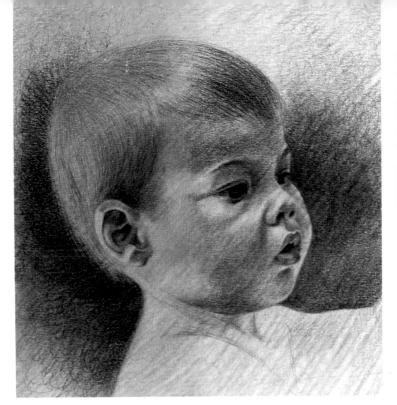

Right: How you react to your child's emotions will influence your drawings. A toddler's assertive shout can be irritating—or as it is portrayed here, the reflection of an exuberant child.

Below: Blurred images and directional lines can be incorporated in a sketch to indicate action.

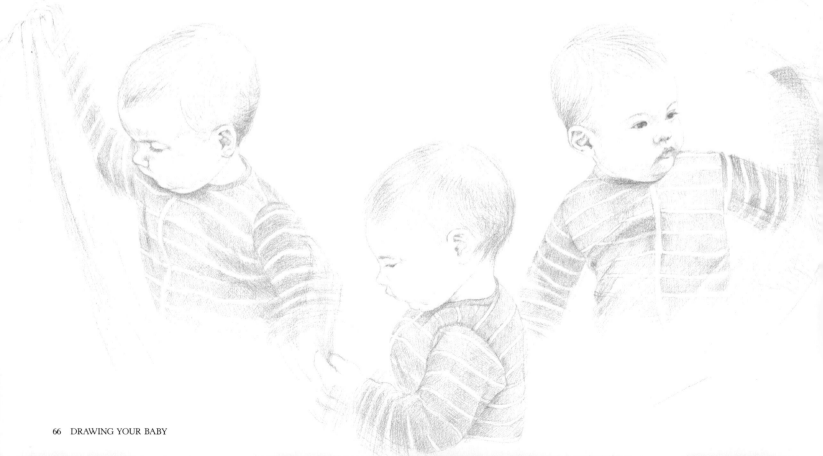

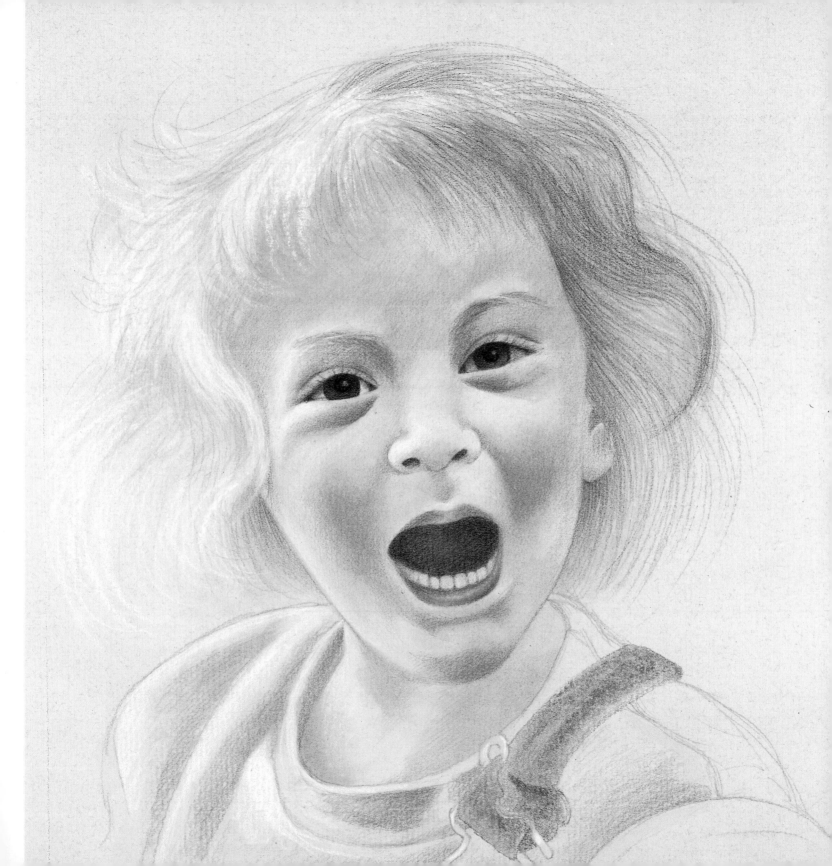

PERSPECTIVE

The theories of perspective, which help you to draw anything three-dimensional convincingly in two-dimensional space, can be quite complex and confusing. Here are a few basic rules and visual clues that, along with practice drawing, will enable you to sketch a wide range of poses.

According to the principles of foreshortening, objects closer to the eye appear larger than those at a distance. This distortion can be creatively incorporated in a drawing, but sometimes it may be difficult to make the relationship of the various parts understandable. You may have to make use of artistic license and manipulate what you actually see by making the angle of vision less extreme as you draw certain areas, or by showing something in more detail than you can actually see from one position in order to clarify its relation to the whole. If you find yourself having to make too many of these adjustments it would be better to choose another pose or move to another view of the same pose.

When drawing objects at different distances from the viewer, remember that objects seen up close have more detail than those at a distance. This is the texture/detail gradient mentioned earlier, one of the visual signals that cause you to see three-dimensionally. Refer back to the section "Understanding How You See" for a discussion of the visual signals and how they work to create the illusion of depth.

When parts of the body bend (such as fingers, arms, or legs) and one form comes forward while another recedes in space, the receding joint (such as a knuckle, elbow, or knee) becomes partially hidden by the part of the body extending toward the viewer. You must emphasize and sometimes exaggerate this effect in order to make the pose read correctly, regardless of size. Two other ways to make something recede are to make it darker in value than objects in the foreground—that is, to shade it, or to hide part of it behind foreground objects.

In extreme foreshortening, the apparent shape of an object changes abruptly, indicating a sharp compression of form. Cylindrical forms, such as fingers, become more circular as the length of the form shortens in depth. (A finger seen straight on looks more like a circle or a stubby box than a long cylinder.) Often clothes or accessories help as reference points in defining form and shape. A headband around the head, cuffs on sleeves and pants, waistbands, suspenders, and so on, all give you clues about whether the form they encircle is tipped toward you or away from you.

Albrect Dürer originated a device for dealing with the problem of foreshortening in drawing. He placed an upright wire grid in front of his line of sight between his model and himself. Then, using a paper the same size as the wire grid, he drew a series of lines to correspond with the grid. Each square on the wire grid would frame a particular part of the model he was drawing. He then transferred the information contained in that square onto the corresponding square on his paper.

Dürer's grid works to keep the artist from drawing what he thinks is the correct size, position, and shape of his model's anatomy. In short, it pushes him to draw only what he sees. If the artist is faithful to what he sees in each square, when he completes the composition, he will have a correctly foreshortened drawing of his

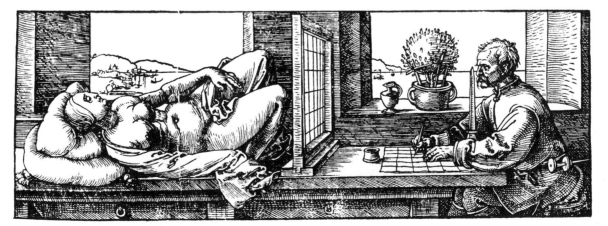

Albrecht Dürer, *Draftsman Making a Perspective Drawing of a Woman*,
print from *De Symmetria Partium Humanorum Corporum*.
Courtesy of The Metropolitan Museum of Art, New York. Gift of Felix M. Warburg, 1918.

Many parts of this sketch show extreme foreshortening. The shortness in distance between the neck and the top of the diaper indicates that the abdomen is at a right angle to the hips. The relatively small shapes of the thighs and the fact that they are behind the arms indicate that the legs are quite far away from the viewer and bent forward. The truncated shape of the hands and the more circular shape of the fingers also indicate extreme foreshortening.

model. He will have correctly drawn the figure three-dimensionally despite all its distortion, and the viewer will have no trouble seeing a woman lying down from the artist's particular point of view: looking at his model from below her knees as she stretches out in front of him.

You can create a different version of a grid drawing by drawing a square grid system onto a sheet of vellum or tracing paper, then taping it onto a large sheet of Plexiglas. Hold the Plexiglas up between you and your subject, and sketch it right on the grid paper, concentrating on each square of the image as you draw. (Even though you are drawing something three-dimensional, this exercise is almost like tracing something flat, because you draw each line exactly where you actually see its image.) Your subject must remain absolutely still during this exercise, so it is best either to use an adult model who won't move or to set up a still life. Your point of view must also remain consistent; a shift in your position or your model's will alter which part of the drawing belongs in which square.

Try to see the image in separate squares, each containing its own small composition. Then relate the squares as they fit together like a puzzle to form one large unified picture. Seeing the image in such a fragmented manner will help you to bypass any preconceived notions about forms and shapes.

Like most of the exercises described in this book, drawing with a grid system is intended as a means to an end, not as a permanent method for working. Therefore, discard it as soon as you feel you have learned the lesson it teaches—but continue to work toward drawing only what you really see.

In order to draw the head three-dimensionally, you must carefully observe what happens to the shape of the head and the features of the face as they rotate in space. As the head turns, the center line of the face, as well as the features, shift in unison. First, determine the amount of turn—that is, how far the vertical axis of the face has moved to the right or left. Then, lay in three-quarters views of the eyes, nose, and lips on either side of this new axis. Often the farthest corners of the features are hidden in three-quarters views as the nearer parts bulge out in front. Also, study the curve of the facial features along the far edge of the cranium. This curve differs for a face viewed from the side, above, or below.

Any angle of perspective that differs from a straight-on view of the body will alter the relationship of the individual body parts to the body as a whole. The more extreme the perspective, the greater this distortion will be. For example, when you view the head of your child from below the level of the chin, his ears, which in a straight-on view would fall between the top of the eyes and the mouth, will be somewhere *below* the mouth. The tip of the nose may actually be *above* the eyes. This sounds bizarre, but you can verify it by tipping back your head in front of a mirror. This dynamic alteration of relationships gives poses employing extreme perspective their energy and interest. A sketch of a person from a unique viewpoint pulls the viewer into the picture and makes him an active participant rather than a passive observer. Because he doesn't have a typical eye-level relationship with the subject, the viewer cannot rely on his stereotyped preconceptions of what people look like, and is forced to see with a fresh eye.

Understanding these rules of perspective will help you to choose poses that "draw well." While you are just beginning to draw your baby, it is easier to make a properly proportioned drawing if all parts of his body are at about the same distance from your viewpoint. Thus you will avoid the optical distortions that arise from being too close to his head or feet, or having an arm that reaches out toward the viewer with a disproportionate hand on the end of it.

Along with an awareness of perspective, many artists employ sighting techniques to help them draw what they see without using any formal perspective system or theory. Sighting involves mentally measuring and comparing what you see, and continually referring back and forth between the different elements in a sketch, to ensure that the overall relationships are correct. This method can provide a helpful framework for the novice approaching a pose.

When drawing a face from above or below, you will be aided considerably by imagining that the facial features line up along an arc that curves across the head. For example, an artist drawing an overhead three-quarters view of a child might make some of the following calculations:

The eyes are contained within parallel arcs, and their outer corners still have a triangular relationship with the tip of the nose. But the shape of the triangle is no longer isosceles as it would be at eye level, because the extreme perspective compresses the angle between the eyes and the nose. The nose seems farther down on the face; the tip of the nose is about halfway between the center of the eyes and the mouth. The mouth also shifts downward as distance compresses the lower half of the face.

The corners of the mouth are almost on a line with the upper lip because the distance is condensed, the mouth is open, and the upper lip is stretched into a slim line. It is therefore important for the left side of the upper lip to curve in front of the corner of the mouth, indicating that it is above and in front. The chin seems

In this pose the fact that the upper body is bending away from the viewer is emphasized by the way that the lines at the back of the hips (indicated by the arrows in the top sketch) overlap and are in front of the abdomen. Also, the left leg is bent and correctly reads as a form moving away from the viewer because the folds at the back of the upper and lower legs come together behind the knee. The general shape of the leg indicates that it is seen from behind and only slightly to the side.

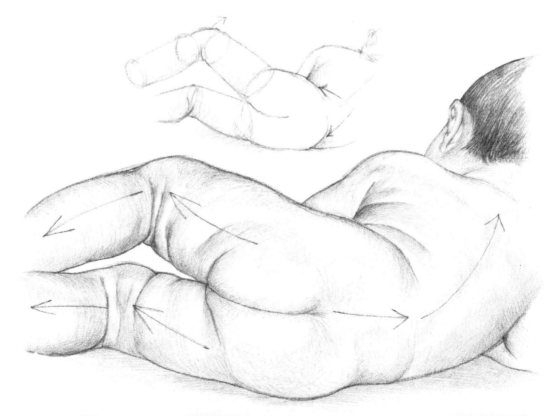

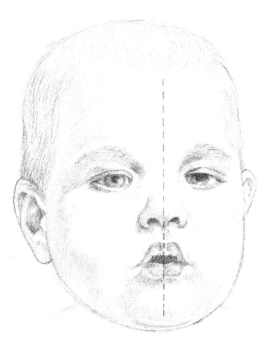

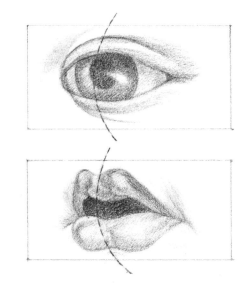

As the head turns, the center line of the face shifts in unison with the center of each individual feature. When the child's face shifts from full face to a three-quarters view, you begin to see indications of the forehead, the brow, the slight bulge at the outer corner of the eye, and the roundness of the cheek.

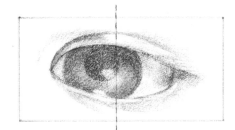

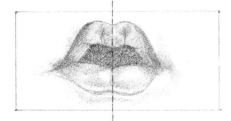

Take caution when drawing a pose in which part of your child's body extends either farther forward or farther behind the rest of him. Pay careful attention to the change in length and shape of the intervening areas, as well as the closest or farthest parts. In the sketch on the right, the boy's right hand is drawn much larger than his left, but it does not seem out of proportion because the length and shape of the arm as it moves from shoulder to elbow is correctly foreshortened.

proportionally smaller and more pointed than usual because the downward perspective condenses the lower half of the face. The ears would appear higher than a *straight* horizontal line drawn above the eyes. But if you use the curving arcs as guidelines, the ears will still be between the top of the eyes and the top of the mouth along the facial curve. The angle of the line where the ear attaches to the side of the head echoes a line drawn from the center of the eye to the corner of the mouth.

You can check the vertical and horizontal orientation of the face by holding up a pencil either vertically or horizontally in front of your subject. Then align your sketch within the edges of your paper the same way the face itself aligns with your pencil.

In general, look for things that line up with each other, and for forms that have similar shapes or curves. Be sensitive to observations that can be made only at the particular angle that you are drawing from. For example, when looking down on a face with the eyes open, you are able to see the inside edge of the lower eyelid, where the eyelashes attach. From a three-quarters view, you can see the inner corner of the nearest eye. These are the details that make drawing as well as really seeing your baby so exciting.

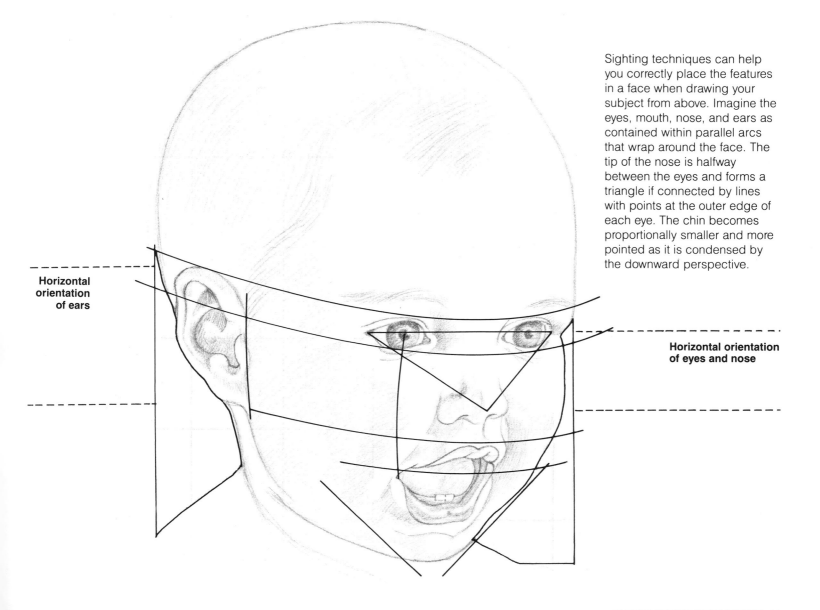

Sighting techniques can help you correctly place the features in a face when drawing your subject from above. Imagine the eyes, mouth, nose, and ears as contained within parallel arcs that wrap around the face. The tip of the nose is halfway between the eyes and forms a triangle if connected by lines with points at the outer edge of each eye. The chin becomes proportionally smaller and more pointed as it is condensed by the downward perspective.

Horizontal orientation of ears

Horizontal orientation of eyes and nose

LIGHT AND SHADOW

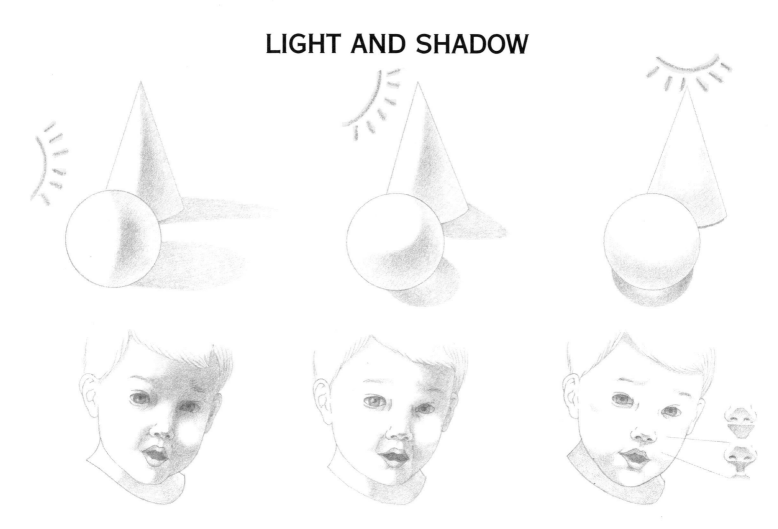

Another way to give a drawing depth and solidity is by recording the way light falls on the subject and the shadows it creates. A shadow is dependent on light; it is the other side of the light area of a solid form. The shape of a shadow or the shaded portion of a drawing depends on the angle and direction of the light. For example, the lower the light is in relation to the object, the longer the shadow it creates. The quality of the light also affects the shadow. Sharper-edged shadows are caused by bright, direct light, while softer-edged shadows are the product of diffuse light.

Of course, the shape of the object that the light falls across will be echoed in the object's shadow. But this shadow can also be distorted by the surface upon which it falls. The shadow of an arm on a wrinkled blanket will be full of ripples. But even when a shadow is distorted, it can still give the viewer a feeling of depth.

A shadow's shape reveals a second view of the object, not from the angle of the viewer, but from the angle of the light source. As mentioned earlier, this is much the same way that your two eyes in binocular vision give you two versions of what you are looking at. After studying the variously lighted faces shown above, you understand that the nose, mouth, and cheeks have height and stand out from the face because of the shadows that they cast. The same illustration also demonstrates that certain angles of illumination are better for defining features than others. Neither side lighting nor top lighting is as effective in adding depth and character to the face as high side lighting. In side lighting, much of the face is lost in shadow, while top lighting creates unnatural shadows in the eye sockets and under the nose and chin without giving the viewer much of a feeling for the profile shape.

Because we are accustomed to seeing things illuminated by one principal source of light and it is usually overhead (the sun, windows, indoor lamps, and so on), this is the logical location for the main source of light when you are sketching. But slight changes in

Left: This illustration shows a cone, a sphere, and a child's face with three different types of illumination: side lighting, high side lighting, and top lighting. The symbol of a sun with rays indicates the location of the light. The important thing to notice here is the size and shape of the shadows that each type of lighting casts within the shape as well as behind it. On the child's face, note especially that the shape of the object that the light falls across (such as the nose) is echoed in the shape of the object's shadow. This shadow can also be distorted by the surface upon which it is cast (such as the ridges between the nose and mouth).

Right: This watercolor sketch shows a sleeping baby lighted by a source above and to the right. If you squint your eyes, you will be able to see a heightened contrast between the lights and darks. The right arm, since it lies on a flat surface, casts an undistorted shadow that is a projected shape of the arm. Within the arm itself, a full range of tones form a soft-edged shadow ranging from a middle tone closest to the light to a darker tone running down the center of the shadow. The shape of this shadow describes the contour of the arm and gives it solidity. On the outer side of the lower right arm, the shadow becomes lighter in value. This is caused by light being reflected off the sheet and bouncing back to partially illuminate the underside of the arm.

the angle of light can be very dramatic, and any disturbing areas of shadow can be lightened or opened up by using a secondary light or by holding some reflective material, such as a white board, in front of the subject to bounce light back onto it. (This technique is discussed further under "Choose Appropriate Lighting.") Just as you must sometimes alter your position relative to your subject in order to get the best view, you should manipulate the lighting when it is necessary or desirable to do so.

Reflected light is a valuable aid in describing a full, rounded form. Its position and shape is often critical in bringing an image to life on paper. When you are working on a drawing with a lot of shadows, it is important to keep the direction and angle of the light clearly in mind. Some artists make a notation in the corner of their sketch, a light and rays symbol, to remind them of the light source. The darkest area of a shadow will be where the marks are as dark as the medium will allow. The tones in between can be produced through a number of different techniques used with a variety of media. Obviously some methods of shading work better with certain media and some methods are inappropriate altogether. For example, smudging does not apply to pen and ink.

When working with a soft medium, such as a soft pencil or charcoal, you can smudge the darker sections to create a lighter tone using either your fingers, paper stumps, or a chamois cloth. An eraser can be used to lighten a dark tone. If the medium is soft enough and the paper is smooth, you can create a varied tone simply by changing the pressure of your hand as you draw. Cross-hatching can be employed with both soft and hard media. This is done with short, parallel marks made in one direction and then crossed over with another set of parallel lines at a slightly different angle. You can add as many layers of parallel lines as you need to make a tone, but be aware that this technique also models the form, so you must be careful not to create a bizarre interior shape.

Still another option to use in creating a sketch with a full tonal range is drawing on a toned paper, letting the background be the middle tone and adding in the whites.

Pen and ink or hard pencil and charcoal can be used in various ways besides cross-hatching to produce a tonal range. Simple scribbles can be massed together for a dark tone or be lacy and delicate for a light tone. Dotted or pointillistic patterns can create a modulated tone; by making strokes across the grain of a paper with a rough surface, you can achieve a stippled effect.

To emphasize a shadow, make the illuminated area brighter as it nears the boundary where it meets the shadow area. Also make the shadow area darker as it nears this same boundary. This will result in the highest possible contrast between the two areas. As long as it is not too extreme, the illuminated area will glow subtly brighter than it actually is and the shadow area will seem darker.

This figure demonstrates four different techniques for creating a full range of values. Starting at the top: charcoal with smudging and erasing out; cross-hatching and varying pressure used with a soft pencil on a smooth surface; drawing on toned paper and adding white for the lighter values; and pointillistic patterns done with pen and ink.

COLOR

Choosing the colors you feel comfortable working with is based on personal aesthetics. You have your own private conception of color harmony, and your color choices can reveal much about your thoughts, feelings, and character. This is subjective color. Although it is important to strengthen your individual response to color, it is also important to understand the general objective rules of color theory.

Color is the result of light waves. Objects have color when certain wavelengths (colors) of light are absorbed by that object; the eye then sees only the remaining colors of the spectrum, which are reflected off the object's surface. Thus, when a book looks blue it is because the book has absorbed all the other colors of light and reflects only blue. The book does not have color in itself; light generates the color. When the quality of the light changes from bright sunlight to shadow, the color of the book also changes.

Colors interact in different ways, contrasting and creating different emotional and visual effects. Each type of contrast deals with a different property of color. Before we discuss color any further, here is a short glossary of color terms to aid you in identifying and understanding these unique properties and their effects.

Analogous colors: Colors in a side by side position on the color wheel. (Example: red, red-orange, and orange.)

Chroma: The strength of a color. The chroma of a color varies on a scale from strong to weak as the colors go from pure, intense color to dull, diluted color. Other names for chroma are saturation, purity, and intensity. Colors may be diluted in different ways. You can darken a color by adding black or gray, and you can lighten a color by blending it with white. You can also reduce a color's intensity by mixing it with another color. If the colors are analogous, the change will be subtle, but if the colors are complementary or near-complementary, the change will be dramatic.

Complementary colors: Two colors that produce a neutral gray when mixed together in equal parts. There is only one complement to any given color, and the eye requires that the two be continually balanced. This is the force behind the phenomenon called spontaneous complementaries, in which the eye will spontaneously generate the complement of a color viewed if it is not present. Any color can therefore instantly transform an adjacent gray area into a value of its complement. (See the illustration on page 79.) Complementary colors can also incite each other to maximum vividness; when placed next to each other the colors will seem to vibrate.

Dimension: A measurable visual quality of color. Each color has three dimensions: hue, value, and chroma. Each dimension may be altered without disturbing the others.

Gradation: A change by degrees in one of the dimensions of a color, usually used to describe a gradual change in value.

Hue: The specific color name (such as viridian green); also, an undiluted color at its most intense. When three distinct hues are used in equal proportions in a composition, the resulting contrast of hue is invigorating and intense. The primary colors (yellow, red, and blue) are the extreme instance of contrast of hue. This type of color scheme is found in folk art around the world and is a testament to the pleasure that bright contrasting hues bring. Of course, any combination of pure, undiluted colors could be used to create a contrast of hue, but the intensity of effect is muted as the colors move away from the primaries.

Primary colors: The three hues from which all others can be mixed: red, yellow, and blue.

Secondary colors: Colors that appear midway between the three primary colors on the color wheel: green, violet, and orange. They are the result of mixing two primary colors together.

Temperature: The sensation of warmth or coolness associated with certain colors. Experiments have demonstrated that certain colors (such as blues and greens) can slow down a person's circulation, while other colors (such as oranges and reds) can stimulate it. Blue-green and red-orange form the cool and warm extremes of the color wheel, respectively. The hues between them may be either cold or warm, depending on what colors are placed next to them— in the same way that grays are light or dark only in relation to their surroundings. The relative coolness or warmth of a color can also affect where you see an area in space. Cool colors seem to recede, while warm colors seem to advance.

Tertiary colors: Colors that appear between the primary colors and the secondary colors on the color wheel. They are the result of mixing a primary color with a secondary color. (Examples: blue-green, red-violet.)

Value: The lightness or darkness of a color. The number of gradations that one is able to see in any given color and in gray is dependent on the sensitivity of the eyes of the viewer.

When people speak of color harmony, they are evaluating the degree of discord between two or more colors. The colors that we find pleasing have a certain orderly relationship to one another. In the artist's world, color is contained not only in the light waves that we see, but also in the colored pigments we use in art. Here are a few rules that can help you order your use of color.

Two or more colors are considered harmonious if they yield a neutral gray when mixed together. Two colors that do not mix to a neutral gray are in a discordant relationship with each other.

The essential element in any discussion of color theory is the color wheel. This will determine the description of various colors and will also aid you in seeing the relationships among the colors. The color wheel depicted here is based on the twelve-hue color circle described in Johannes Itten's book *The Elements of Color*. Each hue has its own unmistakable place within the sequence of the natural spectrum.

Starting with yellow at the top, every fourth color is a primary color (yellow, red, and blue). Midway between the primaries are the three secondary colors. (Orange is equidistant between yellow and red; green is equidistant between yellow and blue; and violet is equidistant between red and blue.) Thus the six points of the hexagon inside the wheel touch the primary and secondary colors. The remaining six colors, which fall halfway between a primary and a secondary, are the tertiary colors: yellow-orange, red-orange, red-violet, blue-violet, blue-green, and yellow-green. Complementary colors are located directly across the color wheel from each other.

Juxtaposing such colors can have a provocative and exciting effect in a composition. The objective of learning about color harmony is not to eliminate color conflict, but rather to control the amount of conflict so that you can put the drama and tension exactly where you want it in your work.

In the natural world the surface across which a shadow falls will influence the shadow color. Shadows on light-colored surfaces are lighter than those on a dark surface. The farther away an object is from the light source, the lighter the shadows are that it casts. Remember also that shadows must appear transparent or they will seem painted on. Therefore, indicate the texture, shape, and color of the surface across which the shadow falls.

Shadows and shade in color drawings should *not* be black or gray as often indicated, but should always contain some color. The best color for use as shadow color is formed by mixing two complemen-tary colors together. This will produce a lively gray with a subtle color, as opposed to the dead color of a commercially mixed gray. Shadows are approximately the same chroma as the lighted portion of the object upon which they fall. Only the value of the color is changed by the addition of black. Unless there is very little light, shadows usually contain a trace of the local color of the object throwing the shadow.

Sometimes shadows can appear as complementary colors to that of the object casting the shadow. This is due to the creation of spontaneous complementaries. In his painting *Cake*, Wayne Theibaud makes effective use of this phenomenon and creates a painting that seems more vibrant than the colors are in actuality. Here the shadows are extremely important. Try to imagine how uninteresting and ordinary a painting *Cake* would be if the shadows were a dead, flat gray.

Wayne Theibaud, *Cake*. Oil on panel, 5½ × 9″ (14 × 23 cm). Courtesy of the Philadelphia Museum of Art, Philadelphia, Pa. Gift of the Kulicke family in memory of Frederick W. Kulicke, III.

You can test spontaneous complementaries by creating a small gray square in the center of a larger, vividly colored square. Stare at the large square for 30 seconds. If the larger square is red, the small gray square will appear greenish-gray; for violet it will be yellowish-gray; for yellow it will be violet-gray; and for green it will be reddish-gray as each color generates its complement in the neutral gray area. The effect is more intense the longer the background is viewed and the more intense the color is. After a long period of viewing, the actual color will lose intensity as the eye tires, while the sensation of the complementary color will strengthen.

RECORDING WHAT YOU SEE

So far this book has concentrated on helping you understand what you see when you look at your baby: the structure of his body, and the numerous factors that influence how you perceive him. Now it is time to translate what you see into actual drawings.

For many people, the first step toward beginning to draw is simply to conquer the mistaken belief that they cannot draw, that they were never meant to be artists because they lack the necessary talent. For this reason, this section opens with ways to overcome drawing block. Many of the ideas suggested here will help you approach your subject in novel ways that short-circuit old drawing and seeing prejudices. By copying images that are upside down or reflected in a mirror, you may be amazed at how much better you draw something when you are concentrating on the lines and shapes that compose it, rather than thinking about what specific part of the body it is. Most of the exercises described in this section are similar to those that have been used to train art students for years. These techniques for bolstering your perceptual and drawing skills can do wonders for your artistic self-confidence and loosen any inhibitions you may have about expressing yourself on paper.

Next come some useful tips for conducting an actual sketching session. You will find suggestions on setting up your materials, warming up, studying your subject, arranging poses and lighting, and planning compositions. I've also included some ideas to keep in mind while you actually draw.

You will also need to know something about artists' materials, so I've included a discussion of the special advantages of several kinds of drawing surfaces, as well as a number of popular media: graphite pencils, charcoal, colored pencils, pastels, chalk, oil pastels, pen and ink, felt-tip pens and markers, watercolor, collage, and mixed media. You will see one or two drawings done in each medium to give you a feel for its visual quality. I hope this media sampler will pique your desire to experiment with recording what you see.

OVERCOMING DRAWING BLOCK

In her well-known book *Drawing on the Right Side of the Brain*, Betty Edwards observed, "The majority of adults in the Western World do not progress in art skills much beyond the level of development they reached at age nine or ten."[11] Most adults have had a drawing block for a very long time because they still draw like children.

That leaves us right where we began this book: In order for anyone to learn to draw, he must first learn to really see what he is looking at. Most of this book has been concerned with giving you an analytical approach to drawing, because I have found that understanding exactly what you see and how you see it often generates great enthusiasm for drawing. This enthusiasm, along with the emotional commitment you feel toward you child, usually outweighs any negative or awkward feelings you might have about the act of drawing, and gives you the courage to experiment.

TRAIN YOUR RIGHT BRAIN Another, nonanalytical approach to drawing suggests that the artist must alter the task of seeing and drawing so that he approaches it freshly, viewing images as lines and angles and not naming them. This philosophy is the basis for *Drawing on the Right Side of the Brain* by Betty Edwards. Her book emphasizes the difference between the right and left sides of the brain and the type of thinking each side controls. Along with a discussion of the act of drawing as a right-brain task, there is a series of exercises and approaches to drawing designed to force the right side to take over, thus bypassing the left brain's stereotypical responses to what you are seeing. These are basically the same techniques that have been taught to students in art schools for centuries.

As Betty Edwards phrased it, "Since drawing a perceived form is largely a right-brain function, we must keep the left brain out of it. Our problem is that the left brain is dominant *and* speedy and is very prone to rush in with words and symbols, even taking over jobs which it is not good at."[12]

You can develop the perceptual skills of your right brain by practicing the exercises on the following pages. These techniques work by easing the conflict between what you are really seeing and what you think you *should* be seeing. They can also work to overcome any "I can't draw" block. Enjoy them!

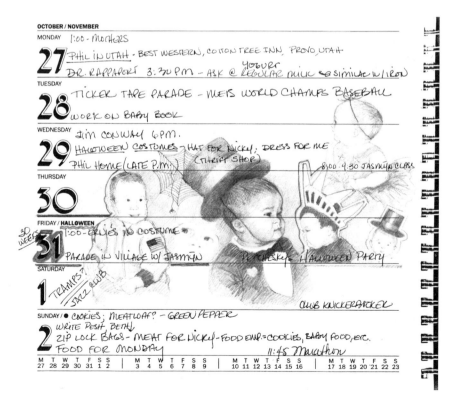

On-the-spot drawings can be done on any piece of paper with any drawing instrument at hand. Often they yield new insights because of their spontaneous quality. This sketch of my son's first Halloween party on a page from my datebook, the only paper available at the time, was embellished and doodled upon as I returned to the page during the remainder of the week.

In order to facilitate viewing images as lines and angles, try drawing a photograph as it is reflected upside down in a mirror. Remember to look only at the reflection and draw exactly what you see.

COPY IMAGES UPSIDE DOWN

Begin by copying drawings or black and white photographs. Rather than trying to copy these images straight on, you can short-circuit your natural (left-brain) urge to record stereotypical responses by drawing them *upside down*. This forces you to concentrate on the actual lines and shapes you are copying, instead of saying to yourself, "Now I am drawing a hand."

A variation on this exercise is to place a drawing so that it is reflected in the mirror and sketch it. This method can give you a more objective look at the relationship between parts of the drawing and the whole. Holding your own drawings up to a mirror is often an effective way of finding out whether or not corrections are needed.

PRACTICE CONTOUR DRAWINGS

Another way to loosen up the tension caused by confronting a drawing situation is to make a contour drawing. In a pure contour drawing, you draw the edges of a form without looking at the drawing while it is in progress. This is more an exercise in seeing than in drawing; the resulting picture is usually distorted, with lines jumbled on top of each other.

To do a pure contour drawing, you take your pencil loosely in your hand and focus your attention on what you are drawing, paying no attention to the drawing itself. Find an outside edge of the object and simply follow it around. Your nondrawing hand is a good choice of subject because it is interesting and always available. Simply keep your eyes focused on your subject, and allow your pencil to caress its contours. Whatever you do, don't check to see what your drawing looks like until it is completed! Some artists sit in a turned-around position, with their drawing hand far to one side and their head turned the opposite way, to make it impossible to see the paper. This is not necessary, however. It is more important to be completely comfortable and at ease, and not to try too hard. This is an exercise in seeing; it will be successful if it teaches you to give your undivided attention to your subject, no matter how the resulting contour drawing looks.

After doing a pure contour drawing, you might want to try a modified approach in which you are still concentrating on the visual information, but you are giving some attention to the drawing. Glance at what you have drawn once in a while to note whether or not the proportion of parts is correct.

When making either type of contour drawing, you move your pencil in unison with your eyes, imagining that you are actually touching the form as you draw it, the way a blind person explores an unfamiliar object in order to "see" it. Don't pause too often, but keep a slow even pace. And resist the urge to look constantly at what you've drawn.

The two modified contour drawings above are contrasted here with the pure contour drawing below.

USE PHOTOS Sometimes it can be helpful to draw from a two-dimensional representation of your child, such as a photograph, and then compare it with the real-life, three-dimensional image. Try taking a Polaroid snapshot of him asleep and tape it next to your sketching pad to refer back to while you draw him from life.

By sketching from photographs, you can also work on your drawing skills when your child is not around. In the early months, spare time and energy will be difficult to find, but as your child gets older, you will surely find yourself with the time to reflect on how fast he is growing and changing. Drawing from a photograph can be a special way of remembering a particular moment in his and your lives. It may also inspire you to make a memento with your drawing, such as those described later in this book under "Creative Applications."

When working from a photo, remember that you are still in control of the final image that you set down on paper. Editing out unnecessary or unwanted details is still an important part of creating an interesting drawing. As demonstrated in the photo and drawing on the facing page, even a good photograph with a pleasant composition should not be transferred like a carbon copy. Feel free to make your drawing more aesthetically pleasing than the photo by using what some people call artistic license. Artistic license is the power implicit in drawing whereby the artist can alter the real world to create his own reality—the reality of the drawn or painted picture. This is your prerogative. Don't be afraid to use it!

There are also several unconventional ways to incorporate a photo into an actual drawing; you may find some of these techniques less intimidating than drawing "from scratch" and thus a good way to warm up before sketching. For example, a photostat made from an original photo can be collaged onto with images cut from magazines and newspapers. Or try making a color Xerox of a photo you like, gluing it onto bits of random magazine background or some textured paper, mounting it onto a board, and then drawing and painting on the surface. You can make another interesting type of mixed media drawing by cutting up a photo print and a drawing of a similar pose, repositioning pieces of both into a new composition, and gluing them to a board. It is also possible to "draw" on a Polaroid photo as it develops, as illustrated on this page.

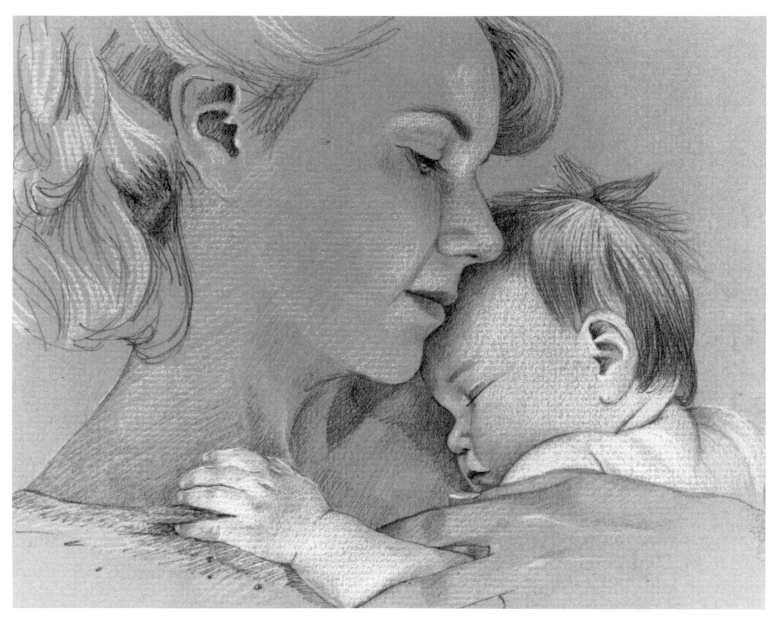

Opposite page, below: This SX-70 photo print was manipulated before the color and image were permanently set. To do this, place the print on a hard surface and use a blunt instrument to move the emulsion around under the plastic top, taking care not to break through the protective covering.

The drawing above was based on the top photograph on the facing page, but it further emphasizes the intimate relationship between the mother and child by focusing tightly on their faces. The point of greatest contrast is the area behind the mother's nose and lips, where her face casts a shadow on the baby's lightly colored forehead. The baby's hand is also highlighted against the shadows on the mother's neck. An unflattering chin line and awkward mouth have been altered through the use of artistic license.

DRAW NEGATIVE SPACES FIRST A drawing is composed of positive shapes (the object or person) and negative shapes (the empty areas around the object or person). The two fit together like puzzle pieces within the format of the paper. A pleasant composition is arrived at by concentrating on how these shapes share the space, giving as much attention to the negative as to the positive space. Most people spend all their time and energy drawing the positive shapes. This often leads to a sketch of a figure that looks as if it is falling off the end of the paper, or one that is trapped in an awkward place.

This gives rise to yet another way to practice your drawing skills: Draw the negative spaces first. The exercise demonstrated on this page emphasizes how important negative shapes are in creating an interesting drawing. The empty spaces in a sketch must be varied in size and shape. Also, if the negative spaces are precisely drawn, the positive spaces will also be correctly outlined.

To see the negative spaces in a sketch, start by finding a painting or drawing that pleases you. Be sure that the subject (the positive form) touches the edges of the picture in at least two places. Then lay a sheet of tracing paper over the artwork and trace the contours of the subject, including the edges of the picture as part of the negative space. Lift off the tracing paper and put it on top of a sheet of white drawing paper. Next darken in the negative spaces (the spaces around the subject) to enable you to see them as actual shapes. Look at the original painting and try to see the negative spaces as forms themselves.

When you can see the negative spaces and shapes without referring back to the negative-shape drawing on the tracing paper, try the same process with a drawing you have made. Keep the subject simple—perhaps a toy, or an article of clothing laid out on the bed, or a chair. As you look at the object you've chosen to draw, imagine it disappearing and leaving only the negative space that was around it to define where it was and how it was shaped.

Mary Cassatt, *The Bath*, 1891. Oil on canvas, 39½ × 26″ (100 × 66 cm). Copyright 1989 The Art Institute of Chicago. Robert A. Waller Fund. Used by permission. The negative spaces in this painting are as varied and interesting as the positive shapes they surround. If faithfully drawn, the contours of the negative spaces will correctly define the central subjects.

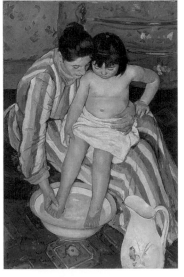

START EASY After you have practiced some of the exercises on the last few pages in order to loosen up, it is time to set up an actual sketching session. Make sure that you will have a certain amount of uninterrupted, quiet time. Your baby's naptime is a natural for this first session.

Many beginning artists feel intimidated by subjects they consider complex or especially appealing. You may feel uncomfortable starting right off drawing your baby, even if he is sleeping and very still, so begin by drawing another part of the pose: a toy, the drapery folds in his blanket, or some part of his clothing. From this you can work up to the various parts of his body, taking them one at a time. Remember, you do not necessarily have to begin by drawing your child's head.

Try a drawing in which you begin with your child's feet or torso and work up or outward to complete the image. This method works best with media that do not smear too much.

In this illustration I started with the stuffed animal and pillow in the lower right corner. Then I moved up to the feet and diagonally across the paper from right to left, ending with the head.

READY TO DRAW!

Drawing, unlike painting or printmaking, requires only a small amount of equipment and is not dependent on a studio. You can draw anywhere. Simplicity of approach should be your guideline for setting up a sketching session with as little clutter as possible, to avoid accidents or becoming distracted. Situate yourself in a comfortable position as close to the baby as possible without getting the visual distortion caused by extreme foreshortening. In the beginning, it is best to draw the baby in a pose that does not create a lot of perspective problems, as discussed earlier.

SET UP YOUR MATERIALS Be sure to have all your sketching materials handy before you begin to draw. Next to your sketch pad, have your chosen medium in as many shapes and variations as you might want to use, perhaps some other types of paper to try, and an eraser.

Safety note: If you are using charcoal or pastels, don't use fixative anywhere near the baby because it is very toxic to an infant as well as to an adult. If you need to fix a drawing during a sketching session, go into another room that is well ventilated, use the fixative, and return only after the fumes have dissipated.

To support your sketch pad you will need either an easel or a sturdy drawing board (a piece of plywood larger than your sketch pad that can be held in your lap). This board should be at such an angle that you are drawing on the same plane that you are viewing from. For example, if your subject is straight in front of you as you sit or stand, your board should be as vertical as possible, while still comfortable to draw on (see illustration). If you are looking downward into your baby's crib for an overhead view, the board should be horizontal. The idea is to place your paper so that you can constantly glance back and forth to compare your drawing with reality, without moving your head.

Warming up with your materials is also important. If you are going to be using more than one combination of medium and paper, make a few small sketches using each in as many combinations as possible. As you concentrate on the various effects you are able to achieve, you will find that your hand is more relaxed and your mind is more focused on drawing.

START WITH QUICK GESTURE DRAWINGS In art school, life drawing classes usually begin with the model striking short poses of 30 to 60 seconds. The students warm up by doing a series of gesture drawings. These quick sketches capture the essentials of the pose: the stance of the model, the major curves and arcs of the body, arms, and legs. Shading, indication of hair or clothing, or placement of the figure on the paper are not important because these are not finished drawings, but exercises. This way of working is meant to get your arms and hands used to moving in a fluid rhythm without the tense markings of detail.

When you move on to longer poses and sketching sessions of 30 minutes, you still should start with a modified gesture drawing. As you block in the figure for a longer pose, give consideration to the placement of your subject on the paper. Try to plan for interesting negative space as well as positive space, but don't let this interfere with the spontaneity of the drawing process. Study the proportion and shapes of the various parts, as well as the relationships between them. Learn from your gesture drawings that economy of line makes a much more expressive and powerful drawing than a lot of sketchy, unconnected details.

Whether you sketch from life, from a photograph, or from a combination of the two, prolonged observation is the key to success. Always give yourself at least 45 minutes of uninterrupted time to do even a tiny sketch, and spend 10 to 15 minutes of that time just observing your subject. Move around to get the best angle of vision, if necessary. Think about how you will place the image on the paper, what the focal point of the drawing should be, and how you will emphasize it.

As you move from drawing inanimate objects or drawing from photographs to sketching the real thing, you can refer back to the anatomy section of this book. Study your baby's head and try to see the facial and cranial masses and their relative proportions. With your eyes, "feel" the contours of his face as you trace down the forehead to the nose and over the septum, the lips, and the chin. Then swing back underneath to that tiny, wobbly neck.

Study his hands, feet, arms, shoulders, abdomen, pelvis, buttocks—every single part. Don't forget to see how each part articulates with the surrounding parts. Feel the muscles and layers of fat underneath the fine, soft skin. Do this without touching him physically, and try to discover the visual clues that indicate just how soft and awkward he is. If you have trouble seeing a certain pose—a particular turn of the head or twist of the body—put your own body in the same position and feel what happens to your own muscles.

These gesture drawings were done very quickly in charcoal on bond paper. In the central sketch only the sides of the torso and a few lines for the rest of the body were drawn at first. Then, as the child moved around striking similar poses, I completed the arms and legs. In the other two poses my son was asleep on his father's shoulder and taking a long drink from his bottle, so I had a longer period of time to observe and draw him.

Holding your drawing surface at an angle parallel to your subject enables you to compare your drawing with reality frequently.

FIND AN APPEALING POSE The key to setting up a good pose is deciding what mood or aspect of your baby you wish to capture. The intensity and location of lighting are very important in creating a mood as well as delineating mass and volume. Props can also add to the drama of a drawing, as well as serve to distract and occupy the child.

If you are creating a sketchbook of your baby that records the general itinerary of his rapid journey from infancy to babyhood to childhood, the following are just a few suggestions for possible poses. Among the things that a four-week-old baby can do are to focus on an object while on his back, and lift his head while lying on his stomach. At eight weeks, the first of his social smiles would be a lovely act to record, perhaps also showing how alert he has become. The first attempts at sitting up, cooing, and babbling occur at about twelve weeks, and at around sixteen weeks old, a baby is playing with his hands and reaching for things. Your sketch can show this exploratory nature and his infatuation with his own hands. By twenty weeks, a baby is laughing, and by twenty-eight weeks old he

may pat his own reflection. Later, of course, he tries to stand. Your baby will have his own timetable, but one thing is universal: The picture possibilities will be limitless.

Perhaps the best first pose for sketching, at any age, is the baby asleep. Seen against the background design of his crib sheet or surrounded by his toys in the playpen, you have the perfect subject for a still life. The very vulnerability of a baby—his dependence, fragility, and innocence—can provide tremendous emotional motivation for recording a moment in his life.

When choosing a pose, pay attention to the angle of vision. One option available with a sleeping child is the "ceiling shot," which is difficult without the aid of a camera unless your baby is on the floor and you are sitting on a stool or table over him. If your baby falls asleep on a bed or sitting up, you can take advantage of a low angle of vision by drawing him at his eye level or lower. This is different from the way we usually view children (that is, from above), so it is more intimate and personal.

No matter what angle you choose to sketch from, first check your baby's pose to make sure that he isn't in an awkward or rigid position. If you are all set up to sketch and your baby falls asleep in an undesirable pose, just gently nudge him and he will probably stir and rearrange himself. Then you can begin.

CHOOSE APPROPRIATE LIGHTING
It is much easier to create a clear drawing when your subject is illuminated by a strong directional light that makes obvious shadows. Of course, you can always draw out what you don't like in any lighting situation, but as long as you are in control, you might as well have the lighting help you to focus your sketch. The drama of a pose brought out by a strong light can get you excited about capturing the look on paper.

Study the lights and darks that are created as you move the light source around. Some lighting possibilities will be more interesting and more helpful in defining the form than others. Squint your eyes to increase this contrast and to aid you in defining the major areas of light and dark.

Safety note: Light bulbs warm up quickly, especially spotlights, and they can be very uncomfortable and even dangerous if placed too close to your baby.

Left: In this series of sketches, Poses A and B are ceiling shots. Pose A is the better of the two because the body is more curved. Pose C is an interesting low angle of vision; this would be a good pose to start with if you are wary of sketching the face.

Pose D is also appealing because you are almost nose to nose with the baby. Both the heaviness of his chin as it rests on his chest and the overhanging upper lip are very visible. Pose E seems the least unusual.

In this photo the light is very strong and from the left, creating deep shadows on the right side of the blanket and the child's head and body. Here the folds of the blanket are quite interesting, and there is an expressive medium range of values contained in the face, arm, and torso. The hand lying within the folds of the blanket and the compressed form of the left ear suggest a languid, deep sleep.

This photo shows the light coming from below on the left, and too close to the subject. The very white highlights are too strong for such a retiring pose, and should also alert you to the danger of overheating your subject. The light was also bounced by holding a white board across from the light source so that there would be more light and detail within the shadow areas.

Here the light is coming from the upper right side of the photo. This time the blanket becomes an interesting diagonal line across the picture plane. The hair gains texture, and the shadows cast around the body accentuate the coziness of the pose. The light glancing along the child's cheek, ear, and upper arm seems to caress him as he sleeps, accentuating the heaviness of his inert body.

PLAN YOUR COMPOSITION

Before you begin to draw, you must take a few minutes to consider how you are going to arrange your subject on the page. Decide on a vertical or horizontal format for your drawing. This may or may not involve turning your paper to accommodate the image. Try to develop a relationship between the parts of what you are going to draw so that they will work together in harmony. Just as the Greeks based their definition of perfect proportion (called the Golden Section) on the relationship of the parts to the whole, you must find some balance within your own work.

Sometimes you may see a strong geometric formation within your composition. For example, the use of triangular groupings gives a picture stability. Often the emotional content of a drawing will dictate the scale and placement of the central figure(s). A small figure surrounded by a great deal of space can heighten the feelings of loneliness and isolation, while an extreme close-up of someone's face can convey a sense of intimacy. In most cases it is wise not to place your main image directly in the center of the picture.

Place the elements within your format so that they will help to keep the viewer's eyes circulating within the picture plane. If the subject is looking out of the picture, leave more space on the side of the sketch toward which he is looking. For example, do not center a head that looks to the left; instead, place the head farther to the right and give it extra space to look into. This will keep the viewer's attention from sliding off in the direction of the subject's eyes.

You can help to bring the viewer into a picture by adding directional lines in the background or clothing that curve toward the center of the picture. Avoid using strong gestures or lines that point out of the sketch, and do not emphasize the corners. To keep your subject from seeming to slide off the bottom of the paper, allow some extra space at the bottom of the composition. A good rule is always to begin your sketch a little higher on the paper than you think is necessary. You can always come back and trim off the bottom if there is an excess of paper.

Phil and Nicky at Four Days Old. Pen and ink on board, 12 × 8¼" (30 × 21 cm). Artist's collection. This is the illustration I did for my son's birth announcement. The curve of the waistband on my husband's pants holds Nicky up visually, almost as if he were dancing on the rim. Even though Phil's elbows are cropped out of the picture, his arms encircle the infant. The parallels between the baby's right leg and the father's left arm, and between the baby's left arm and the father's right hand, emphasize the harmony between father and son. Not only does this pose accentuate the tremendous difference in size between father and son at this age, but the relative lightness of Phil's grasp indicates how small and light Nicky is to hold.

Trying to achieve a successful composition is largely a matter of trial and error. Experiment by placing your subject in different areas of your drawing in various groupings with props, and with a variety of features or items highlighted for emphasis. In this figure the sleeping child's face is at the apex of a triangle formed by his extended left arm and the line of demarcation between the white blanket and the darker sheet. These two converging lines bring the viewer's attention directly to the face, and the dark hair serves as a barrier to keep the viewer's eyes from floating off the top of the composition. The fingers of the right hand curling inward toward the face also act to focus attention where you want it.

Basically, this is a close-up version of the sketch above. I have hidden the extended left arm under the blanket to keep the viewer's eyes from exiting the picture along it. The viewer's glance will travel along the folds of the blanket in the lower right corner and flow counter-clockwise around the head; again, the curved fingers of the right hand will bring his attention directly to the face. Strong directional lines in the lower left corner will also help hold the viewer's attention and keep it circulating within the picture.

KEEP IN MIND AS YOU DRAW A line has many properties. It can be thick or thin, or both; it can be straight or curving; and, depending on the medium you are using and the pressure of your hand, it can be dark or light, or a combination of the two. When your are drawing from life, variety and change in the quality of the line are preferable, as are sinuous, curving lines. This is what occurs in nature. Save the mechanical look of uniform lines and rulerlike precision for technical subjects such as architectural drawings. Even if something looks straight, make it curve ever so slightly. Avoid outlining the figure or anything that you draw. Generally, areas that receive more light should have lines that are appropriately lighter than areas in shadow. If you do not vary the strength of your line by changing either its width or its value, you will end up with a cartoonlike image, especially if the outside contour line is dark.

If there is an angle that is particularly difficult to capture on paper, take a Polaroid snapshot of your child in that pose and study it. Copy it and see how the lines you use to trace the two-dimensional image work to convey reality. How do you know that one thing is behind another? On top of another? What was the hardest aspect to translate into a drawing—the fact that your baby is round and not flat? If he is looking away from you, how is it that you can still recognize him? As long as you keep up this dialogue, you will be teaching yourself how to see and thus how to draw.

A final word before beginning: Relax and enjoy this time! Concentrate on seeing and don't worry about how the final drawing is going to look. Play your favorite music or music that fits the pose and feelings you are trying to evoke. Dress comfortably and perhaps brew a pot of tea—although you may get so absorbed in drawing that you forget to drink it!

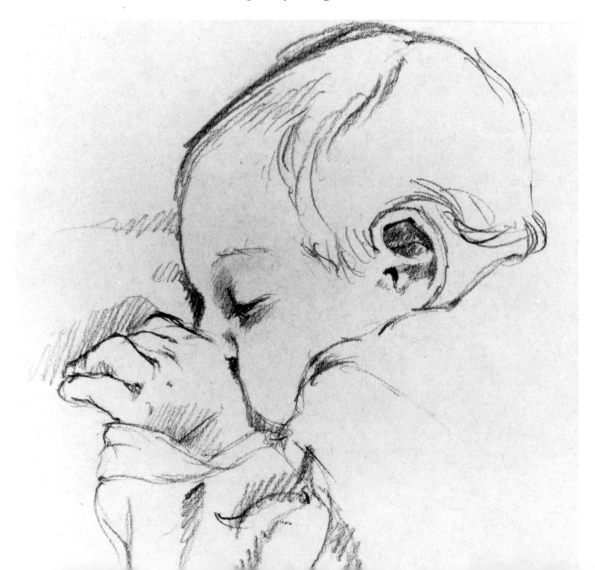

As you draw be conscious of using a variety of different lines: dark and light lines, thin and thick lines, and lines close together as well as lines far apart. Variety and contrast of lines add interest to a sketch.

MATERIALS

When a baby is your model, speed in sketching is essential (unless you are working from a photograph). A 2B pencil on plain, smooth, white paper can be the best combination for making a simple line drawing. All the drawings in the anatomy section of this book were made just this way. The softer drawing media, such as pencil, charcoal, and pastel, are the best to use in your first attempts because they flow more easily over the surface of the paper. Being forced to work quickly need not be a handicap, but it is important that your materials work with you, not against you. Sometimes, in order to capture a fleeting moment, you may have to rely on materials at hand. These on-the-spot sketches can have a special look and, in forcing you to be inventive, they may yield new insights.

The key with all the media is to practice with them and experiment! Begin with either a soft lead pencil or charcoal and concentrate on line and shape, leaving the addition of color and detail until later. Choose an inexpensive paper; newsprint pads, even rolls of butcher paper are good choices. Try making some random marks such as lines, tones, and basic shapes with your pencil or charcoal to see which surface and medium give you the greatest freedom of expression. It is important not to let the frustration of awkward supplies distract you from concentrating on what you are drawing.

TYPES OF PAPER
Drawing paper comes in an enormous range of weights, textures, colors, and sizes. As mentioned earlier, I recommend starting with inexpensive paper so that you feel free to use it liberally. (Trying to conserve expensive supplies is no way to unleash your creativity!) One exception: If you are planning to add watercolor or any other kind of wash to a drawing, make sure the paper is heavy enough not to buckle when wet.

Once you have warmed up on newsprint or whatever cheap paper suits you, experiment with the many kinds of better-quality drawing paper available. The same sketch can take on a different character depending on the paper used. The paper and medium you choose for a particular drawing should work well together and will depend on the mood you are trying to convey.

You will also want to experiment with drawing on colored surfaces. The unnatural flatness of a white background creates problems in many color drawings, whether you are using colored pencils, pastels, chalk, or paint. White is often too much of a contrast to modulated color. Because it is expansive, white tends to come forward, creating a conflict by not staying behind the colored foreground. Also, too much white in a composition will diminish the luminosity of nearby colors. A natural solution to this problem is to work on a colored surface. There are many colored papers and boards to choose from. A few suggestions:

Canson Mi-Teintes. This medium-weight pastel paper, illustrated on the facing page, is available in thirty-five colors of varying values and intensities. Mi-Teintes can be mounted onto board if more support is needed. It is very light-resistant, but *any* paper or board should be stored away from the light and never exposed to direct sunlight for an extended period of time.

Colored mat board. You will find a wide range of colors and textures in this general category.

Hand-colored boards. This is the colored surface that you prepare yourself, on any surface, by covering illustration board with a light wash of watercolor, diluted acrylic, or oil paint before you begin. You can also go back over a drawing and lay in a wash to lessen the white of the background and add strength to previously colored areas.

Note: When you work on colored papers with pastels, pencils, or chalks, you will notice that the color of the background affects the medium's relative brilliance. Try experimenting with a range of colors on different papers and you will be surprised by the lovely effects that can be achieved only in this way. (See the illustration on page 98.) Also, working with lighter values on a darker paper is wonderful for dramatizing highlights. This technique can create a luminous quality similar to that prized by the old masters.

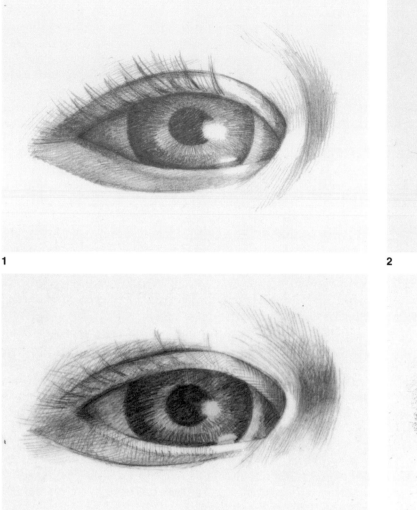

1

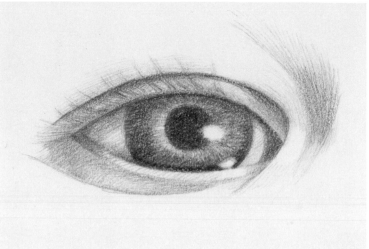

2

3

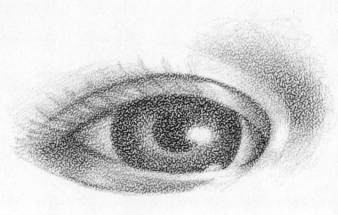

4

These sample sketches of an eye were all drawn with an F grade pencil. A few were then enhanced with other media, as specifically noted. See how different the finished sketches look!

(1) *Strathmore hot-press* is a white, slick paper that shows up sharp pencil lines.

(2) *Strathmore cold-press* is a white, finely textured paper that softens the pencil linework and allows for more smudging.

(3) *Dendril vellum* is a semi-transparent paper that takes the pencil well, leaving a sharper indication of linework than the cold-press, but a softer image than the hot-press. I also applied some medium gray marker to the iris area and shadows of the eye on the reverse of the paper, taking advantage of its transparency.

(4) *Coquille (rough)* is a white paper with a patterned, glossy surface. It is shown to best advantage if the pencil is used to bring out the paper's patterned surface gradually. Care must be taken not to squash the grain of the paper by pressing too hard.

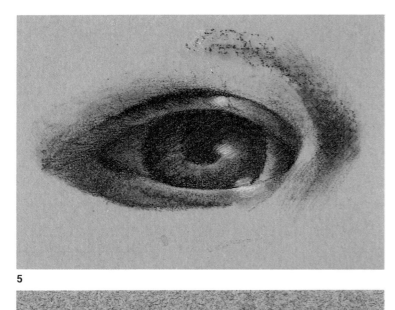

5

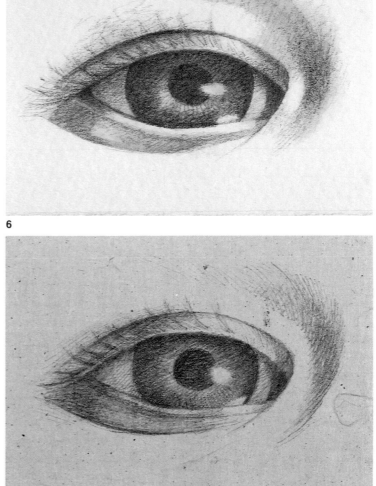

6

7

8

(**5**) *Canson Mi-Teintes (oyster)* is a very distinctively textured pastel paper that lends itself to smudging as well as to the use of white charcoal pencils for creating highlights. Because of the color of the paper, I chose to use a sanguine conté crayon along with charcoal and graphite pencil.

(**6**) *Arches rough watercolor paper* has a texture that can be brought out by applying the pencil in a circular fashion when laying in shaded areas. I also use a light wash of india ink diluted with water over the eye and shadows. It is important to note that the addition of a wash on most papers significantly changes their surface characteristics.

(**7**) *Rice paper* is generally used for printmaking and is usually very absorbent. This particular paper was coated and therefore less absorbent. Rice papers come in many styles—from Toyama and Kaji, which are relatively plain, rough-surfaced papers, to Haruki and "T" (Fuji) Unryu, with many fibers visible underneath the surface. The irregularities on the surface give the drawing interest.

(**8**) *Canson Ingres Vidalon* is a gray-flecked charcoal paper that serves as a medium-value background from which highlights can be picked out with a white charcoal pencil. In this sketch charcoal pencils 2B and 6B were added to the pencil underdrawing, all of which smudged nicely and left a rich, dark black.

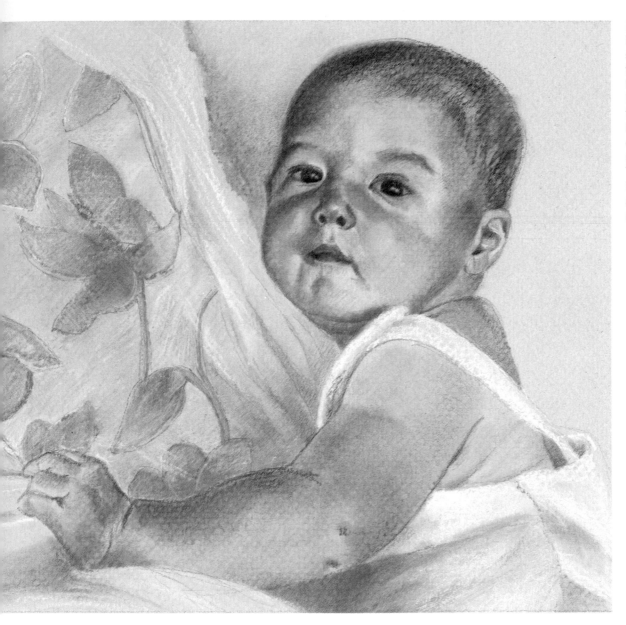

In this drawing I was interested in recording the confidence and strength evident in my son at three months. Here he is holding his head up very erect and looking straight into the eyes of the viewer. I also wanted to echo his triumphant mood in the colors of his skin and in the pattern of the surrounding fabric. The tan paper provided a neutral background tone that served as a foundation for the colors of the drawing.

GRAPHITE PENCILS Pencils are available in many degrees of hardness and softness, ranging from 8H (the hardest) to 8B (the softest). The pencil midway between these two extremes is the HB pencil. Then on either side come the H and B pencils (just slightly hard and slightly soft); the next two gradations are 2H and 2B, which are a little harder and softer than the H and B pencils, and so on. Regular writing pencils come in four degrees of softness: numbers 1 through 4, with the number 2 pencil the equivalent of an HB art pencil. Number 1 is a little softer and the number 4 is the hardest in the series.

Originally, the drawing pencil was simply a stick of graphite. Not until the eighteenth century did pencils develop into their present form: a core made of graphite, clays, and other fillers inserted into wood. You can still buy graphite sticks for filling in large areas.

The softer the lead of the pencil, the darker the marks on the paper will be. Also, the softer leads smudge and blend, whereas the hard leads are difficult to blend and erase because they tend to incise the paper. Different pencils can be used within the same drawing—harder pencils for the linework and softer pencils for the shading. In general it is best to use a less textured paper with graphite pencils, although interesting effects can be produced with rough paper. Do not to get too precise when using pencils, or your work will look stiff and unimaginative.

Make sure all the pencils you buy have leads well centered in the wood shaft. If the lead is off center, it is more likely to break frequently when it is being sharpened. Also avoid pencils whose shafts contain more than one color of wood; the different colors indicate different densities. Such pencils tend to splinter and get caught in the sharpener because the softer wood grinds faster than the harder wood. You can buy pencil extenders that can be added onto the flat end of a pencil when it has become too short to sharpen or work with comfortably.

Kneaded erasers are the best all-purpose art erasers. They can be used to erase larger areas of pencil without damaging the surface of the paper the way a hard gum eraser or a plastic eraser would. The kneaded eraser can also be shaped into a point for more precise erasing in small areas. Blotting with this eraser is often more desirable than stroking it across your drawing. Erasing with a heavy back-and-forth stroke smears adjacent linework, while blotting can lessen the harshness of a line without disturbing the surrounding lines and, if desired, leave a feeling for the sketching process intact. Kneaded erasers can be reused after a little kneading with the fingers. Try to keep all your erasers in a box or on a clean surface away from your drawing, because they can easily pick up particles of pencil that will leave heavy streaks on your paper if you accidentally erase with them embedded in the eraser.

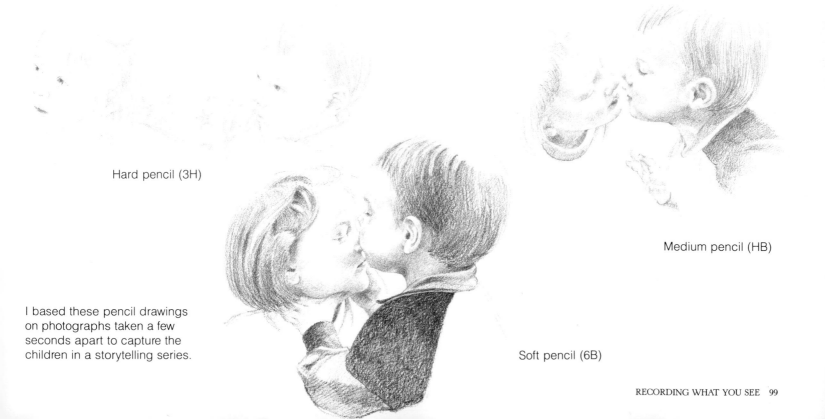

Hard pencil (3H)

I based these pencil drawings on photographs taken a few seconds apart to capture the children in a storytelling series.

Medium pencil (HB)

Soft pencil (6B)

CHARCOAL Charcoal comes in various forms: compressed charcoal, a solid stick of charcoal with various grades of softness (#1 being the softest); vine charcoal, a very light charcoal stick that lays down the finest dusting of charcoal (it looks like a thin vine, hence the name); and charcoal pencils, charcoal in pencil form with different grades of softness much like those of graphite pencils. Charcoal pencils offer more control and are cleaner to work with than vine charcoal or compressed charcoal sticks. As with graphite pencils, the softer the charcoal, the darker and more easily smudged the line.

When drawing with charcoal it is best to work from the top of the composition to the bottom of the page to avoid smudging the work unintentionally. Another way to cut down on the accidental smudges that can be the curse of working in charcoal is to work with

your drawing board as close to vertical as possible, so that the stray particles of charcoal will tend to fall away from the artwork rather than lie on it. Also, I often keep a folded Kleenex tissue under my drawing hand to ensure that the oils from my skin will not discolor the drawing.

It is important to fix the finished areas of a charcoal drawing with fixative (a thin varnish sprayed onto the surface of the paper to form a protective film). The fixative allows you to build up layer upon layer of the medium, and it is the only way to achieve a truly dense black.

Another way of working with charcoal is to use a kneaded eraser in the positive/negative technique, in which you erase into a drawing surface that you have covered with a layer of charcoal. After creating a background of a flat, medium-gray tone, you can bring

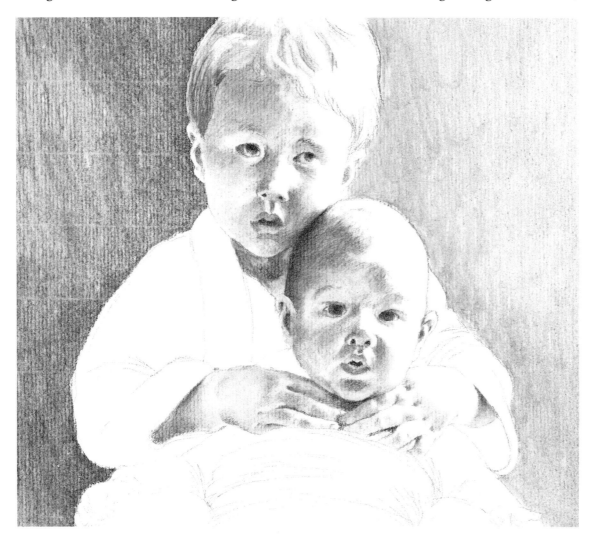

This sketch was done with a number 2 pressed charcoal stick on white charcoal paper. Because the medium is so soft and dense, the lines and shadows created are quite dark and pick up the fine vertical lines of the paper's texture.

out highlights and paler tones by erasing away some or all of the background in selected areas.

Charcoal can instantly create deep, dramatic blacks on almost any surface, thus offering an inspiring beginning for the more painterly additions of turpentine and charcoal washes. If you wish to use turpentine washes on your charcoal sketch, you must give some thought to the appropriate paper before starting to sketch. Because turpentine dries almost instantly, it doesn't buckle paper as much as watercolor washes do. But turpentine is very abrasive to paper, especially if you go over an area repeatedly. Therefore, you need a heavier paper with a sturdy surface. A good quality, two-ply bristol board is sufficient.

As with other media, the paper will influence the look of both the charcoal linework and the turpentine washes. You might choose a slick-surfaced, hot-press bristol board, a textured, cold-press board, or even a rough bristol board. With turpentine, use only the brushes intended for oil paints, and never mix your oil-painting brushes with those you use for watercolor.

Charcoal can be shaved off a stick into a pan of turpentine, mixed, and then applied to the paper surface. After laying in a wash of turpentine, you can still smudge into the wet areas using sponges, Q-tips, cheesecloth, and even your fingertips for various effects and textures. It is also possible to erase any mistakes after the turpentine dries.

After you finish working, fix your sketch with fixative—but remember, use it only in a well-ventilated area far from your baby. Wash out your brushes in clear turpentine and then in warm, soapy water. Store them, as always, away from harsh heat and light.

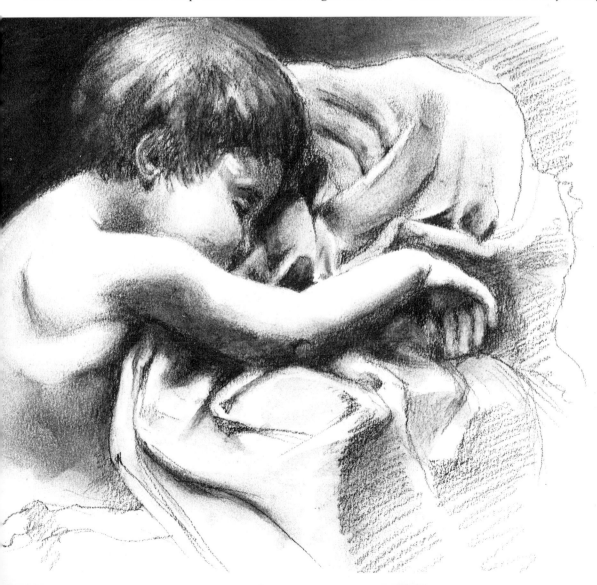

Child Asleep. Charcoal and turpentine washes on white Strathmore charcoal paper, 8½ × 9¼″ (22 × 23.5 cm). Artist's collection.

This drawing was based on a photograph by Arthur Leipzig from the book *The Family of Children*. I am often inspired by a painting or a photograph. After analyzing the work to figure out why it caught my eye, I try to apply that knowledge to a similar pose that I set up myself.

After completing the charcoal linework using a 2B pressed charcoal stick, I mounted the charcoal paper onto hot-press illustration board with rubber cement. With a number 4 round, white-bristle oil brush dipped in clear turpentine, I blended areas of charcoal outward from dark to light. Other washes, especially those in the darkest areas, were created by rubbing an area in the paper margin with charcoal and then rolling the turpentine-dipped brush into the charcoal first before painting with it on the board.

COLORED PENCILS In contrast to graphite pencils and charcoal, which are the perfect mediums for fast, on-the-spot sketches, colored pencils are best for drawings that are much more carefully planned and rendered. The impressive selection of colors, along with the pencils' semitransparency, makes practically any color possible either directly or through blending.

Colored pencils are easily controlled and come in two basic widths. The two brands I use are the thin Berol Verithin and Derwent Studio pencils, and the thicker Berol Prismacolor and Derwent Artists pencils. The thin leads are harder than the wider leads, but neither type of colored pencils can be smudged as easily as soft graphite lead pencils. My favorite pencils are the Derwent Studio, although I like certain colors in the Berol Prismacolor line. Berol also makes a broad stick version of most of its colors— crayonlike sticks that can be used to lay in large areas of color. Be sure that a flat surface of the pencil stick remains squarely against the paper surface when you lay in color. You will have to bevel the tip slightly to accomplish this because the sticks come with a squared-off end.

Several brands of colored pencils are water-soluble. This extends the effect of the medium into the range of watercolor. It is possible to get some lovely effects with these pencils by washing colors into each other or softening the linework by painting over them with a clean, wet brush.

In general, colored pencils are used to fill in color, but they can also be the primary drawing instrument. By simply using one color of pencil for each area of a drawing, you can quickly suggest local color. (This is the simplest way to add color to a graphite pencil drawing.) Using darker colors for objects in the background will create a feeling of depth, because darker colors appear to recede. However, using one color at a time creates a rather flat and uninteresting look to your drawing because the eye does not see color as something flat and static. Color is reflected light, and light is constantly changing.

When working with colored pencils, you can counteract the rawness of a color used singly by juxtaposing it with colors that relate to or interact with it. This is done by layering and physically blending two colors together, by layering a third color on top, or by laying two or more colors down next to each other so that they optically blend in the viewer's eyes. These techniques let you suggest the complexity and depth of color in the real world. (A basic understanding of how colors are related is essential if you are to layer them successfully. You may find it helpful to refer to the color wheel on page 78.)

Because the texture of the paper you work on with colored pencils is emphasized by rubbing the pencils across its surface, the choice of paper is critical to the look of your drawing. Generally, a paper with tooth is best because it catches the color more easily. Using tinted paper of the same hue as the pencil lead, or shading with a pencil over a watercolor wash of its complement, can produce subtle effects. There are also some papers that take the colored pencils well without a lot of strokes, and these will give you more flexibility and speed. When selecting papers for work with colored pencils, be sure to try the pencils on the surface if possible, and test *both* sides of the paper. Often the backside of a paper will be preferable. The following three types of paper surfaces will yield very different results:

Cold-press bristol board or cold-press illustration board. As discussed earlier, this is a medium-grained paper. The colored pencils, when used with medium pressure, will color only the relatively rigid high spots of the paper's tooth, leaving the valleys white in between and giving the colored areas a white-flecked appearance. The tiny white flecks can be filled in only by making many strokes over the area with heavy pencil pressure, or by working with a very sharp pencil to deposit color slowly in the valleys of the paper surface.

Rising museum board, Pacifica museum board, or Stonehenge paper. These papers offer a faster working surface for medium to heavy pencil pressure. Stonehenge is a printmaking paper that comes in tan and different shades of white. The museum boards come in many colors.

Translucent frosted-polyester tracing film. This is the fastest surface of all. The pencil can be applied to either side and the strokes are immediately dense and saturated with color. There is no apparent texture and the overall appearance is very painterly. An example of this type of paper is Dendril.

The blending of colored pencils can be a slow and tedious process in which the artist applies layer after layer, blending and flattening the texture of the paper until it is smooth. By using softer papers that take less time and pressure to break down—or by using Dendril, which has no texture—you can work much more rapidly. There are also ways to use line in conjunction with tone to speed up the process. Often just by adding a few loose lines or some decorative strokes of contrasting color over or under an area of colored pencil tone, you can achieve a measure of complexity.

If you wish to spray your colored-pencil artwork with fixative after you have finished, be sure to do a strip test of the different prominent colors to see how they are affected by the fixative. Many colors change *dramatically*, and often the fixative intensifies any grainy texture that is left on the surface. Of course, this can also be used to advantage. Screen or mask over the areas you don't want affected with tracing or frisket paper to ensure that you get the spray only where you want it.

Colored pencils also work well with felt-tip pens. For more on this technique, see "Felt-Tip Pens and Markers."

To this pencil sketch of Nicky on his father's shoulder, I added a single layer of colored pencil to the face. Applying color only at the focal point of a drawing and gradually fading the color outwardly is very compatible to the way we actually see. The color receptors in our eyes are located at the center of our vision, so that when we look at something, the color is more intense at the center of our field of vision and the periphery appears almost colorless.

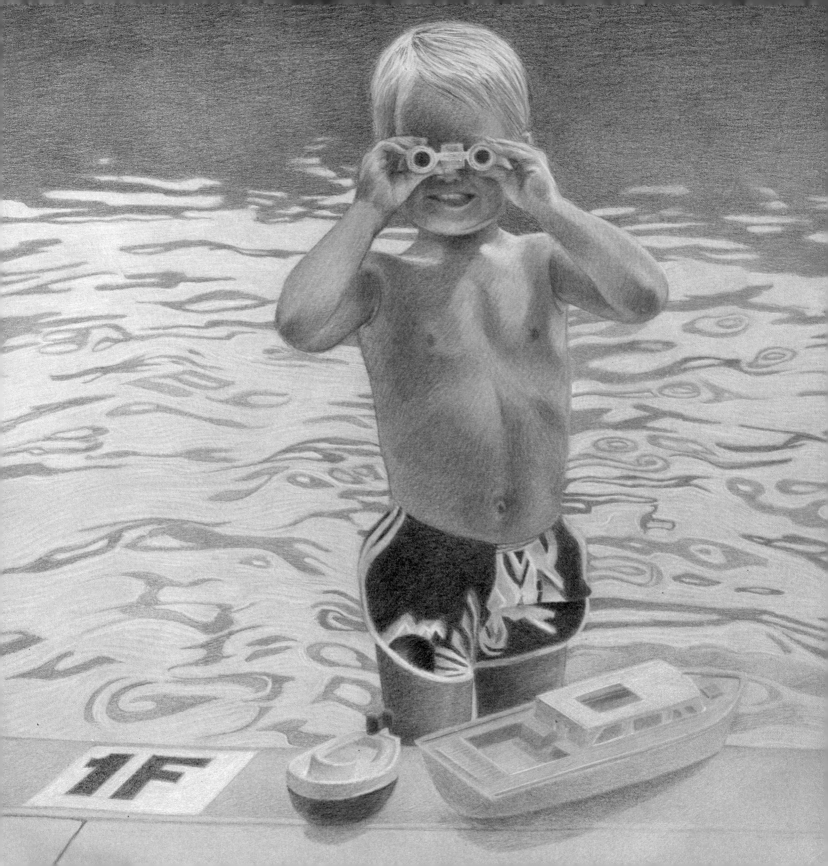

Traver's Island. Colored pencil on tan Stonehenge paper, 10¼ × 11″ (26 × 28 cm). Artist's collection. The illustration on the facing page demonstrates the complexity of color that can be achieved by layering colored pencils. First I laid in the darkest area of the background using a Prismacolor broad stick, true blue 1903. (All colored pencils are Prismacolor unless otherwise stated.) Then I went back over the area with pencils of the same color to even out the tone. If you use a contrasting color to modulate a larger color area, it is very important to feather that color out so that it doesn't create a shape within the other color. The viewer's eye picks up even the subtlest extension of color in much the same way that it picks up echoes of color spread throughout a composition. Be aware of this principle and use it to your advantage.

The pencils used in the water background were indigo blue 901, Copenhagen blue 906, true blue 903, light blue 904, aquamarine blue 905, and Derwent water green 44. The foreground water swirls were Copenhagen blue, aquamarine blue, and white 938.

To simplify my color schemes, I tried to think of each object as having three basic color tones: a general medium value of the overall hue, a lighter value, and a darker value or shadow tone. The three basic colors used in the flesh were cream 914 (the lightest value), Derwent terra cotta 64 (the medium value), and Derwent copper beech 61 (the darkest value). Other pencils were used in transition areas.

Here is a sampler of techniques for colored pencil layering. From top to bottom: (**1**) Mixing colored pencils on illustration board. Note the texture created by the tiny white pockets of paper showing through. (**2**) Modulated color created by inserting a second color into an area, rather than blending the two colors together over a broad expanse. One color is used only in selective spots. This technique adds interest by preventing the area from looking too flat. (**3**) Mixing colored pencils on polyester film greatly accelerates the blending process. These two colors were blended here in one third of the time taken to combine them in method 1 above. (**4**) Subtle effects can be produced by layering pencil on top of a watercolor wash of a similar or complementary color. The colored pencils used in this demonstration were Berol Prismacolor true blue 903, light green 920, and Winsor & Newton cobalt turquoise artist's water colour 078.

PASTELS Pastels are one of the most popular color media for beginners and are better for bold, loose drawings than colored pencils. They are made from powdered pigments mixed with enough gum or resin to bind them into sticks or pencils. Pastels are usually softer than other pencils or chalk, are graded as hard or soft pastels, and come in pencils as well as sticks. The soft pastels tend to crumble easily. In general, pastel sticks are more suitable for broad areas, whereas pastel pencils yield a finer line because they can be easily sharpened.

Pastels can be smudged with your fingertips, a chamois, a kneaded eraser, or a paper stump. You can achieve a variety of textural effects by using different widths of lines, amounts of pressure, and methods of blending colors—or leaving them un-blended. To avoid accidentally smudging your drawings, always work from top to bottom of the paper, and rest your drawing hand on a piece of scrap paper.

Pastels are most often used on pastel paper, which has a textured surface and comes in many colors. The main disadvantage of pastels is that they produce rather insubstantial lines that must be built up through the use of fixative and successive layers in order to define a subject properly.

Regular pastels can be spread and mixed with either a watercolor wash or a turpentine wash to create different tonal variations within a drawing. However, if you are considering adding a wash to your drawing, be sure to use a heavier weight of paper so that it will not buckle when it is wet.

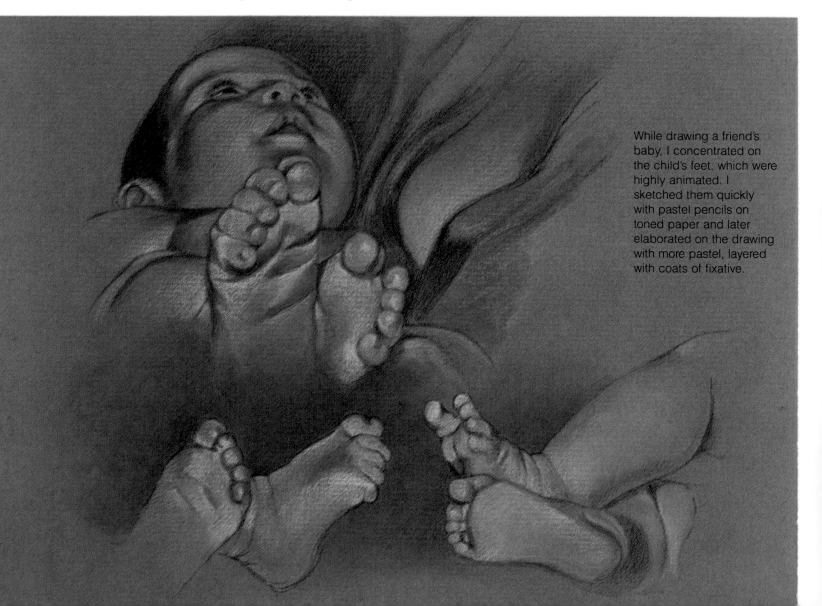

While drawing a friend's baby, I concentrated on the child's feet, which were highly animated. I sketched them quickly with pastel pencils on toned paper and later elaborated on the drawing with more pastel, layered with coats of fixative.

CHALK Chalk is a harder medium than pastel. The pigments are mixed with wax or oil. Conté crayons (a type of chalk) are square-sectioned drawing sticks now available in a wide range of colors. They used to be available only in black, red (sanguine), brown (bistre), and white. They are used more in the manner of pencils than pastels because they are hard and not easily blended. Because of the inflexibility of chalk and conté crayons, the same caution against tightness that applies to using hard pencils applies to these media also.

Although chalk seems to be a difficult and rigid medium, some of the best-known drawings of the masters—including Michelangelo, Toulouse-Lautrec, Watteau, and Rembrandt—were done in this medium. The great pointillist painter Georges Seurat used chalk on a coarse-grained paper and was able to achieve a look that closely approximated his pointillistic painting method. With chalk, as with any hard medium, a natural grading of tones will occur as the pigment is worked more or less thickly into the grain of the paper. The choice of paper for use with chalk depends on the amount of texture desired in the drawing, and on whether other media are going to be used in conjunction with the chalk.

Try comparing the different qualities of regular pastels, oil pastels and chalk by making similar marks with each medium on the same paper, and study the results. I find that pastels give the most flexibility, oil pastels yield the richest and most translucent colors, and chalk is the most precise. Each has its own characteristics and can enrich your artistic repertoire.

This is the same mother and child as on facing page. You can see that the chalk enabled me to make more precise lines, but the color added to the interior of the figure was not as easily blended. This gives the chalk drawing a more rigid look than the pastel.

From top to bottom, here you see a comparison of regular pastels (Grumbacher), oil pastels (Sakura pink 120 and Naples yellow 9), and chalk (Conté a Paris pink 11 and beige 47). Note the differences in line quality and blending.

OIL PASTELS

Oil pastels are made from a coarser pigment than regular pastels and have oil added as a binder. They come in stick form and are relatively clumsy to use, although a fine line can be achieved by pressing lightly on the side of a sharpened stick. They are better for larger drawings rather than sketchbooks.

With oil pastels, as with regular pastels, it is essential to work from top to bottom of a sketch, and also to use paper under your drawing hand to prevent accidental smudging. Oil pastels are often used on a colored surface, but on white paper or board the vibrant richness of the transparent oily colors really shines through. You can create different textures of tone depending on the surface of the paper you use and whether you work with or against the grain. Coquille paper and coarse-grained pastel paper enable you to create a pointillistic effect.

Unlike regular pastels, oil pastels cannot be mixed with a water-color wash. However, they can be diluted and smeared with turpentine to achieve a painterly look, as in the illustration on page 51. The same papers and brushes will work well for both charcoal and oil pastels.

After establishing your own drawing, a good way of working is to color in some bold areas and then, using the brush dipped in clear turpentine, move the color around by feathering out harsh outlines and blending together adjacent areas. You can also draw over these painted areas with different-colored oil pastels and repeat the process as often as the paper surface will allow. The wet turpentine wash can be smeared with your fingertips, and you can even scratch down through layers of pastel with something sharp to create negative texture or linework and expose underlying colors. The surface of an oil pastel wash will accept other media such as pencil or chalk. Oil pastels can be applied almost like oil paints. First dip your turpentine-laden brush in a swatch of color that you have created with the oil pastels on a palette or separate sheet of paper. Then paint with the mixture of color and turpentine.

This is a very bold medium that works nicely as a contrast to a more controlled medium, such as colored pencils. I sometimes work on several versions of a pose in a loose manner, using a bold medium such as charcoal or oil pastels with turpentine washes. Then I leave them for a day or two and when I can see them freshly, I will know instinctively where a little bit of controlled drawing or contrasting texture is necessary. For example, in the drawing on the facing page I added the ink-stamped texture at the top of the composition after I had put the oil pastel drawing away. Upon reexamining it, I realized that there was too much white space diluting the image.

Above: This study demonstrates several techniques for oil pastel. (1) Use the corner of the oil pastel stick for crisp, fine lines. (2) Use the blunt end to lay in color over a large area. (3) Blend colors together by layering one on top of the other using pressure. (4) For a smoother blended look, use turpentine to combine colors.

Right: Oil pastels were a natural choice of medium for this sketch, in which I was trying to capture the vivid colors of Nicky's clothing and surroundings, and the high contrast of light and shadow on his face caused by bright sunlight streaming into the room from high above his left shoulder. Note the contrasting textures achieved by overlapping long, firm strokes in the hair; by making spiral squiggles for the doll's hair; and by using gentle pressure to convey the soft feel of his shirt. The rubber stamps at the top were added later to introduce some contrast to the thick bold lines of the drawing and to fill in some of the negative space.

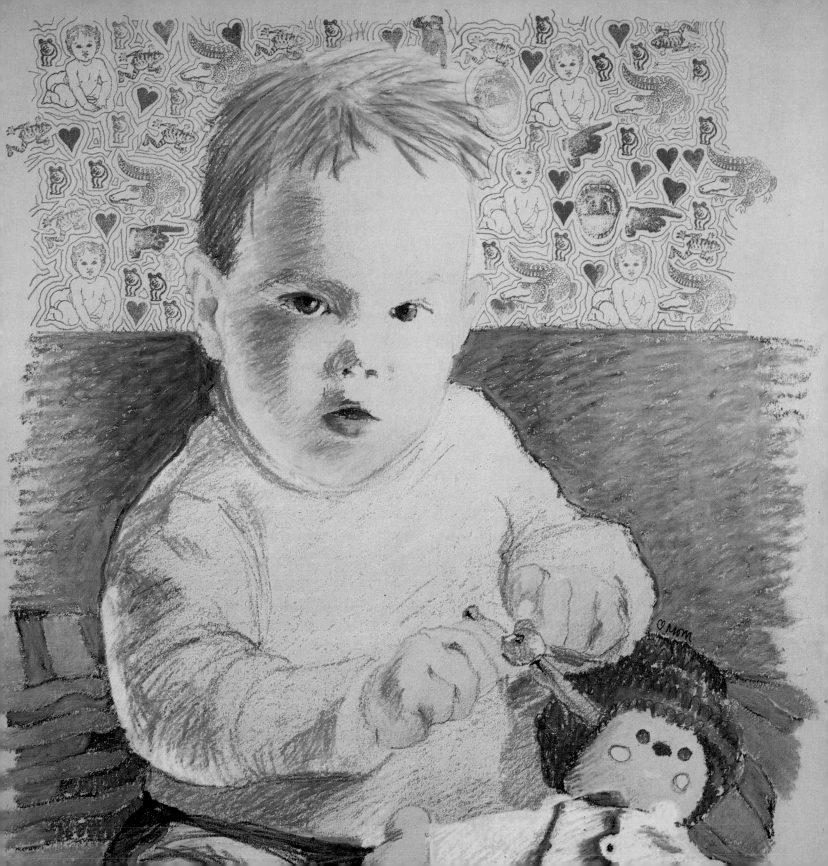

PEN AND INK Pen and ink is best for exacting, precise drawings, especially if the artist uses a pen with an ink-dipped nib. The nib holds very little ink, making frequent stops for redipping and reconsideration of the work necessary. Also, the wide range and permanency of marks possible with the flexible point dictate a concentration and control in the drawing itself.

Pen and ink can be very versatile after you have gained a certain familiarity with each pen nib, so that the amount of pressure needed to produce a certain line width becomes automatic. Besides the flexible nibs that create lines of varying widths, there are pens with interchangeable nibs of specific widths. With these pens you can also create uniform dot patterns and pointillistic effects.

Other styles of pen-and-ink drawings can be made with cartridge pens, which ensure both a consistent point and flow of ink, but these pens tend to produce work that looks slick and insensitive. This effect can be countered by the addition of an ink wash for tone and a more spontaneous look.

The quality of pen line, as with all media, is affected by the type of paper used. Usually a plate or hot-press (smooth) finish on the paper is preferable, so that whatever point you are using glides easily over the surface. An illustration board prepared with gesso (a white primer) or acrylic base is also a good surface for pen and ink. It enables you to make corrections by overpainting mistakes with fresh acrylic paint and reworking on the newly painted area. Various opaque white correctives are also available. If you are working on illustration board rather than paper, you can even

scrape off the top surface (removing unwanted pen lines) with a sharp razor or X-acto knife.

After sketching with pen and ink, you may decide to add more dimension to your drawing by introducing some ink washes. The sketch must be done on a paper or board that will withstand the addition of washes without buckling. Waterproof ink will not run when washes are applied over it. This is important if you want to preserve the look of the original sketch, although interesting effects are possible when you destroy or feather linework done in water-soluble ink. Each black ink has its own distinct color—some are warm, others are cool. You could also use a black made from watercolor paints or colored inks, but for your first drawings it is a good idea to keep it simply a black and white composition.

The same cautions for watercolor paintings apply to ink washes, with the added precaution of determining the quality of your ink. Wash over a large area with a mixture of ink and water diluted to a medium value. Check to what extent the ink separates into granules from the water; this usually happens if the ink is not uniformly mixed with the water, or if the ink wash is allowed to dry out somewhat in your mixing pan and is then remixed. When this test has dried, you will see how evenly the ink you are using covers the paper. After a layer of wash is dry you can even out some of the discrepancies in tone by lightly erasing over the surface with a kneaded eraser. You can use the same brushes you use for watercolor, but be sure to clean them thoroughly with warm water and mild soap. Never allow ink or paint to dry in your brushes.

Left: *Nicky in His Room*, Version 1. Fine-point technical pen and ink on cold-press illustration board, 7¼ × 9¾″ (18 × 25 cm). Artist's collection. To contrast the consistent quality of the linework, I spattered the area of wall in the background by using a toothbrush dipped in the same ink while other areas of the drawing were masked off.

Right: *Nicky in His Room*, Version 2. Ink on Strathmore cold-press illustration board, 5⅜ × 8″ (14 × 20 cm). Artist's collection. This is the illustration above with the addition of washes of Higgins waterproof india ink done with number 7 and number 10 sable round brushes. Because the original drawing was done in waterproof ink, it did not run when washes were added. The addition of tone softens the modeling on the face and further focuses the viewer's attention on the chair and the child's face by giving them the lightest values in the composition. This drawing is also cropped in more tightly than the first one.

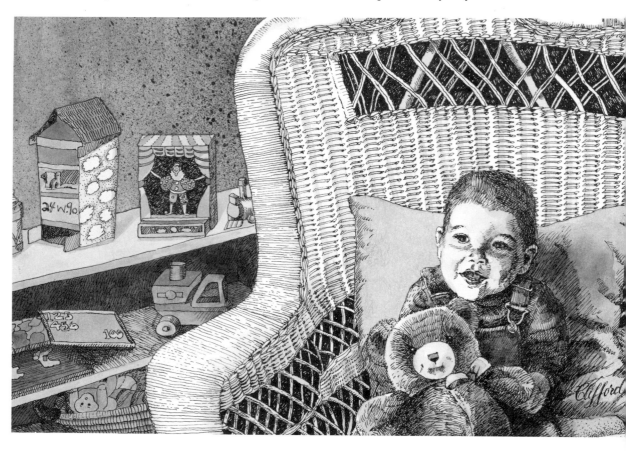

FELT-TIP PENS AND MARKERS Markers are best for bold, high-contrast drawings. There are actually two kinds of felt-tip pens and markers: permanent and water-based. Permanent markers contain either the rather noxious solvent xylene or an inoffensive alcohol base, but both kinds of permanent markers dye the paper and dry instantly. If you use the xylene-based markers, you must be careful to have adequate ventilation; these markers have a strong odor and are not recommended for use around children. Water-based felt-tip markers are far superior for drawing details because they don't bleed onto the paper. Their range of line widths and brilliant colors also makes them very versatile. Although it is possible to create some subtle effects by blending the permanent with the water-based brands, the strength of this medium is its dramatic impact.

For the demonstrations in this book, I have used Graphic Markers U.S.A., which are refillable and nontoxic. Like several other popular brands, these markers offer between 100 and 200 different colors. Your palette is practically unlimited—especially when it is possible to get an even wider range of variations by using colored pencils with the markers Most markers have a corresponding colored pencil of the same color.

A soft, waxy colored pencil is better than a hard, brittle one because it will give you the most brilliant deposit of color. The best brands are Eagle or Berol Prismacolor or the larger-lead Derwent Artists pencils. Colored pencils can also be blended with a colorless marker because the solvent in the marker liquefies the colored pencil binder. This method will instantly color small areas, but it may streak unattractively in larger areas. The marker-blended colored pencil will dry into a matt surface, so you must go over the area with some pencil afterwards to restore the waxy sheen. Another way to work with markers and colored pencils is to draw over an area previously colored with markers. The pencils will leave a semiopaque coating that will be a visual mix of the pencil, paper, and marker and will have depth and complexity.

Markers cost about twice as much as colored pencils, so it is best to limit them to a few basic colors and to fill in the gaps by overcoloring with colored pencils. When using gray, I use the cool gray markers and I temper them with either cool or warm gray pencils depending on the effect desired. There is no need to have two sets of gray markers.

The best pens to use in conjunction with markers and colored pencils are felt-tipped pens or an ordinary fountain pen. Technical pens often clog when used over waxy colored pencils. Four different widths of linework can be accomplished by using the following pens:

Pilot Razor Point gives a very fine line.
Sharpie extra-fine gives a fine line.
Stabilo fine gives a medium line.
Markette by Eberhard Faber gives an extra heavy line.

Lightly toned papers are better than plain white when working with markers because they make the colors seem less brilliant; most markers are unnaturally brilliant. Toned papers also work well with colored pencils but have the opposite effect, as discussed earlier: When light-value colored pencils are used on toned paper, they appear to glow because their lightness and brilliance contrasts with the dull-toned paper surface. Also, as mentioned under "Types of Paper," too much white dilutes the color it surrounds.

A particularly rewarding way to work with markers is to do your drawing on vellum or tracing paper (it is important that the paper be transparent) and then have several diazo prints made. These prints can be made at blueprint shops on black, blue, brown, red, or green papers. The paper color can be chosen to blend with the general color scheme of your artwork. You can work on the diazo prints, adding your marker and colored pencil colors, perhaps even trying several color treatments without having to redraw your original sketch. If your additions are unsuccessful, you can simply make another print of your original drawing.

Diazo prints can be run at different speeds through the machine allowing for more or less exposure of the background. If you run the print through quickly, you will get a background color—a cool background with a blue line, a warm background with a brown line, and so on. Running the paper slowly through the machine will give you a copy of your linework in black, blue, brown, red, or green without a background.

Other papers that lend themselves to marker drawings are yellow tracing paper and Strathmore bristol board. Yellow tracing paper mutes the darker marker colors well without diminishing the glow of colored pencils. This paper is especially effective if you mount it first on a darker paper or board. Strathmore bristol board is a 100 percent rag paper with a vellum finish. Markers bleed very little on the surface, and colored pencils may be applied without a great deal of pressure because the grain of the paper is not too pronounced. The one disadvantage to using bristol board is that you cannot make diazo prints of your linework because it is not transparent. Therefore, when you work on bristol board you will always be working on an original.

In this series of sketches done very quickly with marker on vellum, I deliberately allowed one pose to overlap another to bring out the vitality and immediacy of the moment. Later I added colored pencil to shade the figures and emphasize the drawing being held up.

HUE	PENCIL COLORS**	HUE	PENCIL COLORS**
LIGHT RED-ORANGE — 1*	927: Light flesh / 928: Blush	GREEN — 8	907: Peacock green / 909: Grass green / 45: Mineral green**
RED-ORANGE — 2	921: Vermilion red / 922: Scarlet red	BLUE-GREEN — 9	905: Aquamarine / 920: Light green / 58: Kingfisher blue**
RED — 3	924: Crimson red / 937: Tuscan red	BLUE-VIOLET — 10	906: Copenhagen blue / 933: Blue violet / 901: Indigo blue
LIGHT YELLOW-ORANGE — 4	940: Sand / 19–58: Raw sienna**	RED-VIOLET — 11	930: Magenta / 931: Purple / 22: Magenta**
YELLOW — 5	915: Lemon yellow / 916: Canary yellow	LIGHT COOL GRAY — 12	968: Cold grey very light / 967: Cold grey light / 964: Warm grey very light
LIGHT YELLOW-GREEN — 6	912: Apple green / 913: Green bice	MEDIUM COOL GRAY — 13	966: Cold grey medium / 963: Warm grey light / 962: Warm grey medium
DARK YELLOW-GREEN — 7	911: Olive green / 51: Olive green**	DARK COOL GRAY	965: Cold grey dark / 961: Warm grey dark / 935: Black

*See List for Marker Number and Name

**All Prismacolor except where identified by ** as Derwent colors

Left: This is a beginning palette for Graphic Markers U.S.A. and related Prismacolor and Derwent pencils. I have only three cool gray markers, and I temper them with colored pencils of cool or warm gray. There is no need to have a set of warm gray markers.

Marker Numbers and Names
(All Graphic Markers U.S.A.)

1	128	Pink flesh
2	123	Coral pink
3	143	Dark vermillion
4	102	Beige
5	74	Lemon yellow
6	59	Light chartreuse
7	65	Medium olive
8	43	Forest green
9	30	Sea green
10	18	Colonial blue
11	2	Wine red
12		Cool gray #1
13		Cool gray #5
14		Cool gray #9

Markers needed but not on chart:

Black
Clear (for blending)

Right: *Nicky in British Stripes.* Graphic Markers U.S.A. and Prismacolor and Derwent colored pencils on diazo blackline print, 11½ × 7¼" (29 × 18 cm). Artist's collection. For the face I used an overall tone of marker (pink flesh 128) and pencils (light flesh 927, blush 928, and pink 929). I then added shadow areas with marker (beige 102), and used colored pencils to blend them in smoothly. The hair was rendered with many strokes of marker and related colored pencils. Yellow highlights in pencil were added to both the hair and flesh for color harmony.

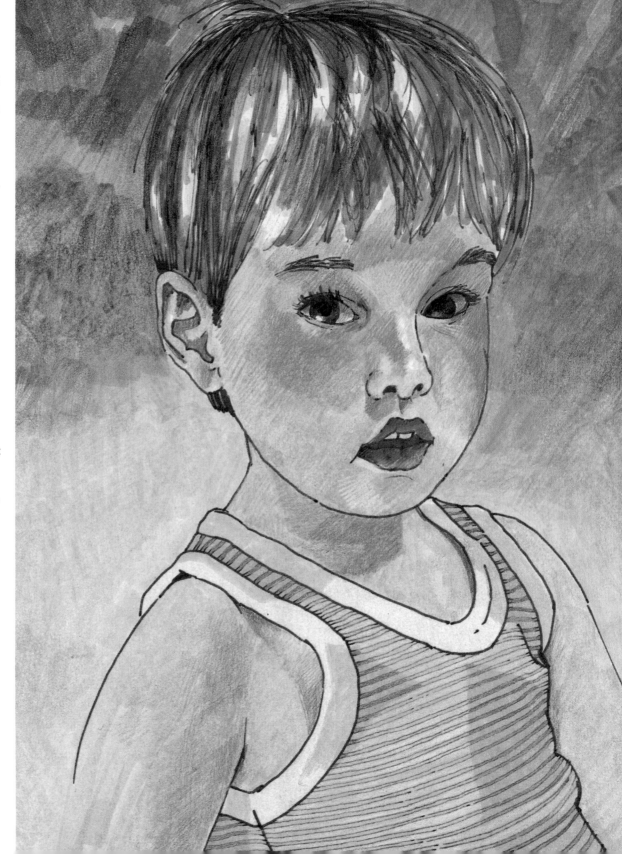

WATERCOLOR Contrary to my advice earlier in the book to use any grade of paper when you are sketching, when you plan to work with watercolor, I recommend that you use the best paper available. If you want to use watercolor to add interest to a sketch, then you must do your drawing on a surface that can hold water without buckling. Most watercolor papers need to be stretched unless they are 140-pound paper or heavier; the higher the weight, the stiffer the paper. This is a relatively simple procedure for adhering the paper to a heavier support to keep it from buckling. For our purposes, there are ready-made solutions to this problem that are easier than stretching and that work well when you want to experiment with many new media at the same time.

Blocks and pads of paper are sold in which the paper is bound on all four sides so that you can use watercolor on the surface without stretching the paper first. However, these pads will not take large areas of flooding with water, so unless you work in small patches at a time, it is best to use a heavy watercolor paper or board. Two excellent heavy watercolor papers are Arches paper and Cotman paper, both by Winsor & Newton. They are available in 90- and 140-pound weights. Watercolor boards such as Winsor & Newton Arches watercolor board can be used with the heaviest washes.

After you decide on a watercolor paper or board, there are three types of surfaces: hot-press (smooth, best used with pen and ink); cold-press (fine texture, best all-around surface); and rough (strong texture, avoid in the beginning). The quality of a paper greatly affects the way the paint is accepted; therefore it is not a waste of time to experiment with watercolor papers the way you did with drawing papers so that you can make an informed choice. If you can afford it, use the best paper because it will allow you to work longer without the surface breaking up. Also, some lovely effects are only possible on the better papers and boards. Experiment and see!

Watercolor paints are essentially pigments bound with gum. They are sold in various forms: dry cakes, pans, jars of concentrated color, tubes, and dropper vials of watercolor dyes. I recommend using the tubes because their paints mix more readily with water than the paint from dry cakes or pans. You can squeeze out exactly the tube paints you want and have them side by side in their mixing pans, which is more convenient than using prearranged pans with an array of colors you won't need. Also, tubes of paint are easier to store than the jars of concentrated color. I use watercolor dyes only when I need the most vibrant color in an illustration, because their chroma (color intensity) does not diminish when they are diluted.

There are two grades of watercolors: artist and student. Here again my advice is to use the best (that is, the artist grade) because the colors are more intense and tube colors will mix more readily with water, making the paints go further and last longer. A good way to learn about your watercolors is to lay down small sample

Jane and Nicky on the Stairs. Watercolor on Winsor Newton Arches watercolor board, 10¾ × 11⅝″ (27 × 30 cm). Artist's collection. After blocking in the basic details of the drawing with a 2B pencil, I laid down a clear wash with a number 10 sable round over the entire surface to prepare the board and set the pencil. I allowed the board to dry completely.

Next I laid in the background to establish the darkest value area with Payne's gray. I also used this color in a very light wash in the shadows of the flesh and clothing to tie them into the background. Again I allowed the board to dry completely.

The flesh tones were filled in using very light washes of brown madder alizarin with a touch of Hooker's green. These layers were built up slowly and let dry in between. The folds in the clothing were delineated using a wash of warm sepia, Hooker's green, and Winsor violet. These layers of medium value were built up simultaneously with the flesh tones. I also darkened some areas to hold the forms of the children with more Payne's gray and some sepia.

Some of the details on the clothing were brightened to stand out along with highlights in the hair and flesh. For this I used cadmium red, cadmium yellow pale, cadmium orange, and yellow ochre. A light wash over the stairs with yellow ochre helped to lessen the contrast between it and the children.

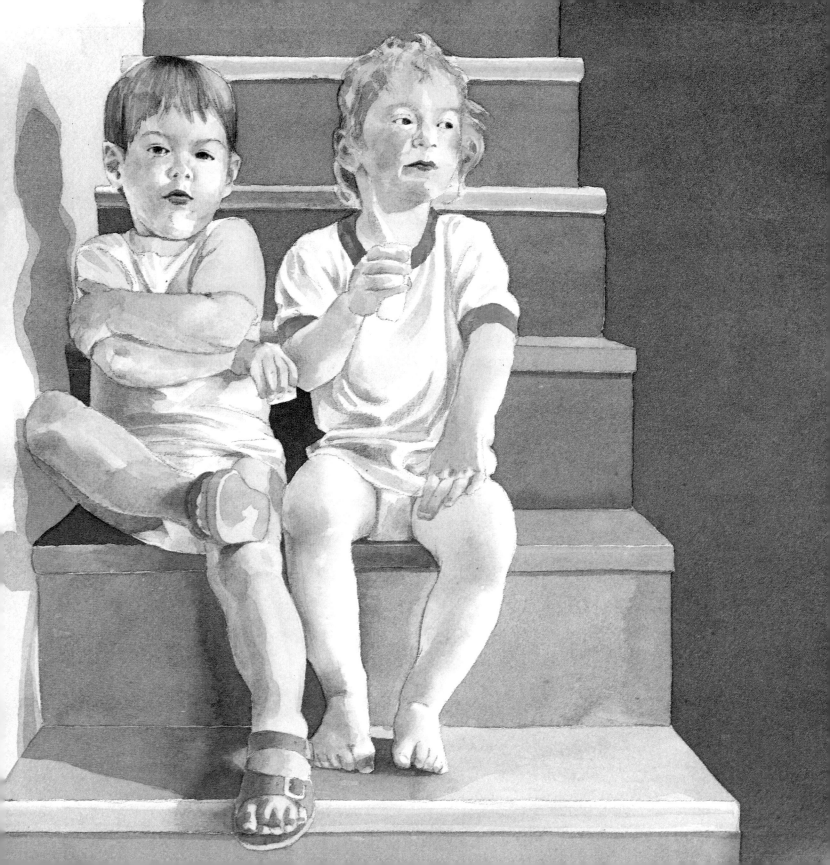

washes of all your colors, gradually diluting them from full strength to a pale wash. Save these swatches to remind you of what each color looks like full strength and diluted. Also, note that the color always dries lighter and duller than it looks when wet. Be careful when buying artist grade watercolors because each color is priced differently, and some are very expensive. Along with your paints, you will need some ceramic or plastic palettes or cups for mixing.

You will also need a watercolor brush. Once again, get the best you can afford. The best brushes are made from red sable and are far superior to any other type. They are springy and hold lots of paint—qualities you will appreciate once you start painting. Ideally, you should have three brushes: a large flat brush for laying on washes, a small round for detailed work, and a medium round brush for larger areas. The medium round is a good all-purpose brush, and if it has a good point you will be able to also do surprisingly detailed work with it. Art supply stores have a jar of water handy for the purpose of checking the wet point on a brush before you buy it. Use it! Always wash your brushes thoroughly in warm (not hot) mild soapy water when you are finished. Be especially careful to work all the paint out from the ferrule to the tip. Then restore the point by shaking the brush briskly in a sweeping downward flick of your wrist. Remember to store brushes with the tips up and away from harsh light and heat.

As you start out using your watercolor paints, limit yourself to two or three colors, using them separately and mixing them together to create different effects. Never work directly from the tube or pan. Mix up a wash in one of your palette pans first, then paint from the mixed wash. This gives you much better control over the blending of color. Always mix more color than you think you will need. Have a large jar of clear water handy for cleaning off your brush, and use a dropper to add this water to your pigments when diluting washes.

Successful watercolor paintings are a wonderful blend of control and accidental effects. Color intensity is achieved or altered by layering successive washes, after allowing each coat to dry thoroughly so that the next layer sits on top instead of picking up the layer beneath. Because of the importance of letting the layers of paint dry completely, often an artist works on more than one watercolor painting at a time. Sometimes different versions of the same subject can be worked on as the artist tries out several color schemes or lighting effects.

Here are a few words of warning before you begin to experiment with watercolor. Perhaps the biggest limitation of watercolor is the fact that you cannot apply light over dark, so you have to begin your painting with an idea of where you want to place the lightest values. Build up your darks by layering successive washes. Remember that the only white available in a watercolor painting is the paper itself.

You can pick up color by going over a too-dark area with a brush loaded with clean water, and then mop up the flooded area with a dry brush. In this way you can remove some of the color, but because the paints actually stain the paper, it will never be white again.

If you apply watercolor wet onto dry paper, the edges of the color area will be sharp; wetting the paper beforehand softens the edges of the color area. When you wet the area you will be working in with clear water or a faint color wash, the amount of water you leave on the paper is critical. If there is too little water on the paper when you begin to paint, the color will dry before you can work it over the area. If there is too much water, the color will spread out of control and may create tidemarks as it puddles and runs.

There are watercolor techniques for masking off areas that you want to remain clear and many ways of creating different textures through creative brushwork, spattering, and various chemicals. Consult the bibliography section if you wish to read further about watercolor technique that goes beyond the scope of this book.

Dreaming About Baby. Watercolor on D'Arches paper, 22½ × 19½″ (57 × 50 cm). This drawing depicts me holding in my left hand a heart-shaped crystal containing an image of what I imagine my child will look like while I try to draw him with my right hand. On the left side of the picture are objects that represent life before his birth: a bottle of French wine in memory of trips with my husband to France; an orange and an apple representing our life in California and New York respectively; a framed photograph of my husband; a crumpled piece of drawing paper that stands for artistic frustration; a map of the Hawaiian Islands, where we used to live; and a pocket watch stopped at 3:44, just five minutes before the time of his birth. A stalk of foxglove flowers (Digitalis) represents the conflicting emotions which accompany the birth of a child. Digitalis increases the heart's efficiency but can cause death if large quantities are ingested. When you have a child you experience both the opening up of your heart to the love and wonder of the experience and the sometimes overwhelming fear that some harm might come to your child. You also become more aware of your own mortality and the fact that someday in the future you will have to leave your child.

COLLAGE Collage is similar to working in mixed media in that you are putting together many disparate elements and you must find a way to bring the inherent conflict into harmony., But with collage you are working with many found objects normally not associated with one another, such as newspaper clippings, fragments of letters, snips of fabric, and so on. The tools are quite simple. You will need:

A surface to work on.

A board or piece of artwork stiff enough not to buckle under the extra weight of glue and objects.

A good pair of scissors and perhaps a single-edge razor blade or X-acto knife blade No. 11.

Glue or rubber cement.

The odds and ends of found objects.

The inspiration for a collage can come from many sources. "One thing I suggest is that in each picture you use at least one object that you really love."[13] This tip from *Gloria Vanderbilt Book of Collage* is very good advice because it is important to have an investment in the project. If you are considering using a treasure, you will be more involved in the outcome. No matter how strong the initial idea was that inspired you to begin the collage process, it is important to leave yourself open to flowing in whatever direction the materials take you. Also, be generous with the number of objects you allow yourself to play with. It is better to start with more than you think you will need.

Start collecting items and set them aside in a shoe box labeled "collage materials." After you have been working in this medium for a while, you might want to organize your collection of items by subject matter, color, texture, etc. Do not worry about how you will eventually use these objects in a specific collage; as long as they please you, they will find their way into a picture.

The best way to start out is with a white background so that the objects are not overpowered, unless they need a color background to unify them. Any board that is not already white can be prepared with a coat of gesso or a white paint that does not yellow.

When you are composing a collage, it is best to leave the gluing to the end even if you are working on multiple layers of objects. You want to be able to move the pieces around freely until the best solution has been found. Keep scrambling the pieces and you will be surprised by the number of compositions that can be assembled from the same objects.

Here are some useful collage techniques:

Tearing and shredding. Sometimes cutting paper or fabrics with scissors leaves a hard edge that looks too predetermined. Tearing and shredding leave an irregular edge that has more life. If you use the scissors as an edge along which to pull the paper or fabric, you can control the general direction of the tear.

Decoupage. This is a precise technique for cutting out delicate patterns. When scissors are too clumsy, a single-edged razor or a No. 11 X-acto blade can be used to eliminate the unwanted areas.

Painting or drawing over collaged material. This is done to change the color or add a color in order to integrate different pieces. It can also add texture or focus attention in a particular area if the collage is becoming too cluttered.

Photocopies or magazine rubbings. These are both ways to duplicate or add multiple images to your collage. Transferring ink from the printed page onto paper or cloth can be done using only unvarnished ink images printed on newsprint or clay-coated paper, such as *Newsweek* magazine. (The varnish used on glossy magazine pages and on most magazine covers, such as *Vogue* magazine, cannot be dissolved by the solvent.) Begin by taping your blank paper or cloth onto a hard surface face up. Then tape the magazine image to it, face down. Apply a teaspoonful of either silk-screen transparent base, lighter fluid, or Carbona spot remover to the back of the magazine image and spread it around until the solvent begins to penetrate the paper. Next, rub the back of the magazine image hard with a metal spoon. This process can take up to 15 minutes to complete. You can check the results by lifting up a corner of the magazine image.[14]

Three-dimensional additions. You can simply glue objects onto the surface, or you can cut into the collage background and sink objects into the support to control how far above the surface the object will stick out. You can also work directly on a three-dimensional surface such as a shadow box or a typesetting tray. The artist Joseph Cornell was a master at this type of collage.

Handmade backgrounds. Instead of beginning on a board with a flat white or color surface, you can create a textured background that will give the composition depth. Use a board spattered with paint; collage onto a drawing or painting; glue a previously printed background or fabric onto your support, or distress the background support by pressing or hammering objects into the board surface.

Baby. Collage on board, 13½ × 15″ (34 × 38 cm). Artist's collection. Beginning with a drawing of my child and some flowers previously done in watercolor and colored pencil, I collaged onto the surface the letters to spell out b-a-b-y, portions of a paper lace doily, a baby's face from a Gerber label, and several pictures cut out from greeting cards, including a rose, a hand, and a Leonardo da Vinci drawing of a baby.

Next I spattered three tones of gouache (an opaque form of watercolor) similar to the colors originally used in the background of the drawing over the entire composition, masking out only the central image. This brought all the elements into a color harmony. I scraped off some spatter in places where it obscured an object, such as on the cut-outs of boy athletes.

Using a small round frame as a guide, I cut a hole in the lower right corner. I then inserted a round gold frame so that its rim was about one-quarter inch above the drawing surface, and I spattered it with the same colors used elsewhere. The interior of the frame was filled with a Christmas postage stamp of a Raphael Madonna and child glued to a background from a magazine. The back of the collage had to be built up around all four sides adjacent to the cut-out to allow it to lie flat because of the frame that protruded out the back.

MIXED MEDIA When you mix one medium with another you must integrate the two or bring them into harmony unless the unifying theme is itself contrast. If you use a somewhat flat color (one that is painted on) with a textural color created by pastels or color pencil, you can get a textural effect in the flat painted area by working pastels or colored pencils on top of the paint—or underneath the paint if it is transparent (colored pencils first, paint second). This will serve to bridge the gap between the two media, creating harmony rather than conflict.

Graphite pencil is a medium that works well with many others. You can use it as an underdrawing to hold important details. There is no need to erase it because it blends in with all but the lightest washes, pastels, or colored pencils. In fact, the look of the underdrawing showing through the artwork often injects the finished piece with a feeling of emotion and immediacy that is sometimes lost if the work becomes too precise.

Blending oil pastels and charcoals with turpentine to create a painterly effect can be used to mix these mediums with oil paints. Feathering water-soluble ink lines and tones with a water-laden brush will help integrate watercolor or colored inks with a pen-and-ink drawing. When using waterproof ink with flat, transparent, or semitransparent color, you can stipple, spatter, or draw underneath or on top of the colored areas to blend them with the linework.

Susan and Danielle. Mixed media on Canson Mi-Teintes oyster-colored paper mounted on hot-press illustration board, 16 × 21″ (41 × 53 cm). Collection of Mr. and Mrs. Michael Nash, New York, N.Y.

After drawing in the figures with a red mechanical pencil, I added the highlights of the skin—and the darkest values in the hair, the robe, and the background—with colored pencils. Next I worked in the medium values of the flesh and robe with regular pastels and colored pencils. I added colors to the rug and darkened the background around the figure with blacks and grays to bring out the central figures of the mother and child.

Where highlights seemed too intense, I lessened their effect with a dilute wash of raw umber watercolor. I then intensified the robe color so that it would offer more of a contrast to the flesh with a wash of watercolor dyes, which are very intense even when diluted.

With a dry brush and lampblack watercolor, I painted in the darkest areas. To augment this, I also went into these areas with a 6B charcoal pencil. The areas that I wanted to be especially dark, such as the hair, I repeatedly sprayed over with fixative and added layer upon layer of charcoal pencil, carefully masking off any area that I didn't want altered by the fixative.

Finally I added the color borders with colored pencils (aquamarine blue 905 and scarlet lake 923) to finish off the painting.

PRESENTING YOUR WORK

After you have completed a sketch, always take the time to put it away carefully so that it cannot become damaged. Next to making a sketch in the first place, this is the most important step to making sure that your artwork will be preserved. If you are not using a book sketchbook, store loose sketches in a portfolio or flat file drawer. If you take the time when you first complete a drawing to protect it, you will not be disappointed when you return to retrieve it for framing or for other uses.

There are many approaches to choose from when you decide to show the world a particular drawing. Do you want to display it in a mat and frame, or do you want to use it in a novel way such as a design for a rubber stamp or stationery? No matter how you eventually decide to use your drawing, you will probably alter its look somewhat from the way it originally appeared on the paper or board. You may either crop in and lose part of the empty space, or you may make copies or multiple images. You may even group together a series of similar drawings.

There is no guarantee that presenting your work in a mat and frame will automatically enhance your sketch. Only if you make the proper decisions when you crop, mount, mat, and frame your art will you be successful in presenting your work at its best. There are many professionals who can help you with these decisions, but it is always wise to understand the principles behind the correct approach. It is also possible, with a little time and practice, to do most of the work yourself. This is economical and also gives you even greater control over the final image.

This section provides basic information about cropping, matting, and mounting your drawings, as well as several methods of copying them. Ideas for keeping a sketchbook or journal of your baby are also included, and so are suggestions for a few more unusual ways to display your work. When you have finished a drawing you like, it is highly satisfying to display it. Enjoy coming up with your own ideas for how to use your artwork!

Right: This illustration is composed of three separate sketches of my son that I glued together onto a large hot-press illustration board. I liked the way the different poses worked together, almost as a stop-action film clip. To tie the images together visually, I ran a series of lines done with Prismacolor broad sticks behind the three figures.

CROPPING After you have completed a drawing and you want to present it in some fashion, either framed and hung on the wall or matted and stored in a portfolio, there are certain decisions to be made concerning how the image will be contained within the mat. There are often many ways to crop a drawing.

The best way to experiment with various croppings is to use two corners cut from an old mat (preferably white) with sides long enough to enclose the image you are working with. Move the corners around your drawing, creating different framed images— compositions that show less of different areas, and some where the subject is placed asymmetrically to one side of the frame. Try all configurations until one catches your eye. Now you will see the reason for not crowding your image on the drawing surface. When you leave space around your sketch, you increase the cropping options that are available to you.

When you have a number of sketches of the same subject or pose and individually they are not important enough to warrant a special presentation, it is possible to give them more interest by grouping the separate drawings together into one large work. This approach generally works better when each of the sketches is done on the same drawing surface and with the same medium. Two-coat rubber cement is the best glue to use when the mounting project involves several surfaces that must be glued next to one another. You spread the rubber cement on *both* surfaces to be glued. Neither surface will be tacky when it is dry, and they will adhere only to each other. By holding a piece of tracing paper between the coated surfaces, you can adjust their positions without having them stick together until you slide the tissue out from between them. This is an important advantage of rubber cement over many other adhesives. (For more about using rubber cement, see "Mounting.")

This closer cropping of the original sketch is almost square. It focuses the viewer's attention on the faces of the mother and her baby.

Here I have elected to create an extremely vertical version of the original sketch by tilting the figures to the left and cropping in tightly on the sides.

In this cropping of the original, I made the picture horizontal by eliminating much of the lower half of the drawing and extending the background on the left so that the figure of the mother could have some space to look into.

The original charcoal sketch on the facing page shows a mother and child, with the central figures in the middle of the paper. Although the negative space is not identical on both sides, it is not very dramatic either.

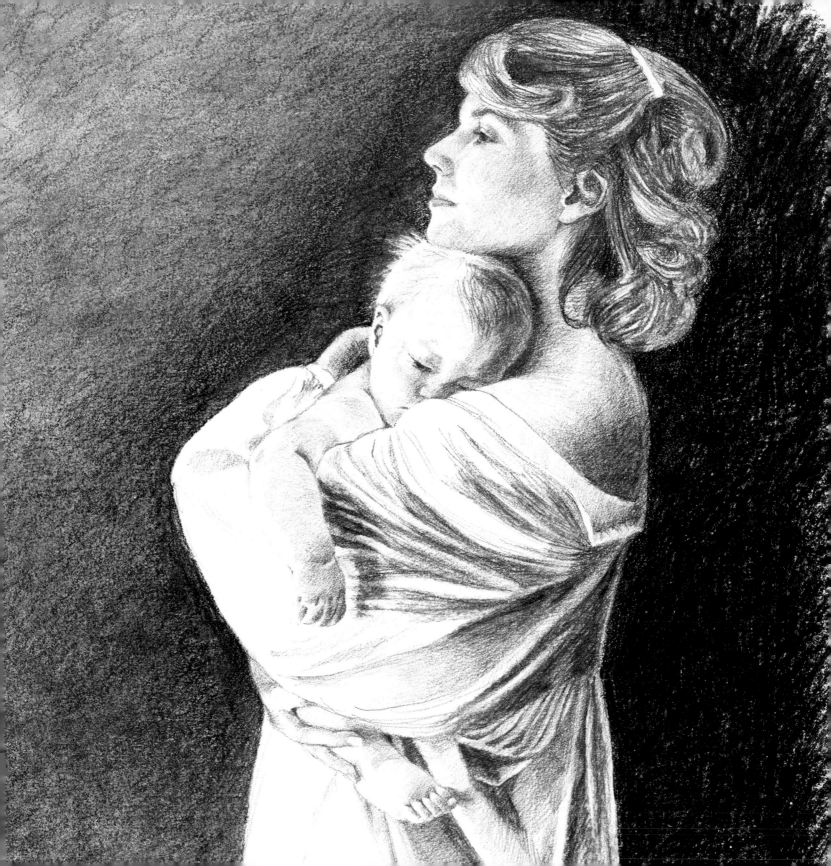

COPYING Many sketches, if they are bold enough, yield interesting results if you have them copied using one of the various methods demonstrated on this page. Making Xerox copies, both black and white and color, can alter your drawings in interesting ways. The black and white Xerox image does not allow for much subtlety, so sketches with a lot of gray tones may not reproduce well. As the contrast is adjusted on the machine to pick up the lighter marks, the dark areas will fill in as too much ink is deposited. Also, large areas of black tend to come out streaked instead of a solid tone. Sometimes the effect of having the middle tones drop out of a drawing can be exciting because it increases the dramatic impact of the sketch, but generally the best Xerox images are made from bold drawings that already contain a great deal of contrast. Fortunately, the wide range of papers now available to be used in Xerox machines enables you to use colored bond paper as well as heavier-weight cover stock. Both are good surfaces for markers, pencils, and even small areas of watercolor washes.

Most color Xerox copies look like coarse magazine images. There are some fine-screen color Xerox machines, but they are the exception. The color is broken down into a dot pattern the way it is in newspapers and magazine printing; this can be a fun way to distort your artwork slightly. But color Xerox images can be done only on $8 \times 10''$ paper, which limits the size of the art being duplicated. Another drawback is that the only paper used is very thin and glossy. Color Xerox copies are quite expensive compared to black and white ones, which are still the best bargain in the field of image copying.

Diazo prints, as described under "Felt-Tip Pens and Markers," are reproductions of a drawing made by the diazo printing process. The print is produced by exposing the drawing along with unexposed print paper to a special light and then to a developer, usually ammonia. Diazo prints are commonly made on blueline, blackline, or brownline paper, although other colors are available. The prints can be run at different speeds through the machine, allowing for more or less tone in the background.

Comparing a blackline diazo print with a Xerox copy of the same drawing, you will see a softer quality in the line, due to the softer and more absorbent paper. If the print was run slowly through the diazo machine, there will be a medium-value gray background where the original was white. The biggest drawback to using a diazo print is that the original must be done on transparent paper, either tracing paper or vellum. Diazo prints are more expensive than Xerox copies but not as expensive as photostats.

Photostats make the most faithful copies of a black and white original. Veloxes (photostatic copies shot through a screen of dot patterns) are the best way to reproduce a drawing with gray areas, washes, or a lot of blending; these are called halftones by the printer. Both photostats and Veloxes are quite expensive, but they can be done in a wide range of sizes which allow you not only to copy artwork of any size, but to reduce or enlarge your drawings. In an enlarged photostat the grain of the paper usually becomes more visible, and there is more texture and detail than was apparent in the original. A reduced photostat, on the other hand, tightens up the linework and often gives the impression of a more precise image.

Photostatic posterization is a process where the artwork is broken down into three distinct shades: white, black, and gray. All the areas in the artwork that are white or near-white will be pure white in a posterization, whereas the darkest areas will go black. The middle tones will be gray to the eye although they also are black, but broken up into a matrix system of dots. This matrix can be either a light or a dark gray, and you can choose from many different textures. The gray areas can have a wavy texture or a very grainy look, called mezzotint. This is the most expensive reproduction method discussed here. Photostats, Veloxes, and photostatic posterizations are available at many photocopy stores.

This series of copies of the same illustration (see page 99) was done by using different methods. Starting in the upper left corner and moving clockwise, the type of copy made was: (**1**) a Xerox copy, (**2**) a blackline diazo print, (**3**) a Velox, and (**4**) a photostatic posterization.

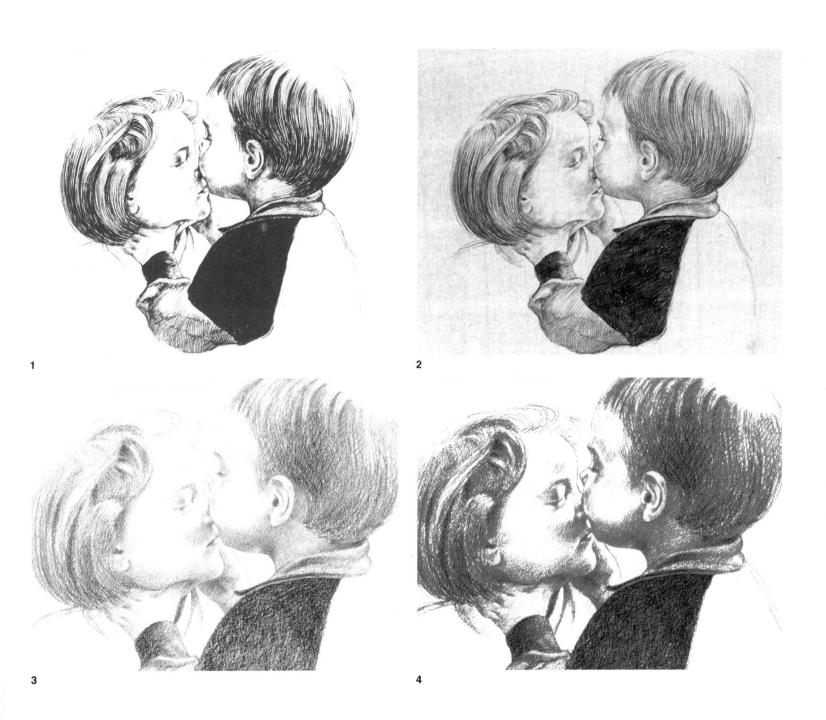

1

2

3

4

MATTING If you decide to mat your work you will need a few basic tools: a cutting board, a right-angle triangle, a utility knife and blades for cutting heavy boards, a No. 11 X-acto knife and blades for cutting paper, a steel ruler, preferably 24 inches long, an emery board or sandpaper for cleaning up the inner edges of your cuts, and a thick surface on which you can cut. The process for cutting a mat is:

1. Using a set of corners cut from an old mat, select the desired cropping for your artwork.

2. With the corners framing the sketch, lay a large sheet of tracing paper over the sketch and figure the outside dimensions of your mat by adding on the borders. A good rule of thumb for medium-size drawings between 8 inches and 12 inches is to have a 2-inch border on the sides, a 2- to 2½-inch border on the top, and a 3-inch border on the bottom. The larger border on the bottom is needed to counteract the optical illusion that would make the picture seem not centered in the mat if the borders surrounding it were all the same size. Cut the mat using the outside dimensions.

3. Measure in from the edges of the mat and mark on the board the inside edges of the borders, being careful not to go beyond the corners. Draw along these lines with a ruler until you have connected them at all four corners. Then put pinpricks in the corners to use as a guide when actually cutting the mat, so that you won't accidentally cut beyond the corners.

4. Cut along the lines, using a *sharp* utility knife and metal ruler as a guide. Be sure to move your whole arm as you run the blade down the ruler so that the angle remains consistent. After you have cut the inside edges of your mat, clean up any stray bits of paper or jagged portions with fine sandpaper or an emery board.

Bevel edges give a more finished look to a mat, particularly when viewed up close, but from a distance they are hardly noticeable. To bevel the edges, you must hold the knife consistently at a 45 degree angle, which takes a lot of practice. If you wish to have bevel edges on your mat, I recommend that you have it cut by a professional at a framing shop. For general purposes a bevel edge is not necessary, especially if you plan to mat many sketches.

Cutting a mat.

There are several ways of securing your artwork on a backing of heavier board to keep it in position when framed, or to save it from wrinkling. One way is to make a hinged mat. You can do this quite easily, as follows:

1. Check the fit of your sketch under the mat that you have cut to make sure that everything aligns correctly. Then cut a piece of hot-press illustration board to the same outside dimensions as the mat. Hinge the two boards together at the top inside the mat with water-soluble packaging tape; the adhesive on this tape lasts longer than the kind on regular gummed tape. Before you do this, be sure that the mat is positioned correctly over the hot-press board, with the larger border on the bottom.

2. Place the artwork between the mat and the hot-press board, and adjust it into the correct position for the cropping you desire.

3. Tape the artwork to the hot-press board on all four sides. Be careful not to let the tape extend far enough into the sketch to show.

4. When the mat is closed the art will stay correctly within the window you have created. The work is now ready to frame.

Making a hinged mat.

1

2

3

4

MOUNTING Other methods of attaching your drawings to a stiffer backing include dry mounting and gluing with rubber cement. Dry mounting can be done with a household iron. Follow these steps:

1. Cut a sheet of dry-mounting tissue slightly larger all around than the sketch you intend to mount. Tack it to the center back of the sketch by pressing lightly from the back with the point of a cool iron (permanent press setting).

2. Trim off the edges of the dry-mounting tissue to the exact size of the picture, using a steel ruler and No. 11 X-acto knife.

3. Put the sketch, with the dry-mounting tissue behind it, on hot-press illustration board cut larger than the artwork. Lift the corners of the picture to enable you to tack each corner of the tissue to the board by pressing against the tissue with the point of a cool iron. (The tissue will not stick to your iron.)

4. Lay a sheet of medium-weight paper over your sketch to protect it. Then iron over the paper, exerting firm pressure and working from the center outward.

Dry mounting using a household iron.

1

2

3

4

To attach a drawing to a backing with rubber cement, follow these steps:

1. Using a card or brush, apply the rubber cement smoothly over the entire back of your work. (I usually lay the artwork face down on the board to which I am going to mount the artwork. The board is larger than the drawing and it will not matter if the cement goes over the drawing's edges while I am spreading it on, because the entire surface of the board will eventually be covered with cement.) Also spread the rubber cement on the mounting board (usually hot-press illustration board). Allow both of the glued surfaces to dry completely.

2. Place a sheet of tracing paper between the glued surfaces as you lay the artwork down loosely on the mounting board.

3. With another sheet of tissue paper on top of the artwork, burnish (smooth down) the portion of the sketch that is exposed to the glue-covered board below with a burnishing tool or a soft cloth. Slide down the tissue paper underneath the drawing, exposing more of its glued surface to the glue-covered board. Continue burnishing until the entire drawing is affixed.

4. Clean up the excess cement around the edges of the drawing with a rubber cement pick-up (an item sold in art supply stores).

Mounting with rubber cement.

KEEPING A SKETCHBOOK For many artists recording drawings in a sketchbook is a relaxed and joyful part of being able to draw. Often they will keep a pad tucked away in their studio for use when they feel the urge to go out and sketch, or for particular assignments or paintings that require some on-the-spot drawings. Of course, there are artists who never go anywhere without their trusty pocket sketchbook. The dedication these artists have to sitting down and carefully recording life around them is truly remarkable and the resultant sketches are usually wonderful in their immediacy.

The thought of having to keep a tidy, elaborate sketchbook, especially one in which the pages cannot be torn out, is uncomfortable. Sometimes the best way to create a sketchbook of related drawings is to bind them together after they have been completed. You can collect sketches and trim them down to a uniform size and then have them bound together at a bindery or a printer's shop. There are also portfolios in which you can store drawings and specially treated envelopes and boxes for storing and protecting anything made of paper.

Sketchbooks come in many sizes. Some are small enough to carry in your pocket so that they will be handy in any situation. Often when I travel, I take a sketch pad or watercolor block the size of a large postcard. Then I do sketches of the places or people I see and send them as postcards to friends back home. Remember when choosing a sketchbook not only to pick the right size, but also to match the paper to the medium you will be using. A good-quality drawing paper or a cold-press bristol board pad will take a wide range of drawing instruments.

Spiral-bound sketchbooks and pads with perforated sheets are useful if you like to pull out certain drawings and keep them separately. Pages from sketchbooks that are bound book-style are not meant to be torn out. One benefit to the book-style sketchbooks is that you can work across the double spread of paper. All sheets in a pad are usually the same paper except in tablets of assorted pastel papers. As I mentioned earlier, watercolor blocks are especially convenient if you want to add washes to your drawings. The paper in these pads is bound on all four sides and will take light washes. When you are finished there is an area at the top where you can release separate sheets by slipping in a knife and cutting all the way around.

If you want to begin a journal or sketchbook in a special decorative book, there are many handsome examples to choose from. There are books covered with marbled or patterned paper, fabric, hand-tooled leather, and even metal. It is up to you how elaborate you want the outside of your special book to be, but just don't pick something so intimidating that you never feel adequate enough to use it.

This is the journal I made of my son. After I had completed thirty-two sketches, most of which are in this book, I cropped the paper around the drawings (which were done on various sizes of paper) so that all the pages were 8½ × 11″. Next I cut two pieces of hot-press two-ply illustration board to the same dimensions, for the back and front covers. On the front cover I glued wallpaper over the entire surface and added a photo, a plastic geometric shape, and other pieces of wallpaper and magazine images. Then I painted on the name Nicholas using gouache and sealed it with acrylic matte medium to protect the white paint.

I organized the sketches, put everything together, and had it spiral-bound at a bindery. Later I added some trinkets onto the spiral binding: a teething ring, a silver bear, and a plastic heart . . . just for fun!

Left: There are many types of sketchbooks that would be appropriate to use for a drawing journal of your baby. (**1**) a large watercolor block bound on all four sides as described under "Watercolor"; (**2**) a plain and simple Mead sketchbook, a sketchpad of spiral-bound drawing paper; (**3**) a ribbon-tied folder portfolio for storing single sheets of drawing paper; and (**4**) three fancy sketchbooks with deckle-edged paper and covers of marbled and patterned paper in small, medium, and large.

Photos this spread by Patricia Decker

Right: I did these sketches outdoors at a playground on an autumn afternoon. The autumn leaf tucked into my sketchbook at the time reminds me of the feeling of the air and the crackling of the leaves as the children gathered them up and played with them.

Perhaps the biggest advantage to using a sketchbook rather than a single sheet of paper or board is its portability. Not only can you take your "studio" with you, but once you've found something you want to draw, you can move freely around the subject and draw it from different angles. With a sketchbook you are never trapped in one place—you can even climb up a rock or tree if you want a particular viewpoint. Most pads are relatively stable to use without a drawing board as a support. Hold the pad with your nondrawing hand, and be sure to keep it up. Don't let drawing in a sketchbook foster the bad habit of drawing with the sketchbook in your lap. Always have your pad angled so that your subject is visible over the top so that you will be able to easily check back and forth between your subject and the drawing.

If you have the habit, as I do, of collecting odd bits of memorabilia, these can be added to the drawings in your sketchbook. Either as a collage on part of the artwork or as a reminder of the moment, these items add a sense of whimsy and can also serve as an extension of the memory. All kinds of found objects can be used inside sketchbooks: postage stamps, old gift tags, antique stickers and paper cut-outs, plastic stickers (such as dinosaurs), decorative papers, wallpaper, rubber stamps, fortunes from Chinese cookies, even labels from food jars.

The inclusion of handwritten observations and feelings alongside your sketches can enhance your ability to recall the memories later, and will add visual texture to each composition. Combining words with drawings in sketchbooks, journals, and letters is a longstanding tradition. Artists' drawings and preliminary sketches can be found in combination with the written word on practically every imaginable scrap of paper. For example, one page from Cézanne's Basel sketchbooks combines a study of a woman's head with a drawing of a nude and a shopping list.

Many artists find that while they are straining to express themselves in words they are overcome by an urge to draw out what they want to say. A letter written by Vincent van Gogh to his friend and fellow artist John Russell reveals his unique ability to switch back and forth between writing and drawing. Van Gogh was living in Arles in the south of France at the time, and he wrote of the series of harvest paintings that he was working on. He wrote, "I must hurry off this letter for I feel some more abstractions coming on and if I did not quickly fill up my paper I would again set to drawing and you would not have your letter." Obviously van Gogh could not contain himself for long; after two more brief paragraphs, he penned a sketch of the sower.

Vincent van Gogh, *Letter to John Russell (with drawing of Sower)*. Ink on paper. Courtesy of The Justin K. Thannhauser Collection, Solomon R. Guggenheim Museum, New York, N.Y.

Opposite page: Here is a collection of items that I made from my sketches. (**1**) A bookplate created by making a reduced photostat of a drawing and combining it with press type. It is possible to have artwork printed on specially backed paper so that you can just peel it off and stick it onto anything. (**2**) A postcard sketch of a punk Madonna with her child in the London underground. I did the drawing using a pencil on a small watercolor block while riding in the underground, then added the color and stamp when I got back to my hotel room. The address and message are on the reverse. (**3**) A cassette containing Nicky's first babbling, which I sent out to the family for Christmas. I made a reduced photostat of the drawing and put it on the inside of the plastic cassette cover, with the identifying title on the spine: Christmas 1986. (**4**) Stationery made using a reduced photostat of a drawing with a ruled border and press type for the address. This design was printed on stationery paper. (**5**) A rubber stamp made directly from a reduced photostat of a drawing. In this case, the bolder and simpler the artwork you choose, the better the reproduction will be.

CREATIVE APPLICATIONS Besides presenting your sketches in book form or hanging them on your walls, there are dozens of ways you can use your artwork. When you have a drawer or portfolio full of quick sketches, you can always surprise a member of the family or a friend by tucking one into a letter, or just gluing it onto the top of a folded piece of stationery paper and creating your own distinctive note card. If you have a sketch on a large piece of paper and have left a lot of negative space around the image, you can write your letter in that negative space and add a new textural element to the composition.

Your drawings will inspire you just by the way they capture the special events in your child's life. What better way to celebrate your baby's first Christmas than to send out a photocopied image you have drawn of him, along with a few words describing how his arrival has changed your life? Stationery created using one of your drawings at the top or the bottom is also a good way to use your artwork to personalize something mundane. A word of caution when preparing any artwork to be printed on a press: You must leave a ¼-inch margin all the way around the design for the press grippers to hold onto. This means that your design cannot "bleed" (go off the edges of the paper). Xerox copies made on colored stock are a less expensive kind of personalized stationery.

Another particularly apt use for a drawing that you have created is to incorporate it in your baby's birth announcement. One way to work on your announcement is to take a series of photographs of your baby shortly after his birth if you wish to capture him when he is still a newborn. Since this is not the most opportune time for any parent to be working on a finished drawing, you can create the final artwork by working from the pictures that you took earlier. The announcement that I did for my own son did not go out until he was about three months old. I never regretted the time I spent on the artwork or the tardiness of the mailing because the announcement will always be a reminder of how important his birth was for us.

There are many ways to get your birth announcement printed. Some stationers offer a broad selection of styles in typeset, embossed, and even hand-lettered messages along with drawings, borders, and cut-out images. You may be able to substitute your own artwork as part of the personalizing process. If this is not available, you can always make up your own announcement with the help of a printer or a graphic designer and have it printed by a small specialty printing house. There are usually only a few standard colors to choose from along with black, but any color can be mixed if you can afford to pay extra. The best drawings to use for this purpose are straight line drawings without a lot of shading and middle tones, because these can either become muddy or drop out completely during the printing process. When printing something to be mailed, be sure to check with the post office and make sure that the size of your design is within the limits set for letters.

A sampler of inventive birth announcements from my collection is shown on these two pages. (**1**) Announcement for my son, Nicholas Landon Clifford, front and back. (**2**) Announcement for Wesley Cooper Miller Rice incorporating an etching from a favorite children's book. (**3**) Announcement for John Austin Wilson with a border drawn by his artistic mother, Meredith. (**4**) Announcement for Amanda Summer Wilson, with a drawing of her done by her artistic big brother Austin Wilson, age four (see previous announcement). (**5**) Announcement for Spencer Wilson Coon presented in the form of a stapled booklet, entitled "Babes in the Woods," stating relative weights of baby animals and giving humorous play to the last name Coon. It was designed by Dick Mitchell at the design firm of Richards Brock Miller Mitchell & Associates/The Richards Group (Dallas). (**6**) Announcement for Charles Alfred Michael Raisch using photostats of his footprint walking across the page, creating an image of independence and self-sufficiency from the start. (**7**) Announcement for Marisa Roi Schimmel done in the format of *Performing Arts* magazine, which is distributed at theatrical events. All the statistics are presented as production notes for a performance. This announcement was printed and supervised by the mother, Linda Schimmel, who worked for the magazine at the time.

1

2

3

4

Babes in the Woods

Baby Elephant
(200 lbs.)

Baby Zebra
(50 lbs.)

Baby Bird
(½ oz.)

Baby Coon
(8 lbs. 1½ oz.)

Everett and Celia Coon
proudly announce
the birth of their son
Spencer Wilson Coon,
August 25, 1987.

He's warm and cuddly
and already has his eyes open.

5

Charles Alferd Michael Raisch

was born healthy, handsome and
strong on summer solstice, the
twenty-first of June, 1988 at
19:15 hours in Manhattan.

Beth & Charles Raisch
230 East Fifteenth Street
New York City
20003

6

PERFORMING ARTS
California's Theatre & Music Magazine

LINDA AND JASON SCHIMMEL

PRESENT

THEIR MOST EXCITING PRODUCTION

BABY

7

CONCLUSION

Bertha L. Corbett, pen and ink illustration from *The Overall Boys* by Eulalie Osgood Grover (New York: Rand, McNally, 1905), 2½ × 2⅛″ (6 × 5 cm).

The need to capture images of a child as he grows from infancy into childhood and from there into adolescence is not unique to artists. Most parents sense the poignant, ephemeral nature of each rapidly passing phase in their children's lives and wish that they could engrave certain moments indelibly in their minds. But mental images gradually fade and are replaced as the child grows older.

Photographs can serve as a reminder of the past, but they often make the viewer feel oddly distanced from it. The still images of life seem vaguely sad because the pictures lack the tastes, smells, sounds, and feelings of the moment. Even videotape can chronicle only the physical development of your child as he crawls or walks across the floor. Despite the addition of sound, as you watch a movie you are still a passive observer of the past.

But when you preserve your baby's special look with a sketch—his personality and gestures as well as his physical features—you have the added dimension of your own subjective interpretation as a filter. Drawing your child forces you to observe him more closely than simply photographing him. This forges a greater bond between you and him at that particular moment. As a result, your drawings will be infused with your own emotions and will reflect both your child's personality and your own.

Looking back through early sketches of your baby is fascinating because you can trace your own artistic progress simultaneously with his growth. An old drawing may contain the germ of a look that will become typical of your child several years later. Drawing a subject as inspiring as your own child can unleash artistic ability you never knew you had. By making a visual record of his passage through life, you will give permanence and form to his childhood and to your parenthood. You will also create a collection of strong memories that you, your child, and other family members will enjoy for many years.

NOTES

1. Frederick Franck, *The Zen of Seeing* (New York: Vintage Books, 1973), p. 6.

2. Michel de Crèvecoeur, *Letters from an American Farmer* (New York: E. P. Dutton, 1912), p. 49.

3. James McMullan, personal conversation with author (New York: N.Y., August 9, 1989).

4. Larry Rivers, personal correspondence with author (New York: N.Y., June 25, 1989).

5. Ibid.

6. Philippe Ariès, *Centuries of Childhood* (New York: Knopf, 1962), p. 34.

7. Pete Hamill, "Picasso: The Man," *New York* (May 12, 1980), p. 35.

8. Richard Hatton, *Figure Drawing* (New York: Dover, 1965), p. 95.

9. Burne Hogarth, *Dynamic Anatomy* (New York: Watson-Guptill, 1958), pp. 156–157.

10. Desmond Morris, *Manwatching* (New York: Abrams, 1977), p. 257.

11. Betty Edwards, *Drawing on the Right Side of the Brain* (Los Angeles: J. P. Tarcher, 1979), p. 62.

12. Ibid., p. 42.

13. Gloria Vanderbilt, with Alfred Allan Lewis, *Gloria Vanderbilt Book of Collage* (New York: Van Nostrand Reinhold, 1970), pp. 13–14.

14. Bea Nettles, *Breaking the Rules: A Photo Media Cookbook*, 2nd ed. (Urbania, Ill.: Inky Press Productions, 1987), pp. 23–24.

BIBLIOGRAPHY

Ariès, Philippe. *Centuries of Childhood*. New York: Knopf, 1962.

Borgeson, Bet. *Colored Pencil Fast Techniques*. New York: Watson-Guptill, 1988.

Burn, Barbara. *Metropolitan Children*. New York: Abrams, 1984.

Coyle, Terence, and Robert Beverly Hale. *Anatomy Lessons from the Great Masters*. New York: Watson-Guptill, 1977.

Crelin, Edmund S. *Functional Anatomy of the Newborn*. New Haven, Conn.: Yale University Press, 1973.

Doyle, Michael E. *Color Drawing*. New York: Van Nostrand Reinhold, 1982.

Edwards, Betty. *Drawing on the Right Side of the Brain*. Los Angeles: J. P. Tarcher, 1979.

Franck, Frederick. *The Zen of Seeing*. New York: Vintage Books, 1973.

Getlein, Frank. *Mary Cassatt: Paintings and Prints*. New York: Abbeville, 1980.

Gilot, Francoise, and Carlton Lake. *Life with Picasso: The Love Story of a Decade*. New York: Avon, 1964.

Gregory, R. L. *Eye and Brain*, 3rd ed. New York: World University Library, 1966.

Grombrich, E. H. *The Image and the Eye*. Ithaca, N.Y.: Cornell University Press, 1982.

Hamill, Pete. "Picasso: The Man." *New York*, May 12, 1980, pp. 34–38.

Harrison, Helen A. *Larry Rivers*. New York: Harper & Row, 1984.

Hatton, Richard G. *Figure Drawing*. New York: Dover, 1965.

Hogarth, Burne. *Dynamic Anatomy*. New York: Watson-Guptill, 1958.

———. *Drawing the Human Head*. New York: Watson-Guptill, 1965.

Itten, Johannes. *The Elements of Color*. New York: Van Nostrand Reinhold, 1970.

Lipitz, Marc. "Mighty Marker!" *How . . .*, May/June 1986, pp. 72–77.

Maiotti, Ettore. *The Watercolor Handbook*. New York: Clarkson N. Potter, 1986.

McMullan, James. *Revealing Illustrations*. New York: Watson-Guptill, 1981.

Monahan, Patricia. *Step by Step Art School: Watercolour*. London: Hamlyn Publishing Group, 1987.

Morris, Desmond. *Manwatching*. New York: Abrams, 1977.

Munro, Eleanor. *Originals: American Women Artists*. New York: Simon & Schuster, 1979.

Nettles, Bea. *Breaking the Rules: A Photo Media Cookbook*, 2nd ed. Urbania, Ill.: Inky Press Productions, 1987.

Schider, Fritz. *An Atlas of Anatomy for Artists*. New York: Dover, 1947.

Sheppard, Joseph. *Drawing the Living Figure*. New York: Watson-Guptill, 1984.

Smith, Stan. *Drawing & Sketching*. Secaucus, N.J.: Chartwell Books, 1982.

Vanderbilt, Gloria, with Alfred Allan Lewis. *Gloria Vanderbilt Book of Collage*. New York: Van Nostrand Reinhold, 1970.

ACKNOWLEDGMENTS

I dedicate this book to my husband, Phil—who encouraged me to make public a private obsession—and to our son, Nicky.

My deep gratitude goes to the young women without whose help there never would have been enough time to do any of this: Jasmyn Van Ooy, Frederique Smoor, and Stephanie Brooks. I would also like to thank:

My friend and fellow mother Jeanette Mall-Fischer, for her moral support and help with the manuscript.

Dr. Lawrence Connors, for his help verifying the baby anatomy.

My editors, Janet Frick and Mary Suffudy. Thanks to Janet for her patience and help in bringing everything into literary harmony. And a special thanks to Mary Suffudy, who did not want to let go of this book in the beginning and luckily never did.

INDEX